PIMLICO

601

THE MAN WHO DREW LONDON

Gillian Tindall is the author of two short-story collections, six novels, and five other works of non-fiction. Both her novels and her non-fiction work have drawn inspiration from a highly developed sense of place and history. At various times, Bombay, Paris and rural France have all formed part of her essential subject matter; but London remains for her a source of enduring and inexhaustible interest. She lives in London with her husband.

THE MAN WHO DREW LONDON

Wenceslaus Hollar in Reality and Imagination

——

GILLIAN TINDALL

PIMLICO

Published by Pimlico 2003

2 4 6 8 10 9 7 5 3 1

Copyright © Gillian Tindall 2002

Gillian Tindall has asserted her right
under the Copyright, Designs and Patents Act 1988
to be identified as the author of this work

First published in Great Britain by Chatto & Windus 2002
Pimlico edition 2003

Pimlico
Random House, 20 Vauxhall Bridge Road,
London SW1V 2SA

Random House Australia (Pty) Limited
20 Alfred Street, Milsons Point, Sydney,
New South Wales 2061, Australia

Random House New Zealand Limited
18 Poland Road, Glenfield,
Auckland 10, New Zealand

Random House South Africa (Pty) Limited
Endulini, 5A Jubilee Road, Parktown 2193, South Africa

Random House UK Limited Reg. No. 954009
www.randomhouse.co.uk

A CIP catalogue record for this book
is available from the British Library

ISBN 0-7126-6757-1

Papers used by Random House are natural, recyclable products made from wood
grown in sustainable forests; the manufacturing processes conform
to the environmental regulations of the country of origin

Printed and bound in Great Britain by
Biddles Ltd, Guildford & King's Lynn

Contents

List of Illustrations

Illustrations

Everything exists,
And not one smile nor tear,
One hair, one particle of dust, not one
Can pass away.

(William Blake)

. . . plankes and lighter things swimme, and are preserved, whereas the more weighty sinke and are lost. And as with the light after Sun-sett at which time, clear in so many degrees etc; comes by and by the crepusculum then totall Darkness. In like manner it is with matters of Antiquities. Men thinke because every body remembers a memorable Accident shortly after 'tis done 'twill never be forgotten, which for want of registering at last is drowned in Oblivion.

(John Aubrey)

. . . the desire of transmitting virtue to posterity does not torment the minds of the living, and what we read of the dead seems a fable, so different is the present practice of the world.

(Mary Evelyn)

Author's Introduction, and Thanks

More than thirty years ago I bought — for two pounds and ten shillings, I believe — a seventeenth-century print of one of Hollar's miniature Islington views. I bought it because I liked it and because I enjoyed thinking that this rugged, stream-crossed landscape was what lay beneath the streets about the Angel tube station. Hollar's name had, till then, been unknown to me, though I began to realise that I had seen that discreet signature on other pictures of London, that indeed I had internalised his views of Stuart London so that they had become my own images of the city we have lost.

A few years later, lighting on a poster-sized reproduction of a cat's head rendered in exquisite detail, I bought it as a decoration for a playroom. Only after I had got it home did I notice that this, too, was signed 'W. Hollar'.

After that, charmed by an artist whose etching skills extended from fur and lace to the Gothic shadows of old St Paul's, and the depiction of the whole of London town in inspired bird's-eye focus, I learnt more about him. I realised that I might one day want to write about him: but at the same time I came to know that, though there have been some excellent biographical studies of him by art historians in conjunction with surveys of his work, attempting a full-length biography in the usual sense was not a realistic option.

We are lucky to have a large quantity of his surviving work, often in multiple copies, most of it dated or datable, which gives us some idea of where he was in Europe at what time. From this and from other evidence we know that he was present on occasions for which there is other and plentiful historical data. There exist three of his own handwritten letters, and his name crops up fleetingly in the letters and diaries of others. The

Registers in his native Prague and in London, where he spent a large part of his life, provide a little basic evidence of his origins, his marriages, his hopeful petitions to Charles II and his death. In addition, we have brief testimony from three men who knew him personally and from one other who was told about him. It is on their scant and precious sentences that the present story of his life is strung.

'Strung', because the material for a conventional documentary account of his life is not there. Hollar's religious affiliations are perpetually disputed; the number and destinies of his children are conjectural; his wives are mere names. My solution has been to interleave the straightforwardly factual sections of this book with passages in which I have adopted a number of lost, obscure and therefore imagined voices that are there to convey their own perceptions of Hollar and to shed further light on the world that surrounded him.

These fictionalised passages are not romanticised: I have imagined nothing for my characters that is not either likely or hinted at already in the scraps of evidence we have. Through the medium of apparent fiction is imparted authentic information about the places in which Hollar lived and worked and about the better-documented people of the day whose paths intersected with his. Neither imaginative constructions nor purely factual sections are written to stand on their own, but rather to complement each other.

My other object, apart from the elusive central figure himself, is London. Hollar drew many other places, both within England and on the Continent, but I have chosen to concentrate on the life and times of the city he made peculiarly his own and which he has bequeathed to us.

On a few occasions it has seemed that some details (of the recoverable location of a house, say, or the exact dating of a letter), though absorbing to me, are perhaps more than some readers want: I have therefore put such points in the Notes at the end of this book.

Dwelling as he did on the fringes of more illustrious lives, it has been Hollar's fate to be inaccurately represented. For decades, the *Dictionary of*

National Biography entry on him has been faulty (though I understand this is being remedied in a new edition) and a rogue reference to him in an otherwise respected work of recent scholarship labels him as 'Dutch'. I am, however, much indebted to several high-quality studies of his life and work (see the Bibliography) and particularly to Richard Pennington's *Descriptive Catalogue* which, in spite of one or two oddities, is an indispensable work of reference for anyone interested in Hollar today.

I am grateful to the staff of various libraries, including the British Library, the Bodleian in Oxford, Camden Libraries, Westminster City Archives, and the London Library who, with their characteristic under-standing, have allowed me to retain certain key reference books in my possession for many months at a time. Particular thanks, also, to those who have made it possible for me to handle Hollar's original work, including the staffs of the Prints and Drawings Room in the British Museum and of the John Rylands Library in Manchester; Craig Hartley of the Fitzwilliam Museum and Richard Luckett of the Pepys Library, both in Cambridge; and Oliver Everett and Henrietta Ryan of the Royal Library, Windsor Castle. I am indebted to the Map Collection of the British Library for illustrations on pages 145 and 168–9, and to the Guildhall Library, Corporation of London, for details from Hollar's 'Long View of London' which are on pages 3, 5, 119 and 219. My thanks also the staff of Southwark Cathedral for information on Hollar's memorial there; also to Anna Rollova and to Alena Volrábová of the Narodni Galerie in Prague, and to Dr Vojtech Balik of the National Library in Prague for some useful indications about the Hollar family and help in translation.

My thanks, too, for help, to Jane Wilson of the Museum of Garden History in Lambeth; also to the Rector of St Giles-in-the-Fields, William Jacobs, and his assistants, for allowing me to consult original parish registers; and to Philip Case, the churchwarden of St John the Evangelist, Wotton, who so kindly showed me the Evelyn family tombs. I am indebted also to Patrick Evelyn, to the Wotton Estate office, to Messrs Monkhouse and partners, and to the security guard Tom Kelsey, for making it possible for me to see round Wotton House. Also to Michael Baxter of the Albury

Estate office, and to the staff and residents of Albury House for showing me round. My thanks too, once again, to Douglas Matthews for his exemplary indexing and general care.

Friends and acquaintances too numerous to mention have been generous with their own expert knowledge, interest, advice, help with the translation of German, Czech and Dutch, provision of visual material and, in one case, the loan of two invaluable and long-out-of-print books. I feel particularly indebted to one academic friend who, in the course of a casual conversation, revealed a personal skill and knowledge of etching which I had not suspected and of which I at once took advantage. As to the friends who accompanied me on assorted trips to far-flung places with Hollar connections, I can only hope that they got some fraction of the enjoyment from the experience that I got myself.

Gillian Tindall,
London,
May 2002

Chapter I

The Way to London Bridge

FROM KING'S CROSS, set in the lost fields of London's countryside, the train enters the dark tunnel lined with old soot: this is the one-time bed of the Fleet River. Here, where rails have replaced it, the water used to run, bright but already tainted, first between green banks, then between rising walls crossed by shaky bridges. It became Turnmill Brook where the buildings closed it in, cutting down deep and foul past the heights of Ludgate Hill, once dividing the city of London from its western suburbs, and finally pouring into the unembanked expanse of the Thames where Blackfriars Bridge now spans it.

The train, abandoning the damp trace of the Fleet, now crosses the Thames and then swings slowly towards Southwark, downstream on the south side of London Bridge in a wide curve round the backs of buildings, the back of the city itself. It trundles past the sheet-glass of modern offices and the rusting metal and concrete of earlier industrial blocks, past parking lots and triangular scraps of derelict London earth weighted with sodden litter or exuberant with the buddleias that spring from stones. It crosses iron bridges; a brick viaduct curves away between the remains of early Victorian terraces with mansarded slate roofs, and windows through which, if they were not thick with dust, you could glimpse vanished lives. The battered remnant of a Model Tenement creaks past, so do corner pubs with ancient names – disused railway buildings, an old poor house with a bell on top . . .

There are fleeting glimpses of St Paul's or St Bride's, far away on the other shore.

Somewhere below, between here and the unseen river, are the remains of the Clink prison – a doorway, a passage through time – and of the mustard factory that, much earlier, was an archbishop's palace. Playhouses, bearpits, gardens, fish ponds, brothels and galleried inns lie below somewhere, in London's composted earth, but the graffiti-marked zinc roofs of Borough Market spread themselves all around. Then the train, with a long drawn-out grating of wheels on iron, as if the way is hard through so much that has happened here, passes alongside the roof of Southwark Cathedral. It survives down there, St Mary Ovarie as it used to be, St Mary-over-the-water, on a narrow patch of earlier London, pressed on all sides by later centuries. The train, ignoring the cathedral, reaches London Bridge Station.

The empty air itself contains memories. A few feet downstream from the present London Bridge is the site of the older bridge: its packed wooden houses, its collection of severed heads on poles are gone – yet that is still in some sense their place. They are eternally there, as much there as the mythological beings that appear higher in the sky at this point in a famous Thameside panorama. One of these is an angel, blowing for ever on a trumpet to waken the dead.

All this swathe of land called Bankside, facing the town across the river but not in his day officially part of it, was the special territory of Wenceslaus Hollar. It was the place from which he drew the views of London that are his most enduring monument. Whenever an illustrated history refers to seventeenth-century London, or some scene-setting material is needed for an exhibition on Van Dyke, say, or the Restoration, or the Plague and Fire of London, or Sir Christopher Wren, it is the work of Wenceslaus Hollar that is called upon. It is his Old St Paul's ('S. Pauwls' in his clear italic hand) that illuminates any study of the Wren cathedral that rose in its place; his Tower of London that is imprinted on the plastic bags that present-day tourists carry away from the souvenir shops. We see the London of our ancestors through his eyes; his version of it has become part of the general

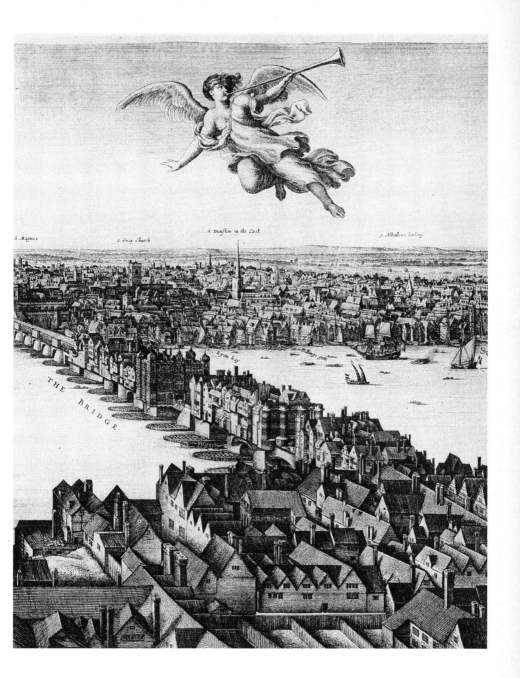

perception of innumerable people who have not consciously heard his name.

Yet the man whose vision has become so identified with London in the minds of others was a permanent exile. He died in debt, and scarcely one of the influential friends of his brightest days noted his death in their diaries or letters. His very place and year of death were forgotten, and it was not till some fifty years afterwards that an admiring collector of prints, himself an engraver, located these in a burial register. He took it upon himself to add to the entry the words 'the famous'.

Although London itself, not Southwark, was where Hollar's comprehensive gaze was fixed when he made the studies on which his greatest set piece was based, the Bankside stretch of Southwark was what lay most immediately under his feet. Therefore, by an almost mechanical chance, that is where the most meticulous detail appears. We see the textures of the tiles on the nearest rooftops above the pointed gables, and the number and variety of the chimneys. We look down into the Bishop of Winchester's formal gardens, where a small procession is walking two by two. We see where a muddy river creek runs up by the sides of buildings, where a horse and rider are leaving the yard of the Angel Inn, and where a feathery mound of grain and some sacks indicate a mill. We see men on one of the cramped spaces between the tall buildings on London Bridge; further over, a tiny coach is just emerging from the dark archway of Nonesuch House, the grandest habitation on the water. We see the line of timbered house fronts that is Borough High Street.

We do not see the tower of St Mary Ovarie, which in Hollar's Reformed England had become the parish church of St Saviour's, though frequently called still by its old name. This is probably because we are standing on it, or rather on the version of the tower that was there at that time. 'Probably' because, although Hollar did make many sketches from this tower, the angle and extent of the view before us suggest a still higher place and one a little further from the river. It had become a convention, by his day, to draw vistas, and also the bird's-eye views that constituted the earliest maps of cities, standing on the vantage point of a sizeable hill just beyond the city.

What is now south London did not in reality have any such hill conveniently situated for viewing the central area, but, like others in his time, Hollar proceeded as if it had. Some of the preliminary sketches from which his 'Long View' was eventually constructed actually show the top of St Saviour's tower, although no taller building from which he could have attained such a view then existed. He was supremely accomplished at drawing buildings from an angle from which he could never actually have seen them.

In his most famous panorama from Bankside, cherubim, Mercury the messenger of the gods, a herald angel and an American Indian group hang in the skies above the town. Their standard forms, like cut-outs from a baroque pattern book, contrast oddly with the insistent, intricate realism of what lies below. It is as if Hollar stationed himself opposite them and only a little lower down, sketchbook in hand, his stocky form in good broadcloth and soft leather boots treading nonchalantly on the London air.

Chapter II

The Artist from Bohemia

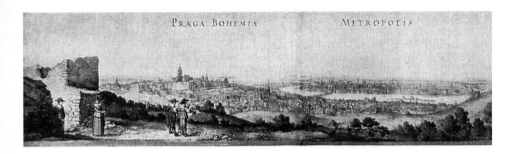

PRAGA BOHEMIÆ METROPOLIS

A ll the various houses, grand or humble, in London or on the Continent, in which Hollar lived during his seventy-year life have gone, replaced by later buildings or by a greater obliteration. The exact nature of place was his passion, but in what sense can a location still be said to exist when a row of timbered houses and gardens has been effaced by a tube station, or a narrow lane by the great pile of the Foreign Office?

Yet Hollar does have a stake in London all the same. His bones lie in Westminster, but he lives today in Southwark Cathedral, much rebuilt since his time but still recognisably the same place. An engraved stone plaque in the south aisle, near to Shakespeare's reclining form, carries his gentle face in slaty aluminium by a Czech sculptor.[1] It was put up, thanks to the efforts of a group of London Czech exiles, on the three-hundredth anniversary of his death, partly in celebration of the existence of a Czech nation-state in the twentieth century after three centuries of Hapsburg hegemony. There used to be a card referring to this, but more recent changes in Bohemia's long and chequered history have led to the removal

of the political reference, which probably pleases Hollar well enough. The stone reads simply: 'Wenceslaus Hollar. Exile from Bohemia – Artist in England.'

Underneath is a poem that has achieved its destiny in stone more than two hundred years after it was written. It is by Hollar's eighteenth-century admirer George Vertue, who modestly pretended it was by someone else:

> *The works of Nature and of Man,*
> *By thee perceived, take Life again;*
> *And ev'n thy* PRAGUE *serenely shines,*
> *Secure from Ravage in thy Lines.*
> *In just Return this Marble Frame*
> *Would add some Ages to thy Name:*
> *Too frail, alas! 'tis forced to own,*
> *Thy* SHADOWS *will outlast the* STONE.

But what was Hollar – whose shadows, insubstantial prints from etched copper that have proved more durable than stone – doing in London at all?

There are several answers to this, one or two self-evident, others still disputed and probably, after the best part of four centuries, unprovable. The search for them leads to another of his cities on a river, the original one, viewed from a genuine hill. From an outlying hillock of the White Mountain, that battlefield that was to precipitate the Thirty Years War when Hollar was just into his teens, he depicted Prague lying at his feet.

Castle complex, River Vltava with its boats and islands, the Charles Bridge, the accumulation of steeples and pinnacles on the further bank – all these are fully recognisable today. The hillside, though no longer covered in vines, is still green and unbuilt. Even the stone wall, constructed pointlessly across the hill in the fourteenth century to provide work for starving citizens, still zigzags downwards. Also Prague itself, in spite of everything it has undergone in the intervening time, is still – or again – serene and shining in its own right. Unlike most of the German cities in which Hollar made a transitory home, including Cologne, all of which were ravaged or virtually destroyed in the mid-twentieth century, Prague survived the Second World

War physically intact. In the long years of post-war Communism it slept in an uneasy time-warp while paint and plaster dropped from the wonderful buildings. But after 1989 the city bestirred itself again, and in its new prosperity the architecture, at any rate, is now resplendent.

It both is and is not the Prague in which Hollar grew up. In the lanes around the Old Town Square, with its animated clock reminding passers-by every sixty minutes of the hour of their death, and in the quiet streets of the Lesser Quarter across the river and below the castle, you can still find the city of footsteps that he knew, with many of its original buildings. But much of the rest of the city, including the castle itself, the monasteries, churches and libraries, was damaged or looted in the wars that lasted till the mid-seventeenth century. When finally the various national and political interests, all marching under the colours of different shades of Christianity, had laid Europe waste from the Rhine to the Danube and beyond and had fought each other to an inconclusive standstill, Prague needed to rebuild.

From being a centre of largely Protestant nationalism, it had been Germanised and Catholicised and was ruled from Vienna. The Gothic houses of old Prague began to be replaced by high, light, baroque buildings with elegant painted plaster work. The austere churches of the Protestant Bohemian Brethren were overtaken by multiple altars, vibrant with gold leaf, saints and rococo cherubim. Domes and cupolas rose; ceilings blossomed with heavenly choirs. There is some evidence that Hollar, as his life went by, might have approved a good deal of this. But he was not to see it. He left Prague as a young man of twenty and seems to have returned only once, for one week, nine years later, while the wars were still in progress.

The few facts we know about his beginnings are soon told: the background is a little more complex. He was born in Prague in 1607, probably on 23rd July if we assume, as was likely, that the new-style Gregorian calendar was by then in use in Bohemia. (The continued use, in northern European countries, of the old-style Julian calendar, which lagged ten days behind, creates a shimmering uncertainty around seventeenth- and early eighteenth-century dates. In addition, because of different countries' piecemeal shifts of New Year's Day from the old spring solstice date of 25th

March to 1st January, even the year is confusingly in question when an event falls in the first three months our-style. The execution of Charles I of England, which was one of the defining dates of Hollar's life as for so many of his generation, is therefore a particularly evasive one. The English regarded him as having been beheaded on 30th January 1648, while the Scots looked on this same day as being in 1649, and the French and Dutch also thought it happened in 1649, but on 9th February.)

Wenceslaus (or Vaclav) Hollar was born at 13 Soukenicka ulicka, the German name of which was Tuchmachergasse, the street-of-the-cloth-workers. It was a district where gentry lived, not far from the river. Central Prague was, and is, very small, and this was just within the New Town – that is, the fourteenth-century development outside the old walls. The street is still there and in recent years number 13 has acquired a plaque on it and a bust of Hollar: the upper levels of Prague buildings are populated by many stone people. This is not the carved wooden house 'at the Sign of the Ram' that Hollar knew, for that was burnt down long ago. But, true to Prague tradition, a working goldsmith currently occupies the ground floor, his presence evoking the semi-mythic Prague of the alchemists that the Emperor Rudolf II was supposed to have gathered round him. Tourists are taken to view the tiny 'alchemists' houses' (more probably court jewellers' workshops) in Zlata ulicka under the walls of the castle, and stories of the mystic Cabbalist Jews of the same era enrich the mixture. The truth is rather that Rudolf, a gloomy and complex man, was a collector of many things including art, people and ideas. His 'cabinet of rarities' – actually treasures spread over many rooms – held curiosities as modern and sophisticated as astrological instruments of navigation and as traditional as a unicorn's horn. The scientific quest for new knowledge, which drew scholars to his court, was not at that time distinct from the ancient quest for the philosophers' stone to transmute base metals into gold.

It was into Rudolf's Holy Roman imperial capital that Hollar was born; his father, Jan, was a lawyer and court bureaucrat in the land registry. But five years later Rudolf was forced to abdicate in favour of his brother Matthias and the court was moved back to Vienna. When Matthias died in

1619, the Bohemian nationalist burghers of Prague seized their chance to revolt against German Catholicism. There occurred what is now the most celebrated single event in the city's history: the castle was invaded and three leading Catholics were thrown from a high window. Remarkably, all three lived to tell the tale: the Catholic faction maintained that angels had borne them up, but the Hussites (Protestants) said they had simply fallen on to a soft manure heap beneath a castle latrine, which was the best place for them. Frederick, the Protestant Elector of the German Palatinate, was triumphantly installed as King of Bohemia, but he and his 'Winter Queen' Elizabeth, the sister of England's future Charles I, reigned for little more than that season. Late the following year, in 1620, the nationalist dream ended catastrophically in the battle of the White Mountain.

The family at the Sign of the Ram must have lived quite comfortably. Jan Hollar's brother, Jacub, was mayor of a provincial town where the brothers owned a 'castle' and land. A few years before Wenceslaus/Vaclav's birth, the brothers were granted by the Emperor the right to bear arms. His mother, Margaret Lowe or Lov, also came of a land-owning and armigerous family, possibly a rather grander one than the Hollars. She bore her husband two sons but died when Wenceslaus was six. Her husband remarried later and a third son was born to him.

Once Hollar left home as a young man, there is no record of him having any contact with either his brother or his half-brother. What was probably his only return visit to Prague was brief and was not of his deciding: it was made under the protective aegis of a diplomatic embassy. After the Thirty Years War was finally over, when Hollar was middle-aged, he never returned to his native city although, with his cosmopolitan contacts and his experience of travel, he could certainly have arranged to do so.

The documentation on Hollar's life is hardly copious. All the same, it does look as if, even in early childhood, events were taking place which were to open the door on to his future lifetime's exile.

With the departure of Rudolf and the imperial glow, and then the dashed hopes of a Czech revival, Prague, which had been a centre of wealth, art and learning, went into decline. The pay of the court artists and

craftsmen whom Rudolf had gathered round him was cut. Many people left in those years, but this in itself does not quite explain why the young Hollar left his home and homeland. The important question is where in the political struggle being played out all round them did the Hollar family belong?

John Aubrey, the indefatigable English man-about-town of the seventeenth century, thanks to whose energy and vision we know the brief facts of many lives which would otherwise have passed into oblivion, becoming as if they had never been born, wrote of Hollar:

> His father was a Protestant, and either for keeping a conventicle, or being taken at one, forfeited his Estate, and was ruined by the Roman Catholiques.

John Evelyn, the statesman, intellectual and passionate Anglican, added a note to his diary-entry on Hollar's work — 'perverted at last by the Jesuits at Antwerp to chang his Religion'.

So far, so simple. Both Aubrey's and Evelyn's comments resonate with the by-then established Anglican view of the Evils of Rome, which was to endure in England for the next three hundred years. As factual statements they could also be true. At the end of July 1627, when Hollar had just turned twenty, the Hapsburg Emperor Ferdinand issued an edict requiring all members of the nobility to convert to Catholicism within six months or to emigrate. Hollar seems to have left Prague soon after, for by November he was in Germany, in the predominately Protestant area of Stuttgart. There is evidence, too, that both his uncle and his first cousin were 'evangelists' for the Bohemian Brethren, so the inference is that his father was Protestant as well: the family seat was in a non-Catholic area. As for Hollar's dead mother, she had come from the upper Palatinate where, we are told, Calvinism prevailed.

Such facts have been enough to convince several twentieth-century writers of Czech origin, mostly exiles themselves from other wars of belief, other tyrannies, that Hollar came of solid, anti-Catholic stock — that he had internalised in childhood the ritual of dark, plain little churches such as St

Martin's-in-the-Wall, whose one decoration was a symbolic wine-flask. The young man could not, it has been suggested, bear to remain in the atmosphere of Hapsburg oppression, treated as an outcast, his native tongue downgraded. In short, he has been claimed as an embodiment of that indomitable Czech-speaking nationalist spirit which, over the centuries, has continually been threatened or suppressed by one world power or another, but which rises phoenix-like again and again from the ashes of conflict (and similar passionate sentiments).

The only difficulty with this theory, and with Hollar's own remarks to Aubrey, is that Jan Hollar the father was, by all evidence, not noticeably Protestant at all. He was given his coat of arms by the Catholic Emperor Rudolf. He was not dismissed from his post in the castle after 1620; in fact, during the 1620s he was promoted. He apparently planned that his eldest son Wenceslaus should become a lawyer like himself; and when in 1627 the edict against Protestantism was issued, the Hollar family property was not seized. Jan Hollar enjoyed an untroubled existence, as far as anyone has been able to discover, till his death in 1630. What is more, when Wenceslaus Hollar returned fleetingly to Prague under diplomatic protection six years later, the Catholic Emperor Ferdinand gave permission for him to inherit and use the family arms so that they should not fall into abeyance. This accumulation of evidence has convinced more recent commentators that Hollar's immediate family must have been Catholic, no matter what he told his English friends years afterwards.

But what sort of Catholic – or what sort of Protestant? On close examination, the absolute distinction begins to fall apart. In the Protestant camp were also German-speaking Lutherans and Calvinists, far more extreme in their views than the original followers of Hus and Wycliff. These, indeed, were the kind of dissenting Protestants who were no more popular in Anglican England than they were in Catholic Europe. The Hussite Bohemian Brethren, who were avowedly nationalist, had as one of the main tenets of their belief an insistence on communion *sub utraque specie*, in both kinds – i.e. wine as well as bread – which the Catholic Church traditionally denied them. However, in this they were not different from the

Czech Utraquists or 'Old Catholics', who made the same demand but were in other ways very little different from conventional Catholics. Then there were the German-speaking Catholics of the Lesser Quarter, and the Jesuits . . .

It was ostensibly for such shades of opinion within one faith that, for two centuries, men and women were prepared to dispossess, destroy, fling from windows, mutilate, torture and kill, and be mutilated, tortured and burnt alive themselves.

One ingenious Czech commentator has suggested that Hollar let people in England think that his family had been Protestant because they were in fact Utraquists, and he felt unequal to explaining the nuances of this reformed Catholicism to uncomprehending Anglicans. It may be so. It may also be that in exile Hollar, who is remembered by Aubrey as 'a very friendly, good natured man as could be', preferred to let his English hosts think what they found it comfortable and natural to think. It should also be said that the history of religious change in the sixteenth and seventeenth centuries in England, let alone Bohemia, suggests that the mass of people, at any one time, were content to keep their heads down and go with the prevailing trend. In England, in marriage and bereavement, Hollar was to avail himself of the Anglican rituals then in favour, but then many prudent Catholics of the period did that. Nothing in his passionately detailed, realistic but attractive drawings of the world around him suggests that his mainspring was either the 'austere moral protestantism' that some have claimed for him or yet the heady, baroque exaltation of the Jesuits that Evelyn thought had snared him. Hollar loved old churches, and other finely wrought things, and that he was a man of feeling there is no doubt, but there is no hint that he was interested in the theoretical niceties of religion that divided one man from another.

Religion, however, is a perennially useful pretext for giving substance to a quarrel that has other roots, material, political or emotional. There is one piece of evidence that is probably more important than all the rest. In the 1640s, when a further exile had taken him to Antwerp, Hollar etched for a Dutch artist and publisher a portrait of himself, no doubt pleased to be

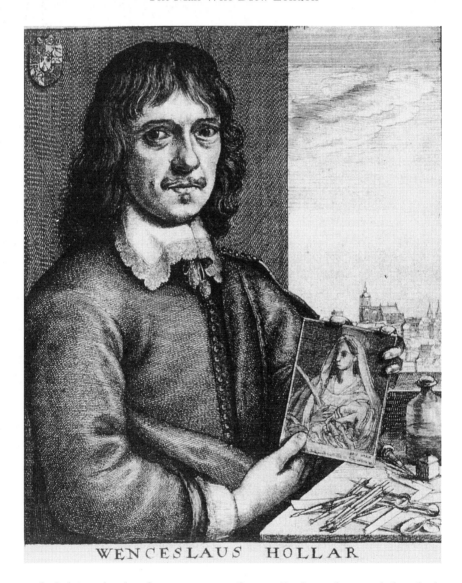

WENCESLAUS HOLLAR

included in a book of contemporary figures. It shows him with his thick brown hair curling over what was probably his best lace-trimmed collar, and his moustache and dab of beard neatly trimmed. He is holding up, as if to display a sample of his work, his engraving of a Raphael portrait of St

Catherine, the patron saint of art. On the table before him are the tools of his trade, and a flask of *aqua fortis*, and in the background through the window is a tiny slice of old Prague. His much-prized arms, complete with a hieroglyphic family castle on a peak, decorate an upper corner. Underneath the picture is a long inscription, in French, since the book for which it was intended was called *Images de Divers Hommes*. It is probably not in his hand. French was a language of cosmopolitan communication, but it does not seem to have been one of Hollar's main ones, and he never lived in France.

> WENCESLAUS HOLLAR — Gentilhomme ne a Prage l'an 1607, a esté de nature fort inclin pr. l'art de meniature principalement pour esclaircir, mais beaucoup retardé par son pere l'an 1627 il est partij de Prage aijant demeuré en divers lieux en Allemaigne, il ç'est addonne pour peu de temps a esclaircir et aplicquer leau forte, estant party de Coloigne avec le Compte d'Arondel vers Vienne et dillec par Prage vers l'Angleterre, ou aiyant este serviteur domesticque du Duc de Iorck, il s'est retire de la a cause de la guerre a Anvers ou il reside encores.

> [Gentleman, born at Prague in the year 1607, was by nature much inclined to the art of the miniature, especially to illumination, but was much held back by his father. In the year 1627 he left Prague and having lived in various places in Germany devoted himself for some time to illumination and etching. He left Cologne with the Count of Arondel for Vienna, and then via Prague to England: having served there in the household of the Duke of York, he retreated because of the war to Antwerp, where he is still living.]

To allow the statement, not in confidence to a friend but on a public presentation of oneself, that one's father had held one back is a powerfully aggressive act, especially in a man whom no one regarded as generally combative or difficult. And this was nearly twenty years after Jan Hollar had died and his son had achieved on his own a fair measure of success. Whatever had passed between the father and son, there was lasting resentment and grief buried there. It seems that the most likely explanation for Wenceslaus Hollar's departure from Prague was a long-term, endemic

15

tension with his parent, and that any religious difficulties his family might be having – or any prudent change of cult that was suggested to him as a way of avoiding future difficulties – simply became a further bone of contention and a convincing and even prestigious pretext for leaving home. Non-Catholic 'nobles' were to be forced to leave. Was he not noble, in spite of his artisan inclinations?

> He told me that when he was a Schoole-boy he tooke a delight in draweing of Mapps; which draughts he kept, and they were pretty. He was designed by his father to have been a Lawyer, and was putt to that profession, when his father's troubles together with the Warres, forced him to leave his countrey. So that what he did for his delight and recreation only when a boy, proved to be his livleyhood when a man.
>
> (John Aubrey, again)

It is not given to most men to turn their boyhood hobby and passion into a lifetime's way of earning a living. On that fundamental count, Hollar's long, variegated and occasionally tragic life must be reckoned truly fortunate. He could hardly have hoped to achieve the lasting fame that eventually became his when he set off, a young man without significant funds or home support, with his personal pack of obstinate ambitions and dreams, into a Europe devastated by bloody battles between neighbours. Near the end of his life, a friend got the impression that he had in fact 'carried arms in the Militia in Germany but was soon tir'd on't'. Art historians have tended to assume that his main purpose in leaving home was to make his way to Frankfurt to study there with the master-engraver Mattheus Merian, but this culture-influenced theory of formal apprenticeship is at odds with the scraps of evidence that have survived, mainly dates on drawings of other towns.

He may have been in Stuttgart for the whole of the winter of 1627–8, perhaps hoping to pick up commissions there in the ducal court of Württemberg. A little later he was in Strasburg, from which some of his most engaging drawings survive, and then moved down the Rhine to Mainz. He was beginning to collect the raw material that was to be his reserve for

many years to come. He already had some experience of engraving and etching, which are not skills you can learn quite alone. In recent years a few of his early efforts from Prague have been identified in the Fitzwilliam print collection in Cambridge – hesitant beginner's efforts on odds and ends of left-over copper. A view of the city seems to be emerging from a mist; the earliest labelled print, a portrait of the regretted Winter King, is dated 1625. A Flemish engraver, Aegidius Sadeler, whom Rudolf had appointed to the specially created post of Imperial Printmaker (*Kupferstecher*) remained in Prague throughout Hollar's teens, producing classical subjects and also convoluted Gothic landscapes with cliffs and mysterious forests – quintessentially Germanic views. It is likely that the boy, whose father was, after all, employed at the court, was able to hang around Sadeler's workshops and watch his apprentices.

Hollar probably did not settle across the river from Mainz, in Frankfurt, till 1631, when he spent less than a year in Merian's workshop. Before that, he had already been to Cologne, the first of several visits to the town that was to be the place of destiny for him: it was where he was to meet the person whose intervention altered the course of his life for good.

Chapter III

The Arundel Connection

There now appears on the scene, and temporarily centre-stage, an august personage. He was some twenty years older than Hollar. His secretary, Sir Edward Walker, another of those invaluable seventeenth-century chatterers, wrote of him in after years:

> He was tall of Stature, and of Shape and proportion rather goodly than neat; his Countenance was Majestical and grave, his Visage long, his Eyes large, black and piercing; he had a hooked Nose and some Warts or Holes on his Cheeks; his Countenance was brown, his Hair thin both on his Head and Beard; he was of stately Presence and Gate, so that any Man that saw him, though in ever so ordinary Habit, could not but conclude him to be a great Person, his Garb and Fashion drawing more observation than did the rich Apparel of others; so that it was a common Saying of the late Earl of Carlisle, Here comes the earl of Arundel in his plain Stuff and trunk Hose and his Beard in his Teeth, and he looks more a Noble man than any of us.

The Earl of Arundel, Thomas Howard, was a descendant of persons undoubtedly great, but whose lives had been tossed and broken by the events that followed the Reformation in the previous century. His grandfather, the fourth Duke of Norfolk, had been arrested and beheaded in 1572 for his part in a Catholic conspiracy to put Mary, Queen of Scots on the throne of England. His father, no longer a duke, but Earl of Arundel

through the female line, was also arrested for treason thirteen years later and spent the rest of his life within the walls of the Tower of London, where he eventually died, honourably refusing to recant, still a prisoner. He never saw his son, Thomas, who was born four months after his arrest. This future great person saw the light in a plain stone parsonage in Essex to which Lady Arundel had retreated. She brought her son up well out of the eye of the hostile Queen Elizabeth and with strict economy; after her husband's sentence for treason was confirmed, and all the marital goods were seized from Arundel House in the Strand, she found herself in real want. She also raised him as a dedicated Catholic, and most of those who helped her during the years of his childhood were of that faith; the semi-secret, tenacious world of the recusant families was taking shape.

But by the early 1600s this Thomas, second Earl of Arundel, was moving in court circles under James I and was artistic mentor and companion to the young princes. In 1611, aged twenty-five, he was created a Knight of the Garter and was active in the negotiations to marry the Princess Elizabeth, the sister of Charles I, to the Elector Palatine – whose Winter Queen she became. It was at about this time that he converted to the Church of England; soon after, he was admitted to the Privy Council. By the 1620s he was Earl Marshal, the head of the College of Arms and the man responsible for court ceremonial, which was the post his great-grandfather had held in the time of Henry VIII, before the evil days came. And in this high position, in spite of occasional differences of opinion with the monarch (one even leading to a brief sojourn in the Tower, like his father before him), he remained.

There were those who hinted that to regain this ancestral place and to be a greater noble than all the rest was the mainspring of the Earl of Arundel's life, that he was without any genuine religion and 'cared not for God nor man'. He was also deeply reserved. Edward Walker remarked that his employer 'kept a greater Distance toward his Sovereign than any Person I ever observed, and expected no less from his inferiors'. Edward Hyde, who would become Earl of Clarendon and grandfather of England's last Stuart queen, and who did not like Arundel, called him 'a man supercilious and

proud who lived always within himself'. He maintained that 'never man used or employed by [Arundel] ever got any fortune under him'. Directly, perhaps, people did not receive favours from him. But this complex man was one of the greatest connoisseurs, collectors and patrons of his day or any other, drawing to England such international figures as Rubens and Van Dyke and raiding the known world for rare and beautiful artefacts. He was also the person who gave Wenceslaus Hollar the chance of a lifetime and, in so doing, gave Hollar to England.

There are three pictures of him by Van Dyck, besides other likenesses. One, painted about 1620, is a classic portrait of a great lord, seated authoritatively in a dark doublet and ruff, a Knight of the Garter jewel in one hand, a folded paper in the other and a vaguely stormy landscape behind him. More individual is the one painted some fifteen years later, near the time Hollar met him. His face has aged and broadened slightly, his hair is greying: he was about fifty years old, still strong, still with the same wary but commanding look. Although he was a diplomat rather than a soldier, he wears a suit of burnished armour. Lord Clarendon said there was 'nothing martial about him but his presence and his looks', and indeed Arundel's one military campaign (against the Scots in 1639) was not a success. The armour is there to evoke older connotations, of chivalry and majesty, and the staff he holds in his hand instead of a sword is the Earl Marshal's staff that his great-grandfather bore. It is raised, as if to protect the small, red-jerkined boy, his grandson, another Thomas, who stands by his side. His other arm is round the child's shoulders. He seems to have foreseen the troubles that lay in the years ahead and was on his guard. In spite of his own prudent change of religious faith, his wife was a Catholic and his children and grandchildren seem to have been brought up, discreetly, in that faith. At any rate, the boys were sent to Italy for their education once they were of appropriate age, as he himself had been.

He had made an advantageous marriage and, for a good many years, his wife was his 'dear heart'; though, with the going on of time, feeling and loyalty wore thin as much on her side as on his, and at the last they were estranged. Alatheia, Countess of Arundel, was a granddaughter of the

redoubtable Bess of Hardwick and daughter of the Earl of Shrewsbury, who had no male heirs. Her inheritance was very substantial, and it was her money that enabled Arundel to pursue the passion for paintings and antiquities that he had acquired in Italy in his youth: he had been present at the excavation of the Roman Forum. However, his scale of spending meant that behind the scenes in the great household the Arundels kept there were frequent financial crises. A portrait in Arundel Castle, in Sussex, shows the pair of them in formal, noble regalia, with a globe between them in the appropriate spirit of seventeenth-century expansionism. Lady Arundel holds a pair of navigator's dividers, while her husband points to the island of Madagascar. He needed rather badly to make a lot more money, and he became briefly taken with the idea of Madagascar, not just as an exciting variation on the New World then opening before men's eyes but as a speculative venture. He even planned at one moment to leave England permanently, though such a drastic step seems to suggest that behind the entrepreneurial ambition to rule a tropical kingdom lay dark and justified forebodings about the state of his own country and his own well-being.

In spite of the dividers in her hand, Lady Arundel's plump face, with its rather heavy features framed in fashionable curls, is not looking either at her husband or at the globe. The picture (which exists in several versions, as if it was intended as an official record to be distributed round the family) was painted in 1639 when the Earl's health was already declining; this may have been the main reason why the Madagascar adventure was, after all, abandoned. Seven years later the Earl was dead, not on a tropical island but in Italy, and Alatheia was in Antwerp selling off his treasures.

Arundel Castle, partially destroyed in the Civil Wars and heavily rebuilt in the Victorian era, is today once more the seat of the Dukes of Norfolk. The title was regained, though not in the Earl's lifetime, and the Howards are the premier Catholic family of the United Kingdom. The whirligig of time brings in rewards as well as revenges.

This, then, was the man who, in Cologne, was to be Hollar's destiny. In 1636

he was sent by Charles I on a diplomatic mission to the Hapsburg Emperor to persuade him to restore the Palatinate to Charles's nephew, the child of Frederick (now dead) and the Princess Elizabeth. This would also have the advantage of going a long way towards resolving the continuing European war, by then in its sixteenth year. It was not, however, a mission likely to succeed. Arundel must have known this, but presumably he welcomed the chance to add more paintings, pieces of statuary and valuable books to the huge collection already at his house on the Strand. Europe was in such turmoil, with palaces, monasteries and libraries sacked and their owners forced to flee, that this was a good time for a man to acquire more treasures. He set out in April, first to the Low Countries and then up the Rhine into Germany. In a world where roads outside the towns were, at best, stony, dusty or muddy tracks – and often no roads at all, just a danger-haunted route through mountains, swamps and forests – the principal rivers of Europe were the only good communication network.

Hollar spent a while in Antwerp in 1634; this was the first time his eyes, bred to rivers, had opened with delight on the waves of the sea. However, in 1636 he was back in Cologne, a city with rich merchants and many people passing through. The young artist had now fully mastered the techniques of copper-engraving and, more particularly, etching, which was then a new technique. In etching, the pressure of a fine, sharp tool on the surface of the copper is replaced by the effect of acid biting into the metal. The surface of the copper is first entirely covered in a waxy composition on which the lines of the intended picture are drawn with a fine etching needle, so that the acid will only penetrate the copper along those lines. By blocking out different areas during repeated immersions in acid, elaborate and subtle gradations of tone and texture are achieved. With this modern skill, which was opening up extraordinary new possibilities of illustration, Hollar might hope to get a living in Cologne, but it would have been a hand-to-mouth one. He had been roaming Europe for nearly a decade now and his sketchbooks were full of towns and castles, but he had not yet produced any public work that would set him apart from other hopefuls, other journeymen turning out reproductions of greater men's work. George Vertue (1684–1756), his post-

humous admirer, who catalogued his works and spoke to people who had known him, says that, in Cologne, Hollar 'resided for some time with difficulty enough to subsist'.

Yet Arundel heard of Hollar and met him. Or possibly Hollar heard of Arundel, who was being fêted by the town corporation, and contrived a meeting. The first ever mention of Hollar in English occurs in a letter Arundel wrote in late May to the man[1] who was then acting as his agent for the purchase of works of art in Italy:

> To my very loving friend, Mr William Pettye at Venice.
>
> Good Mr Petty,
>
> I know not where this rogue Quarke may find you, but I pray be careful that he be kept from disorder . . .
>
> [Quarke was the servant whom Arundel had despatched on the long, hazardous journey by land and water, the only way of getting a letter delivered in a world without postal services.]
>
> I shall be shortly (by God's Grace) with the Emperor at Linz, where I hope to see you and Francesco. I have come in Porrte, as it were, and found a most miserable Countrye, and nothing by ye way to be bought of any momente [. . .] I have one Hollarse with me, who drawes and eches prints in strong water quickely, and with a pretty spiritte [. . .]

In Cologne, that May, was living a Hendrik van der Borcht, or Ter Borcht, or van der Burg, or Burch,[2] a German antiquarian (or Dutch, according to some commentators: in any case, perceptions of national identities were not then as they are today) who was a connoisseur and dealer. He and Hollar had met at Merian's workshop in Frankfurt. Van der Borcht had a son, also Hendrik, an artist a few years younger than Wenceslaus Hollar. The two young men may have been friends already; certainly they became friends later. An engraving by Hollar of a Johann Meyssens portrait of young Hendrik/Henry, with a French inscription referring to Arundel, dates from the later 1640s when both were in Antwerp. The van der Borcht family is surely the link between Hollar and Arundel, since Arundel seems already to have known van der Borcht the elder from having done business

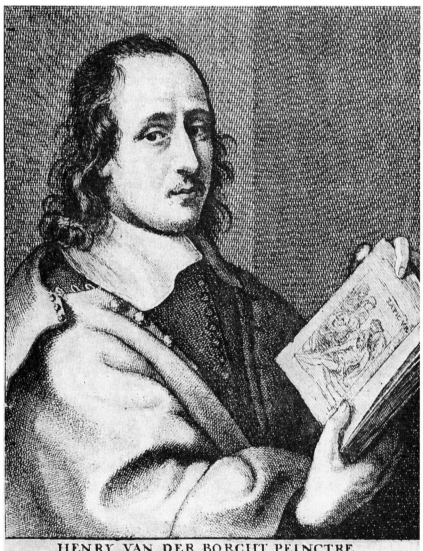

HENRY VAN DER BORCHT PEINCTRE

with him in the past. A probable sequence of events is not hard to imagine.
I see Hendrik van der Borcht the son seeking his friend out in some pie shop
in Cologne's Alter Markt, urging him to button up his doublet and come to

be presented to the English lord: *'travelling down the river with a rich embassy. Father thinks he might take us with him.'*

— Or no, perhaps Hendrik found his friend, more typically, working with rapt attention at a plate after Dürer or Holbein in the last of the daylight reflected from the river, his piece-worker's hour glass by his side:

'Leave your tools, Wentzel. No, don't start laying that ink on! I've something to tell you of much greater import than that your plate should be finished this night. An English Graf — a great man. I am always telling you: in the world this is how things are done . . .'

'Yes . . . It's just that I had given my word to Maria. She may be waiting for me now. You understand, Hendrik? She's been so good to me . . . Oh, very well.'

> He was a very friendly good-natured man as could be, but shiftlesse as to the World.
>
> (Aubrey)

I have not invented Maria, though I have given her a name. In the Kinsky Palace in Prague exists a drawing by Hollar which cataloguers have described as being based on a picture by Rembrandt, though it is not the 'Naked Woman' by that artist of which Hollar made an etching. The drawing bears the German handwritten inscription *'Dieses mach ich zu gutter und immerwehrender gedachtniss in Cöllen, en 31 Julij AD 1633* Wentzeslaus Hollar von Prag' — 'I make this good and not-to-be-forgotten likeness on 31 July 1633' — so it is hard to believe that the sole inspiration for the portrait was Rembrandt and the sole purpose a possible etching. The woman reclines naked on a bed, one arm raised, her head of copious curling hair resting on a pillow. She is fairly young, but not a girl. Her hips and thighs are slightly heavy, her breasts small and shapely in the way approved by the classic sculptors. Her plebeian face is fleshy, with the beginning of a double chin; her eyes are closed, she seems to be lightly sleeping off recent exertions.

Whoever she was, this Cologne innkeeper's daughter, or shop worker, or washerwoman, or seller of fish or flowers whom Hollar conflated with Rembrandt's model to make this personal sketch and its dedication, is now irretrievable. But she did exist. The same face crops up in profile, twice, in

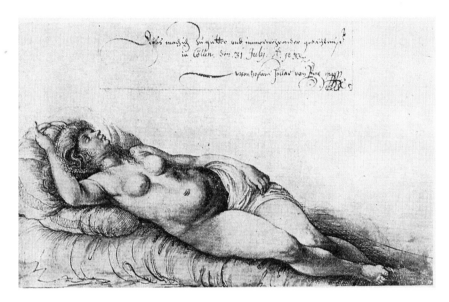

fugitive sketches made by Hollar on the backs of other pencilled German scenes, in a small vellum-covered notebook that is now in the John Rylands Library in Manchester. The soft contour of the face is tender and sure. Somewhere, perhaps in the network of old streets between the perpetually unfinished cathedral and the quays – streets that were scooped out wholesale by the railway trains that came through in the nineteenth century, eviscerating the very bones in the graveyards that lay beneath the church walls – there was a hidden room, a bed with a straw-stuffed mattress, high above the grate of wheels and the cries of street sellers muffled by wooden shutters over the small, glassless window:

. . . loved women, he did, I mean he really loved us, he was like that, some men are, not many, but sweet-natured fellows like him . . . Loved women not just for what we can give them in bed and at table, tho' of course he liked that too, but for what we are . . . When he and I were out together in the streets he used to watch women passing by all the time. Some who were in his company might have objected, might have thought he should have eyes only for them, but it wasn't like that. I knew, I understood him . . . It was all their different styles of clothes he loved and the way they moved. 'Look, Maria,' he'd say, 'look at that – that girl is modestly

dressed, with that dark cloak, but see how fine her shoes are and how she holds her head. She must be the daughter of some distinguished citizen.' I remember how interested he was when our Cologne ladies began wearing forehead pads with a little puff on the end of a stick, like stiff little flowers they were. Houpettes, they were called. That's a French word, he said. He thought them not really very becoming, they amused him, we used to laugh at them together, the two of us . . . He had a whole pile of little pictures of women he had made in other cities, each in the habit of her own place and condition in society. Prague ladies, quite stiff in old-fashioned ruffs — but then he had not been nigh Prague for half a score years or more — and ladies with furs from Frankfurt and Basle and merchants' wives from Antwerp. He liked Antwerp because, he said, wonderful maps were made there. I could not tell about that because, tho' he showed me some maps he had made and I thought them very pretty, like lace, it is hard to construe the meaning of a map if you cannot read letters. He meant to go back to Antwerp when he should have saved some money.

I always knew one day he'd go — somewhere. He was a gentleman really, for all his simple ways and living in that little

store room above the print-dealer's shop and never having two groschen to bless himself with. You could see he had been used to having money about him when he was a child: when he got it he'd spend it on new linen, finer than

needs be . . . and that beautiful lace edging he bought me once: I was afeared to wear it, I still have it put away . . . and a feather pillow. That was nice, now. And so were the treats of Rhine wine and oyster pie over the river in the gardens of Deutz . . . He was always generous, far more than he need have been. That was why I was ready to help him, the many times he was hard

up again. It was a pleasure to help someone so kind and funny, who made me laugh. Most men aren't like that.

When he told me where he'd been, that evening when he did not come, and about how the English Graf had admired his work and was inviting him to travel with him and make likenesses of the places they passed through, I was really pleased for him. Well, you have to be pleased at a friend's good fortune, don't you? And I could see he was really taken with the notion. Only, I was afeared for him. The fighting had got that bad in towns up the river, they said, and the sickness too. He laughed, and said that neither battle nor pestilence would dare come nigh such a grand company as the Graf's. Barges were being provided for them by the city drawn by ten horses a-piece, and dear knows what else.

He said he would come back, when the journey was ended and the Graf went home to England. But he never did. I was sad, but I could not really blame him. I expect that, after all those months, he had gotten used to the company of the gentry, who were really his own kind anyway. It was such a chance for him.

I do sometimes wonder how he fared.

Chapter IV

The Great Rhine Journey

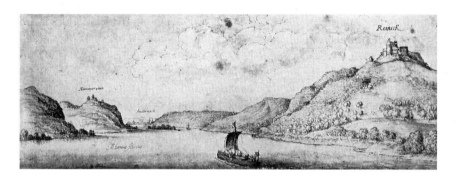

When the Lord Marshall went Ambassador to the Emperor of Germany to
Vienna, he travelled with much grandeur, and among others Mr Hollar
went with him (very well clad) to take Viewes, Landskapes, buildings etc
remarqueable in their Journey —

(Aubrey)

Lord Arundel took on both Hendrik van der Borcht and Wenceslaus
Hollar. They joined a distinguished retinue that included Garter
King at Arms Sir John Borough, other Garter Knights, a Howard
first cousin to the Earl, and Count von Rusdorf, who was the deposed
Princess Elizabeth's man and knew all the continental protagonists in this
diplomatic round-dance. There was also Dr William Harvey, the scholar
and anatomist who discovered the circulation of the blood. He was the
King's personal physician and also, for part of the trip, Arundel's, a man
older than Arundel himself, nearer sixty by then than fifty, with his dark
hair gone quite white, but adventurous and interested in everything around
him. He was to live to eighty, and he and Hollar long remained in touch.

Mr Wenceslaus Hollar (who was then one of his Excellencie's Gentlemen) told me that, in his Voyage, [Mr Harvey] would still be making excursions in to the Woods, making Observations of strange Trees, and plants, earths, etc, naturalls, and sometimes like to have been lost. So that my Lord Ambassador would be really angry with him: for there was not only danger of Thieves but also of wild beasts –

(Aubrey)

Later in the journey, at Regensburg (Ratisbon) on the Danube, Harvey left Arundel's party to travel to Italy, a country well known to him from his youth: he had been the English Consul in Padua in his early twenties. Arundel took the opportunity to send Hendrik van der Borcht along with him.

Good Mr Petty,
 . . . For Henry, the young youth I sent unto you with the Doctor, I hope you shall find him a very good boy, free from vice, and most obediant unto you. I pray you show him all the art you can, I hope in time he will have a good guess of originals from copies . . . He is a very honest youth, and loves all things of art dearly.

Henry van der Borcht was, like Hollar, being groomed 'to take our pictures and collection of designs at Arundel House'. He was to remain in Italy, under the instructions of Arundel and the indefatigable scholar Petty, for a whole year. It was a fine opportunity for him, for Petty was buying not just for Arundel but also for the Royal Collections that Charles I was now amassing as part of the proper trappings of seventeenth-century sovereignty. Petty had extensive knowledge of the classical remains that were becoming objects of desire and value to the world of northern Europe; he was probably the first Englishman to make archaeological investigations. In the 1620s he had visited Turkey for Arundel. There, in the teeth of competition from other Englishmen on the spot and at great personal danger, he acquired and carried back to England the Graeco-Roman sculptures that became known as the 'Arundel marbles'.

It has been suggested that Hollar was disappointed not to have been given the same opportunity as his friend van der Borcht to discover the artistic treasure trove of the Italian cities. But if Hollar had really been burning to visit Italy, he surely would have managed it in the nine years since he had left Prague. All the signs are that northern Europe and, in particular, the new landscape art and map-making of the Netherlands, were what drew him. I think he was delighted at the prospect of travelling over the same territory again, this time not as a penniless seeker of employment, exposed to all the dangers of the times, but as a member of an immensely prestigious and well-guarded expedition. It was also the first time in his life that he could do to his heart's content what he liked best of all – make his own record in pen, pencil and colourwash of the world around him.

There were other young men as companions for him, at any rate in the early weeks. There was Arundel's own youngest son William, the future Lord Stafford, then twenty-five, and also the sons of Sir John Borough. Sir Francis Windebank, the Secretary of State in England, had sent one of his sons too, to profit by the experience of the embassy in the best educational traditions of the time. It was also a means of getting them across Germany under safe escort, for all three young men were eventually destined for Italy. Edward Walker, then only twenty-four, served as Arundel's secretary, but the task of keeping a daily account of the journey was given to another young man, William Crowne, 'gentleman', who seems to have been only eighteen or nineteen.

Crowne refers, in the style of the time, to 'my dred Lord', the Earl of Arundel, which suggests that he himself was already part of the extensive household in the Strand. His Diary is dedicated to 'my true and noble and my honourable master Master Thomas Howard', who was the round-faced eight-year-old boy in the red jerkin from the Van Dyck painting of the previous year. So one can assume that the teenage William Crowne had been employed as some sort of tutor-cum-companion and playmate to Arundel's grandsons. The Diary, a rather plodding but wonderfully informative account, is full of overheard, garbled place-names that he appears never to have got round to checking.

The Jesuits at Collein have built a most stately church, richly adorned and gilded, and in it have erected one of the finest altars I have ever seen; in the City likewise there is a great church called the Dome, where lie the remains of three Kings called 'The three Kings of Collein'. There is also the Church of St Ursula, where is a fine tomb containing the Saint's remains; and nearby are the bones of 1,100 virgins who came here with her to give their lives to the service of God. Here is also a nunnery, some of whose members are English.

After staying here for a week, on the twenty-eighth day [of April] we boarded a boat drawn by nine horses and travelled up the Rhine, past many villages that had been pillaged and destroyed and past many fine vineyards on mountains alongside the river. We passed by Bonn on the right side and seven high 'Bughens' with old castles on them, on the other side of the river, and to Drachenfels Castle on the left of the Rhine opposite which we cast anchor and stayèd on board that night.

They stayed on board many nights, having brought all their own provisions from Cologne for fear of plague in the villages upstream, and because many of these villages were in any case devastated and foodless. Today, the Rhine vineyards still hang on the sides of the steep slopes in the same way. The same castles, some now ruined, some rebuilt in opulent nineteenth- or twentieth-century Gothic by German businessmen, still stand guard over landscapes of grand opera which, in spite of all the subsequent wars they have known, are still clearly recognisable from Hollar's own sketches. From the deck of one of the present-day K-D steamers that ply up and down, you catch sight of a familiar headland, then the profile of distant hills rising above the water, then a low-lying meadow with a tower . . . It is one of Hollar's views coming to life again fleetingly before your eyes, as you reach the right moment in midstream.

. . . and so to Coblenz, a town adjoining the Rhine on the right, where the French had recently been driven out by the Emperor's forces into the Castle of Hermanstein, situated on a very high eminence opposite and overlooking

the town. These forces were skirmishing when we arrived, consequently we cast anchor half a mile short of the town and sent a trumpeter to request a safe conduct for us.

Passage was willingly granted, both sides interrupting the fight. The general in the town, making preparation to entertain his Excellency, caused the gate to be opened in readiness for his Excellency's entrance, but the forces in the castle immediately fired a cannon to the great danger of the town defenders, who now took cover until his Excellency actually appeared. He was hospitably entreated to dine there, but in view of the long journey planned for that day, he declined the invitation.

Might there be a trace of irony here? The Diary was kept at the command of his Excellency for publication: perhaps Arundel would not have thought it appropriate to have it said that he was eager to place a few more bends in the river between his own party and the quarrelsome armies, and that there was little attraction in a dinner, however hospitable, in a town where 'if those inside the town chanced to look out of their windows, there was every likelihood a bullet would whistle about their ears'. One has a strong sense of the formal and artificial element in battle, which was to endure in Europe throughout the following two centuries, up to the moment when the First World War introduced to the descendants of the French and imperial troops the reality of total conflict. It was, however, a formality between commanders, which did not concern itself with the plight of the ordinary citizens caught in the feuding.

. . . On Sunday, May 1, which was their Whit-Sunday, we left Boppard, passing by villages destroyed in the war and past many pictures of Our Saviour and the Virgin Mary set up on river bends . . . So we went on past St Goar and by Rhinefields Castle both on the right side, to Catzenelbogen Castle on the left, then, on the right, by Oberwesel, which marks the beginning of the Lower Palatinate . . . And so to Pfalz Castle which stands on a little island in the river. Further upstream we landed at Bacharach, a town on the right side of the Rhine which has a castle built on a high rock

within the town walls . . . So difficult are conditions here that poor people are found dead with grass in their mouths.

. . . We entered Heientziches Lans passing a little tower in the water called the Mouse Tower, built by a certain Bishop Otto who had lived an unhappy life plagued by mice and who thought that in the tower he would be secure from them. The story goes that even here they pursued him and finally ate him up.

. . . to Rudesheim, a town on the left side of the Rhine into which I entered and saw poor people praying in a little old house where dead bones lay. Here His Excellency gave some relief to these poor wretches who were so starved that they struggled with one another for food which he gave them . . . So violently did these poor people struggle when provisions were sent from our ship that some of them fell into the Rhine and were in danger of being drowned.

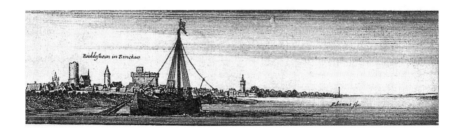

Today, the tiny town of Rüdesheim has hardly changed physically; even the nineteenth-century railway line that intrudes on many of the river settlements is here tucked away at the foot of the vineyards. The little old house where dead bones lay might be standing yet, among the self-consciously Gothic gables and painted plaster of the narrow streets, but these streets are now thronged with some of the best-fed people on the face of the earth. It is the favourite local holiday resort of the workers of nearby Mainz, Wiesbaden, Frankfurt and Darmstadt, a paradise of beer, sausages, cream cakes and elaborate souvenirs. Some of the souvenirs, in ancient Germanic tradition, whisper of death all the same: the bosomy Rhine

maidens preside over skulls, or are occasionally skeletal themselves, gruesome miniature travesties of health and sexuality, degraded mementoes of death in other times.

> . . . From Cologne to Frankfurt all the towns, villages and castles are battered, pillaged and burnt and at every one of our halts we remained on board, every man taking his turn on guard duty. Here we stayed four days until our carriages were prepared for us to continue the journey . . .

Because Crowne mentions none of his companions, except for his omnipresent Excellency, he does not refer to Hollar. Yet the very young man and the slightly older one must have sat down daily to dine together at the same table, or to drink some of the twenty-eight flagons of wine presented to the embassy by the burghers of Cologne. They may have shared the same cramped cabin, as two who were destined to remain with the Earl throughout the trip; they would certainly have coincided on guard duty in the nervous nights, watching the moon over the great river and the occasional weak lights moving along the shores. It would be interesting to know what, behind his expected public deference to his 'Dred Lord', Crowne really thought of the company in which he found himself.

He's a hard man in many ways, Thomas Howard Lord Arundel. I've learnt that, living in his great house. Oh, he's a fair man and makes fair gestures, I'll warrant you that: he made sure I was suitably accoutred for this great excursion across Europe, knowing my mother could hardly provide what was necessary. And he has given a fine new doublet, in the German fashion, and a cloak, and shoon with silver buckles to that Bohemian artist he has plucked from nowhere to make his pictures for him. But, as I warned the Bohemian myself as we stood together on the deck at night keeping an eye for Crabbats or such marauders, our Lord does not give aught for nothing. From those whom he takes under his protection he expects to get his money's worth and more in services and duties. He never forgets he is a great lord, and does not expect you to.

I don't know if the Bohemian understood all my words. His own parlance is an

outlandish eastern tongue called Checke, like to the Muscovy speech says Count von Rusdorf, laughing (though not while the little Bohemian is present). In this tongue the Bohemian writes his notes on his sketches. He can parlay fine in the German tongue, I've noticed, with that other Dutch man my lord has seen fit to bring in also, or with those in the towns through which we pass. But in French he is scarce more able than I am, and in honest English he pains. He learns quickly though, I'll say that, as these foreigners oft-times do. Just as well — if he is to return to England with our Dred Lord and enter his service, as there is talk of him doing. He is amazed at his own good fortune at being with us, as well he might be. He claims his own father was of noble birth, but what may that mean in the wild eastern regions to which we are now travelling? Poles — Checkes — Crabbats — Muscovites (they say the Muscovites wear long robes like Turks and keep hareems like them too. Huh). I told him my father was a gentleman of England, and that is enough for me.

We do not know Crowne's exact age, just as we do not know his birth date or from what family he sprang. I have assumed, as the most likely possibility, that he came from minor Catholic gentry. Only the latter, politically variegated and rather stormy passage of his life has left traces, in England and also in the New World across the Atlantic. He was to become the father of the Restoration playwright John Crowne, but his own contribution to literature seems to have ceased after his dutifully graphic account of the Earl Marshal's journey.

The Bohemian thinks His Excellency marvellous generous with the poor wretches we encounter, and so in fairness he is at moments. When we made our way overland, up hill and down dale between the Rhine and the Danube, we found children starving on their own doorsteps in the country towards Nuremburg where the Swedish forces have been pillaging. His Excellency ordered that food and money should be given to their parents. And again, on the Danube, after we had been in Regensburg, he saw among the unhappy wretches begging on the quay for alms a poor deaf and dumb boy, and with him was his sister, a pretty girl, who, when anyone addressed him, used signs to help him understand. His Excellency took the pair of them in his boat as far as our next landing place, where he commanded that new clothes were to be made for them, and money given too.

— Clothes, you note, again? Clothes make a display, are noticed, poor people say, 'What

a generous tenderness in such a great man to put good cloth on the backs of poor naked wretches.' Oh, I don't deny he may have a sudden and real tenderness for this one or that who catches his grey eye, but all the same . . . Edward Walker said to me, one night when he was somewhat in his cups (or he had not said it), 'It is thus he feels it is seemly to behave. It is how he wishes his greatness to be recognised.' And, by the same token, he scorns to wear rich garments himself. It is as if he should say, 'Fine apparel is the pride of lesser men than I.' His sons have no such scruple.

Edward Walker, another day, also told to me something he had from his own father. That when His Excellency was but a boy, growing to manhood in the reign of our late sovereign Queen Elizabeth, and not loved by her, neither him nor his widowed mother, my lord of Essex (he who was the Queen's favourite, but died for it on the block) was wont to call the boy 'the winter pear'. Edward Walker construed this to me as meaning that our Dred Lord was even then like those fruits, hard and firm in outer appearance but sweet within. I nodded sagely and said nothing, though, to my mind, Lord Essex meant that Thomas Lord Arundel was a whey-faced boy growing up in seclusion who might yet prove (as was the case) to be of great parts and many gifts of mind. Or yet that, like those wintering pears that lie discoloured on cold garret shelves, he was biding his time, knowing his moment would come.

'Tis certain that his upbringing was hard, the winter of his life, for Anne Dacre his mother, that pious widow lady, kept him at his studies away from worldly influences. She raised her son in devout adherence to the Catholic Faith, even as my own widowed mother raised me, in the county of Essex in country obscurity. Because of their Faith, and their circumstances, my mother and the late Countess were close despite the difference in their ages and a certain difference of social degree — though my father, had he lived and times been more propitious, would certainly have been among the most prominent gentlemen of the shire.

More than once when Queen Elizabeth's enmity had forced the Countess and her son to leave London again, they sought refuge and retreat in my grandparents' house, among friends of discretion, and thus my mother was known to the Countess from girlhood. That was long before I came into this world of course, but I remember Anne Dacre well, just as she appears in the little drawing His Excellency has of her in his outer chamber, a stern old lady with her teeth all gone and an air like to one of those Sisters in Ghent for whom she endowed a nunnery. She died some half dozen years past, displeased and grieved to the last (according to my mother) that her son had proclaimed himself for the Church of England.

I said to my lady mother, what I do entirely believe, that a man must make his own way in the world, and that cleaving unto one religion may not be entirely the best way if it brings disaster to others. Besides, a man may in truth change his mind. My mother then told me that the house my lord Arundel had inherited at Greenwich burnt down just after his conversion. I said that 'twas superstition to think thus; that Our Father's Son in heaven surely has much on His Mind besides houses, which do oft burn down? Then my mother was displeased and grieved with me. For the present, I'll say no more to her on the subject of the Church. Bah, I'm minded to agree with little Dr Harvey that man, for all his notions, is but a great mischievous baboon.

All the same, she, my lady mother, must measure the value of all that Sir Thomas Lord Arundel, His Excellency the Earl Marshal, has achieved since his fortunate conversion. For it is thanks to him that I am receiving a fit education in London town associating with great persons, rather than remaining a country bumpkin. We cannot say that my lord is not sensible of the debt of love he owes to my mother and her family.

Two years after the European embassy, William Crowne joined the College of Arms under Arundel's patronage. He also made an advantageous marriage. Had the history of England run differently and the Civil War been averted, he might have continued to rise comfortably in court circles. However, this was not to be, and in any case Crowne seems to have matured into a rather different and more mercurial person than his early career suggests. He turned his back on the Royalist cause; by the mid-1640s we find him with Parliamentarians and sitting on committees. By the end of the decade he was one of Cromwell's colonels, and later a member of Parliament and a man trusted with party funds. Later again, with another twist and shift, he crops up in a bold bid to purchase Nova Scotia, though also attempting to rehabilitate himself as a Royalist in England after the Restoration. In America, in his last twenty years of life, he seems to have slipped both in and out of fortune and respectability at different times, and finally died in Massachusetts. An enigmatic, maverick figure, he flits through the seventeenth century like a harbinger of a time not yet fully come, in every sense a man between two worlds.

My mother pleases herself to think that, whatever I may say to tease her, I am in a good household of the old Faith, since the lady Arundel of today is a Catholic and makes little secret of the fact. But then, times have changed, and she has no need to hide in corners. They live in their house in the Strand in great comfort and state, and have made voyages together to the Low Countries and to Italy, in which place the Countess entertained many distinguished guests. Their children, and now their grandchildren — my little liege-lord, who is my particular charge, and his still younger brothers — have attendants and finely caparisoned ponies, and greyhounds with red leather collars, and swords, and other baubles and toys a-plenty, far more than I ever dreamt of when I was their age, seeking birds' nests in darned trunk hose or going barefoot to the river with the sons of ploughmen. I know my charges must learn to be great lords, but still, it is not, to my mind, an advantage to their characters to be accustomed to such luxury from infancy.

The Countess is Alatheia Talbot, daughter of the late Gilbert Lord Shrewsbury, a man famed for ill-temper, indeed half insane with it. I have heard tell that he once cut the ears off a doctor in the country because he thought the doctor was trying to poison him with gloves. Gloves! It is like an old tale of former days. As if a doctor, with all his phials and potions, would not have a straighter way. I suppose his family paid the doctor monies afterwards to hold his peace; great people can do as they please, a man in humbler circumstances would have been before the Justices, nay, the Assizes. My Right Honourable Lady Alatheia, who is very wealthy and a great lover of wealth, also does as she pleases, but fortunately she has all her wits about her.

She also has about her the attendants she prefers, of the Faith she prefers. These now, of late, number among them one mistress Tracy, whom I fain would know better, but I am here in the wastes of the Palatinate, and who is to say who is seeking her company now in Arundel House? They are so numerous in the household, and when we return there will be still more, what with this Hollar being brought back like booty, as if he himself were something for a cabinet of rarities, and that other fellow who has gone into Italy but will return.

Mistress Tracy has a year or two more than I have — not much — and I think she is some kinswoman of the Countess, though not close in blood. They are all connected by marriages, these families. She has no fortune, it is said, but I would say her fortune is all in her fair face and delicate manner, for seldom did I see a young woman so lovely.

But it is useless to think thus, I know. Marry, I must, when the time is ripe, and marry well, a woman of property, if I am to have any comfort in this life. It pleases my lady Arundel to say she will arrange a good match for me. Laughing, she says it — 'Good

William, we must find you a rich widow' — but I believe she means it too. Of course I make feign to laugh too. A man in my position must make do as well as he can with what he is offered.

After a first abortive visit to Regensburg, Arundel's party finally caught up with the Emperor Ferdinand in Linz. Coaches were sent to meet them. They were provided with lodgings and grand dinners and, under heavy guard, several formal and exclusive audiences took place between the Emperor and Arundel. During that week, as a diversion for the otherwise unoccupied Arundel retinue, there took place the execution:

> of seven rebels, the leaders of an armed insurrection of 400 ignorant peasants against the Emperor . . .
>
> The ringleader of the revolt, a fellow who had persuaded himself that no bullet had power to harm him, was led on to the scaffold with his face covered and with two men holding him firmly against the block. Here the executioner seized him firmly by the chest with a massive pair of red hot pincers and nailing his right hand to the block, chopped it off. Then quickly drawing the sword he wore at his side, he cut off the wretched fellow's head which an assistant raised, shouting into the ears of the dead man: 'JESUS, JESUS.' At this juncture, the Jesuit, who had accompanied the criminal and who had been admonishing him for his sins, asked those present to join in prayer for the soul of the dead man. Following this came the man's accomplices, including a young boy, all of whom bore crucifixes in their hands and made their individual confessions at the foot of the scaffold to priests, kissing their hands and feet at the end of every prayer. After these wretches had been beheaded and quartered, two of their confederates were taken on foot about a mile to a place where the body of a priest of theirs, arrested the previous year in the church of ERING, hung on a pole.

'Twas I told Hollar that he must take his sketching book (which he was minded to leave in our lodgings) to record this scene. He, who is always at work, seemed for once disinclined. 'What,' quoth I, 'His Excellency maintains you that you may take views and anything other

remarqueable on his Journey, and you do not consider this Sight remarqueable?' He made to answer, with many gestures, that the sight of men receiving punishment is neither a view nor a landskape. But I believe that Count von Rusdorf said in German to him something the same. So he did bring his sketching block and his piece of charcoal, and I have since seen the complete design he has made, which he says he will etch by and by, but in it he has drawn so many of the multitude that you see little of the event, only men thick as grasses in the meadow and the backs of their hats.

I think that he has little stomach for such scenes, nor for any foulness, and would sooner make such pretty pictures as may be shown to babes without fear of distressing them. For I have noticed that at times when we have seen a town gate and walls, say, and the body of a wretch that has perished by the way of plague or other cause, lying dead by the town ditch being gnawed by dogs or crows, when Hollar takes the scene — why, then body, curs and crows are nowhere to be found, and instead a decently clad horseman is making to enter the gate, as may be, or fishermen mend their nets in peace on the river strand. 'Tis a weakness in this Hollar, I think me, to see the world thus. But what should I care, if His Excellency is pleased?

Another day, Hollar gave Walker and Windebank and me to understand that his pictures are not to be of one moment but for all time. This seemed to me as something too proud. Yet, in the general way, he is a modest fellow, glad simply that every man should be his friend. I was with His Excellency one evening soon after we left Collein, and Hollar was showing some old gravings he had done when he was a boy, that he took from a leathern wallet he will not be parted from but carries everywhere on his back. They were not indeed half as fine as the Views he does now, but one was a head, in miniature, of Frederick, the late Emperor and Winter King, whose son our own sovereign now seeks to have placed over the Palatinate. With this little picture, Arundel was for a moment surprised, and mighty pleased, tho' 'twas but a piece of luck for this Hollar that he had the etching about him to fall pat with this Embassy.

My lord did visit the Queen of Bohemia (she who was) in The Hague at the start of our journey, and will, I doubt not, see her again to report on his entretiens with the Emperor. She is sister to our sovereign King Charles, and for that, no doubt, as well as for reasons of State, the King thinks tenderly towards her and would wish to advance the cause of his nephew. But I think the boy is too young — younger than I be — and the Winter Queen herself but a feckless lady. I have heard tell that when she and Frederick were forced to leave their castle at Prague, in their haste to gather all the riches they could into their coaches, the Queen quite forgot her latest-born child. By simple good fortune the little creature was heard crying in a chamber,

and one of the servants handed it in through the window of the coach just as that was departing. Great people can be as foolish as any others at times, and more so, I have observed.

When at first Hollar showed the image of Frederick, and His Excellency clapped him on the shoulder and said, 'Assuredly we must show this to Her Majesty on our return voyage through the Low Countries,' my thought was that the little Bohemian was seeking deviously to gain the lord's confidence and ear above the rest of us.

But, on sober reflection, I believe he is too ignorant of English ways and too much of a simpleton in himself for any such device. He is not like us, the other gentlemen, I mean, of Lord Arundel's retinue. It is as if, for him, the world were in his own drawings and not elsewhere, and these drawings, albeit that they are for display, were his private kingdom.

After a stay of fourteen days in Linz, with much ceremonious and conspicuous feasting at the Emperor's expense, the Arundel party embarked on the Danube for Vienna. The week spent there included an audience with the Queen of Hungary, and thence, by rumbling wagons over dust roads, they made their way towards Prague. According to William Crowne, the first place they came to in Bohemia was called Sticky [Stecken?], near a site where 'a certain host, according to repute, had on various occasions killed as many as ninety of his guests and made meat of them'. Crowne was in no doubt but that they were now in the land of storybook ogres and drinkers of blood. 'We spent a fearful night of thunder and lightning sleeping on the bare boards' – a lodging that may have seemed safer than any alternative on offer. They passed through burnt-out towns, devastated by successive armies – Swedes, Bavarians, and even Croats (Crowne's 'Crabbats') who were perceived, in a Balkan tradition that has endured, to have been everyone's enemies. Croats were rapidly blamed by local intelligence for an incident later in the journey, when Lord Arundel sent two of his men to ride ahead of the main party to Nuremberg. He found himself subsequently writing to William Petty, now in Florence:

> I am extremely oppressed with grief for the loss of my good servants, Lamplugh, and William Smith, the trumpeter, who were on Wednesday last, at noon-day, the first post on this side of Nuremberg, most inhumanly

murdered, God knows by whom; one of the post-horses found, only. God give me grace to bear it with patience, and send us all free from like misfortune.

William Crowne recorded further detail:

This day [28th August], after a widespread search, the corpses of His Excellency's Gentleman of Horse and his Trumpeter, together with the corpse of their guide, the Post-master, were found. They had been barbarously murdered five days before . . . their bodies were found tied to separate trees about a pistol shot range from the highway . . . It appeared that each must have witnessed the death agonies of his companions. The head of the Gentleman of the Horse had been shattered by a pistol shot, the Trumpeter's head had been cut off and the guide's head had been split open.

The month before, from Vienna, Dr Harvey had written to a friend in England, in his old-fashioned English:

. . . wee find heare greate expressions and many wishes for the success of my lo: his Embassadg, how the effects will prove we hope well, butt cannot certeynly assure our selves; I thinke the miserable condition of Germany doth more than requier it . . .

But, require it or not, the wars were to continue, with the added involvement of Spain, lasting indeed for rather more than thirty years and only finally petering out in the 1650s, long after Arundel was dead and England's own destructive Civil War had come and gone.

Before finally proceeding back to Regensburg for the scheduled summit conference, the embassy visited Prague. We know that in Prague Lord Arundel obtained the favour from the Emperor that Hollar might be allowed to use the coat of arms previously granted to his father (or possibly – accounts vary – the arms of his mother's family). Hollar may not yet have known, but Arundel certainly did, that he needed this accessory if he was to cut a creditable figure in London circles; without it, he would risk appearing to be a mere artisan. Etching and print-making were hardly known as yet in

England, and the results were not recognised as fine art. When William Crowne saw some engraved copper plates in the collection in Prague, he did not apparently realise what they were for, simply describing them as 'quaint' – it was Hollar himself who, later, was to play a key role in making prints appreciated. But, in any case, the status of the artist in English society, then and for generations afterwards, was precarious. Even celebrated painters in oils were not often considered gentlemen, or not such as you would invite to dinner or allow to marry your daughter. But because foreigners were anyway outside the magic, hierarchical circle exceptions might be made for them: one such was Anthony Van Dyck, who received a knighthood. Hollar's social position, under Arundel's patronage, was both promising and delicate, though he probably did not realise it himself.

Nicholas Hollar, the brother, though included in the same imperial favour as Wenceslaus, was not in Prague at that time; he was the imperial administrator of a monastery elsewhere in Bohemia, and it is therefore unlikely that the brothers met in the few days available to Wenceslaus. Several years later, when the Protestant Swedish forces invaded Bohemia, Nicholas Hollar joined their ranks. His eventual fate when they withdrew again in 1648, having failed to secure any amnesty for their followers, is unknown. We cannot know either when Wenceslaus Hollar in 1636, lapped as he was in Prague in the unaccustomed grandeur of Arundel's entourage, lodged in the Old Town and moving in the Catholic court circles, took the opportunity to see his younger half-brother or any surviving uncles. We do know that during this week he made a number of sketches of the familiar views of his boyhood, one of which, forty years later, was to provide the basis for what may have been his last ever etching.

It is highly likely that he was a member of the party who went to view the Emperor Rudolf's collection, which was then still displayed, unravaged, in the castle. Indeed, since he must have had opportunities to gaze on its wonders in childhood, Hollar may have acted as a guide. A few years later the collection was to be pillaged and laid waste by the Swedish soldiers, though some of its remnants may survive today among the curiosities in the Strahov Library nearby. The high, glass-fronted cabinets, which stand in

the entrance-lobby to this monastic library, in which the atmosphere of the seventeenth century still lingers, have the form of the classic 'cabinet of rarities' and the eclectic contents to go with it: dried fishes, stuffed armadillos, wax fruit, giant crabs, ostrich eggs, huge shells, coral, Iron-Age arrow heads . . . In its glory, when Arundel's retinue saw it and Crowne, wide-eyed, meticulously listed it, the collection contained such treasures as 'astronomical instruments', 'antiques in silver', 'cups made of agate, gold and crystal', 'bohemian diamonds' and 'work from the east'. There were also the famed unicorn's horn 'one yard long' and 'three cupboards filled with anatomies of several rarities, such as cockatrices and fishes partly resembling men'.

In England, too, the amassing of heterogeneous objects from all over the newly opening world was becoming a fashionable preoccupation. Arundel himself had a fine collection of shells, butterflies and other insects, in addition to his grander artistic acquisitions. It was partly to get a full and exact record made of all these that he planned to take his travelling artist back to London with him.

> Here at Prague we stayed for seven days, leaving on July 13 for Regensburg, and travelling over the plain where not more than two miles from the city, the great battle between the Emperor and the King of Bohemia was fought. In this battle about 30,000 men were slain and we observed many mounds which marked the burial places of heaps of the slain and also noted a great heap of the bones of dead men.

Sixteen years they have lain unburied, these bones that were men. Sixteen years and not laid in the earth like Christians. Whatever some may say, these Bohemians are a barbarous people.

This dreadful sight put me in mind of a picture in my grandparents' house. I believe my mother later sold it, as she has been constrained to sell much. It was an old thing, of people dressed in the stiff old way they did affect when Queen Elizabeth came to the throne. But I remember it well, for I used to like to look on it as a child and feel strange. It showed a lady on her death-bed (tho' fully and richly dressed) and at her side two twinned babes, newborn and as may be never lived, swaddled for the grave, and round them the sorrowing father and

another child. The inscription beneath it read: 'Quis in carne spem semat ossa demetit' — 'He who sows hopes in the flesh, reaps bones.'

The great suffer these losses even as the lesser do. Indeed I think they suffer more, for the hopes they sow are far greater. I am told that six sons have been born to my lord and his lady Alatheia, yet only two are living at this day. Fortune smiles, for the time being, on their grandchildren, but none of us can know the future. By the same token, the riches and rarities collected by such as the Emperor Rodolphus, or His Excellency, may, by a turn in fortune's wheel, be plundered and scattered to the four winds more readily than modest goods of lesser men.

My lord must know this as well as any man. He grew up seeing his own mother robbed and bereft. 'Lay not up for thyself treasure upon earth.' Yet he seems, rather, eager to replace all that has been lost and much more. His collection is what he loves most in all the world. You can see it even now, in the way that, in every city we visit, the pictures, statues and other choice things he might obtain there are his first concern, even though he cloaks this in the array of diplomacy. And note how he is ever writing to Mr Petty in Italy, and sending people to assist him in ravishing Italy of her best treasures. Why, I have also heard that when this same Mr Petty was in Turkey on the Earl's business he did steal those marbles from under the nose of the English ambassador, to whom they rightly belonged. When it comes to the riches of this world, our noble lord, so generous to the poor when he chooses, hath, it seems, no real scruple.

— And how come, think you, that poor Anthony Lamplugh and Will Smith were riding so unguarded from Regensburg to Nuremberg, and with gold secreted about their persons too? Sir John Borough, who saw their bodies, says they were savagely beaten before death, as if the robbers would have them divulge a hiding place, and their boots and hose stripped off to search. He claims they must have had hardly an hundred thalers between them. But this I do not entirely believe, for they were going to settle affairs with one who is selling my lord a whole library.

On the return journey, late in the year, we travelled again to Nuremberg and tarried there awhile, that my lord might see to the despatch of all these books purchased. And the city fathers, who were discountenanced, no doubt, by the murders in August, made a present to His Excellency to give to His Majesty, of two pictures by Dürer, and His Excellency was mighty pleased. And still more pleased was he when we stopped at Würzburg, and the Bishop gave him for himself a fine Madonna of Dürer, which he has ever since carried in his own

coach.

Books. Pictures. I swear they mean more to him than any being, mortal or immortal. Though mistress Tracy, one time when I opened my heart to her on the matter, declared that I did not know all and was mistaken. She declared that, in the privacy of my Right Honourable Lady's own apartments, where he need not act the great man, he is the tenderest of husbands and the most loving of grandfathers. She is too gentle a lady to see ill in any one.

Chapter V

A New Country, a New Life

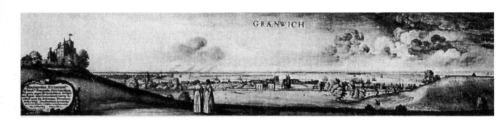

GRANWICH

Through Frankfurt again, with more gifts of wine, and so to the Rhine; then back past the starving villages to Koblenz and more difficulties with warring imperial and French armies, skirting plague-stricken Bonn, the embassy arrived again in Cologne and the flat lands on 1st December 1636. Thence, in larger boats, they travelled as they had come, through the troubled Low Countries where they were fired on below Nijmegen, then to the University of Leyden, to the court of the frustrated Queen of Bohemia in The Hague, to Delft, and finally to Rotterdam – 'and waited there for a favourable wind'.

> Then, at eleven o'clock at night on December 24 (our Christmas Eve), we took boats and sailed through Magan-Sluce to Helversluice where our ship, the *Garland*, lay riding at anchor. At about three o'clock on the next afternoon we sailed for home . . .
>
> Rough seas the following day forced us to anchor in the Downs until the morning of Tuesday, December 27, when we were able to land at Deal. From thence, by post-coach to Canterbury, and so to Sittingbourne to bed.

It must have been too hazardous, or simply not possible, to sail the ship

round the North Foreland, past Margate and straight up the Thames estuary.

> Early next morning we left for Gravesend where we took a barge for our
> return to London, on the way meeting the barge of my Rt. Hon Lady who
> had sailed to meet her husband.

Such were journeys in the seventeenth century. And that was one whose
delays were accommodated in relative comfort, with riders despatched no
doubt from Canterbury on a relay of post horses, arriving sweating and
mud-spattered in London to alert the Countess, in time for her to
materialise ahead of them somewhere between Gravesend and Greenwich in
the pale winter light.

Such was the arrival of Wenceslaus Hollar in England. There had been
ice in the port of Rotterdam, but it sounds as if the weather at the year's end
in England was wet and windy rather than freezing; it was a green
countryside that enfolded Hollar as the barge made its way round upriver.
It also still seemed, at that time, a land wrapped in a tranquillity and
prosperity that had been unknown to continental Europe for the past
sixteen years. No wonder the place appealed to him.

> I remember he told me, that when he first came into England (which was a
> Serene time of Peace) that the people, both poore and rich, did look
> cheerfully . . .
>
> (Aubrey)

By happy chance, or by design, a long-range view of Greenwich, looking
over the curve in the river towards London on the horizon, was Hollar's
first published work in his new country. The print exists in several versions,
with the skies cloudy or clear, but the great extent of the sky and the pers-
pective of space and detail below it show how Hollar had been influenced
by the new landscape art of Holland. The vantage point is in Greenwich
Park, on the lower slopes of the hill where the Royal Observatory was later
to be built on the foundations of a Tudor royal lodge, 'Duke Humfrey's
Tower'. Hollar's drawing makes a feature of this lodge, which manages to

look like a miniature version of one of those Germanic castles overlooking the Rhine he had drawn so often. The old Tudor palace stands in the distance, on the river shore, but it is partly eclipsed by the Queen's House. This, Inigo Jones's first major work, had been planned by James I's queen and only recently completed for Henrietta Maria, wife to Charles I. It is the one building recognisable today, for the rest of the palace was to be replaced by Wren's Royal Naval Hospital at the end of the century. Further off, the pronounced bend in the river that swings northwards at this point to meet the creek of the River Lee is alive with high-masted sailing ships. (This grassy hinterland is, today, an inaccessible waste of wharves, industrial works, a derelict exhibition centre, motorway systems and the forbidding entrance to Blackwall Tunnel.) In the foreground, as in one of the fashionable bird's-eye maps of the period, two women walk slowly in conversation, hand in hand in elegant summer clothes, one with a mask to protect her face from the sun.

In a decorative cartouche beneath the lodge on the hill, Hollar placed in the 1637 version a Latin dedication to Queen Henrietta Maria, mentioning His Excellency Arundel also: just the thing to start an aspiring artist well on his worldly career. But in versions of two or three years later the dedication is erased and replaced by a few lines from a poem on Greenwich by Henry Peacham, the obscure author of *The Compleat Gentleman*, who also seems to have been part of the Arundel household. Maybe this quotation, by 1640, seemed to the print dealer safer, or at any rate more prudently commercial, as Charles's struggles with Parliament intensified, for the Catholic queen was becoming increasingly unpopular. In fact she left England in 1642, hardly ever to return.

But Hollar would have known nothing of the nuances of English politics at this time, and I do not suppose any hint of the troubles to come disturbed his pleasure as he first saw Greenwich, then Deptford, and finally London proper from the deck of a barge. In practice, he who had been something of a chronic exile from home for the last decade had just exiled himself definitively, acquiring the fixed identity as a foreign artist that he was to carry for the rest of his life. Yet it must have seemed to him as he progressed

up the river into the familiarity of another capital city, under London Bridge whose many arches resembled those of the Charles Bridge in Prague, and to the lavish welcome awaiting the whole party at Arundel House, as if he had found his true home at last.

Arundel House was grand in some respects, in a commanding position with an extensive garden on the river front and its own water-stairs, but it was hardly palatial by seventeenth-century standards; it belonged essentially to the medieval London that was rapidly disappearing. Reached through an arched alley from the Strand almost opposite St Clement Danes church, it had been the town house of the Bishops of Bath and Wells until it passed to the Crown after the Reformation. The earliest street-map of London – or rather bird's-eye view, the so-called Agas map dating from near the beginning of Elizabeth's reign – shows a high, battlemented stone building with more modest Tudor buildings on the Strand side and the west, and a parterre garden between the house and the river. John Stow, whose *Survey of London* was published at the end of Elizabeth's reign, thought that much of the bishops' stone fortress had been demolished and rebuilt by Lord Thomas Seymour, who received it from the Crown. In fact, one early drawing by Hollar that is now in Windsor Castle library shows a view from across the river which does look not unlike the old building. But his prints of a different part of the property show gable-roofed, essentially domestic-scale buildings grouped round a large courtyard, and these accord with Ogilby and Morgan's Restoration map – of which we shall hear again.

Thomas Seymour, who was beheaded for treason in 1549, was the brother of the Protector, Somerset – he who was later beheaded also. It was said that Somerset made amorous advances to the fourteen-year-old Princess Elizabeth, the future queen, and that this clandestine affair took place in the house on the Strand. After the Seymours were dead, the house was acquired by the Howard family, though they, as we know, came near to losing it again after Phillip Howard died in the Tower. There is an odd story that while the house had been denuded of most of its furnishings and Anne Dacre, Lady Arundel, was only allowed to lodge there occasionally on

sufferance, Queen Elizabeth made a visit to look round the property. Engraved on one of the casement window panes was a text about the sadness of this world and hopes for the world to come, a conventional and understandable reflection of the times. Queen Elizabeth took such exception to this text that she scratched beneath it – presumably with a diamond ring – 'a message expressing much passion and disdain . . . on purpose to grieve and afflict the poor Lady'. One wonders what corrosive personal memories these empty rooms held for the Queen.

But by the 1630s Arundel House was again full of cheerful life. In those days, when young men of good family were married off early to further dynastic interests, they often produced numerous children while the grandparents were themselves still relatively young and energetic. It was therefore common for the grandparents' house to be the main centre of family life, and so it seems to have been with the Arundels. But it also served almost as open house for the numerous writers, painters and other men of note in whom Lord Arundel was interested, and as a place for him to display his art collection. A long-term plan to rebuild the house as a formal Italianate *palazzo* never materialised, since the Civil War descended like an ice age on all such dreams, but by Hollar's arrival Arundel had remodelled the garden as a setting for some of his 'marbles', which were arranged around walls and in colonnades in the style of a Roman villa. (A 'Roman bath', found off the Strand in the late eighteenth century, is probably a relic of this garden.)

Lord Arundel had a long, open-sided gallery for sculpture, almost certainly designed by his protégé Inigo Jones, the creator of a contemporary plan for a new, classical Whitehall Palace, of which only the Banqueting Hall was ever constructed. This gallery was built out across the garden at a right angle from the house with an arch framing a view on to the river. Two companion pictures by Daniel Mytens show different aspects of it, though it may have been only in the planning stage when the portraits were painted. One has Lord Arundel sitting in state before it in a fur-trimmed robe, and the other has the Countess in black and much fine lace, similarly presiding. The message is clear: here are two great joint patrons of the arts on the Italianate model.

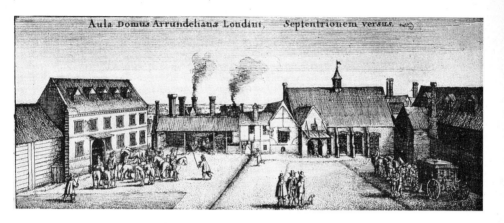

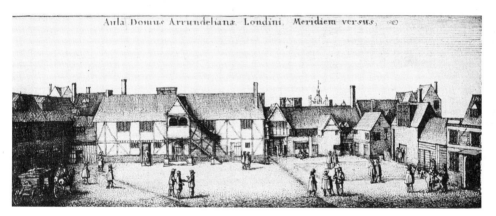

Yet Hollar's pictures, including one view from a battlemented terrace labelled 'London from ye top of Arundell house', depict, not the classical aspirations, but the rambling, older structures. His two well-loved prints drawn from opposite sides of the courtyard form one of the clearest images we have of the complex daily life of such a household – though, confusingly, the inscriptions in Latin, *Septentrionem versus* and *Meridiem versus* – from the north and from the south – in his unmistakable exquisitely clear hand, are the wrong way round. As with so much of the work done during the first happy years in London, the actual etchings were made later, in Antwerp. This probably also accounts for the odd claim on some of the finished

prints that, while Hollar engraved them, the drawing was by someone called Adam Alexis Bierling. This man was an Antwerp print publisher, nothing to do with Arundel House, and the drawings are undoubtedly Hollar's own.

In the one looking in the direction of the river and Lambeth marsh, a chapel or old-style communal hall stands at the back of the yard to the right, next to a similarly ancient little building. Above the roof of an adjacent coach-house, smoking Tudor chimneys are visible on the garden side, indicating that the family's own quarters are on the level of the garden and the river, rather than the Strand. A journey seems imminent: in front of a handsome, three-storey building to the left side of the yard a dozen or so horses, mounted or yet to be mounted, are gathering, with men keeping them in order or hastening towards them. There is someone thin and agitated outside the chapel/hall, who may be Arundel's librarian, Francis Junius; he was celebrated for going jogging three centuries before the practice was generally known. Two children are also watching from there. In the shade on the other side the Arundel family coach, a luxury of the times, stands with a team of horses already harnessed. It will appear again in other scenes. In the centre of the yard three behatted and cloaked men are waiting, with the usual plumy-tailed dog in attendance.

The opposite view suggests a calmer day. There is only one mounted horseman, in conversation with a man in front and with a woman apparently waiting to get up behind him: thus were lifts given in the seventeenth century. The coach in the shade on the opposite side is a smaller one, with just two horses harnessed: perhaps one or other of the Arundels is planning a visit somewhere in the City. Variously, small groups of men chat or stroll over the cobbles; two sit sunning themselves on a bench by the building at the back of the picture, near the archway and lane that leads out towards St Clement Danes, just visible over the rooftops. Apart from its usual Hollar neatness — no rubbish lying around, no sign of dilapidation anywhere — the whole Lilliputian scene suggests the openness and informality of a public house yard rather than a private domain, an impression enhanced by the gate-house and an equally old timbered building next to it with an outside

staircase. But the most interesting structure is an odd-shaped one in a corner, with one very large mullioned window of the kind seen in weaving workshops, high up in the roof to catch the light. By the door downstairs are propped two canvases, or large engraved plates. Was this, I wonder, the studio set aside for Hollar?

One note from Hollar to Hendrik van der Borcht senior was discovered more than two centuries later on the back of a trial proof of an etching. It apparently turned up in a sale in Frankfurt in the nineteenth century, but it has now disappeared again. It was in German: I can only quote it here in the English translation published by the principal Czech collector[1] of Hollar's work in the early twentieth century. It is undated, but the print, from a Holbein picture of Solomon and the Queen of Sheba in the Arundel Collection, was finished in 1642. So the letter is from this early London period when the two young men were together, and it would have travelled to Hendrik's father in Cologne or Frankfurt.

> According to the special wish of your son I am forwarding you this proof, made in his presence. Do not think, please, that this is a perfect proof of the engraving. I have printed it on paper immediately after removing the acid. But in principle after the acid treatment, corrections on the plate must be done. In this case, however, they were omitted. I am therefore rather reluctant to send you the proof. I never send proofs away unless they are perfect. Here in this case you can only notice and see what the acid has done, but it hasn't been touched by the needle. Hendrik is gone for a rest in the country and asked me to send you his love. Your obedient servant, W. Hollar.

It is clear from this that Hollar was in the habit of doing the finest detail – shading, fur, hair, textures of material and so forth – by hand-engraving on a plate that had already been etched. With him, his work – dedicated, professional, obsessional even – was one thing and the rest of his life another. The only other letters of his that survive, written twenty and more years later, strike a much more disorganised note.

He worked fruitfully during these first six years in London. We know

this because much of the material that he published later depended on sketches, finished drawings or actual plates that he made in these years. The rich harvest of that time produced the seedcorn on which his later career was based. But, although he did his most engaging London views then too, much of his daily work for Arundel – who, as we know, did not grant favours for nothing – consisted in preparation for the great catalogue of the Collection that Arundel intended to publish. It was Hollar's role to draw the natural-history specimens and to make prints of pictures that Arundel possessed. At the same time, he does not seem to have felt under great pressure at this period to turn all the drawings he made into complete etchings. Obviously he was at ease in his new, sheltered life, and could not foresee the dark times to come – the build-up to the Civil War piece by piece, with few people planning it or really wanting it, the decline in Lord Arundel's health and then the Arundels' own retreat overseas.

It is hard to know exactly what the financial basis may have been for his arrangements with the Earl of Arundel. But in that world actual sums of money were usually less important than benefits in kind – lodging, food, presents of good clothes (which were then very expensive), participation in household or family events, introductions to useful people. It is clear that Hollar enjoyed much freedom also to pursue his career in London beyond Arundel House. His Greenwich print, and subsequently others including many little plates of women's dress (the *Theatrum Mulierum* that he had been amassing through the years while knocking around Europe), were all published by Peter Stent.

This man, who was not an engraver himself, was the first major British print-seller and publisher. Coming from Hampshire, he was apprenticed in the later 1620s to the widow of a London printer. He presently set up in business on his own, at the moment when London merchants, tradesmen, skilled artisans and clerks, hungry for new knowledge and for the social advancement this could bring, were forming an increasing market. Through prints, everyone could now see versions of famous pictures, old and new. In a world that would have no photos for another two hundred years, they could see for the first time what the great and powerful really looked like,

and this included the King and his family, those divinely ordained representatives of God on earth. They could learn about foreign lands through printed views and maps, and impressions of the strange customs and exotic beasts and plants found there. They could study illustrated series of weaponry, or fashions of distant cities as in Hollar's *Theatrum Mulierum*. It was the beginning of mass culture. With a foretaste of the popular press, already developed in the form of regular pamphlets, they could also see more or less instant representations of notable events. Such would be the trial and execution of the Earl of Strafford in 1641, the drastic step to avert the conflict, which actually accelerated it. Hollar depicted both events essentially as crowd scenes, full of expressive bodies and incidental detail such as onlookers falling off a collapsing stand.

Peter Stent settled in a house at the corner of Giltspur Street and Snow Hill, by New Gate, just outside the City walls, above the miry valley of the Fleet. The house was initially called 'at the sign of the Crown', but Stent, who had a flair for publicity, presently changed the name to 'at the sign of the White Horse', because this had been the sign of the dealer who had published John Speed's ground-breaking maps of England, Scotland and Wales earlier in the century. Stent's eye was good when he took up Hollar, and later, in the Low Countries, Hollar was lucky to have this vital London contact. This enabled him to go on making money out of his store of London material when he himself was once more physically in exile.

Yet, in parallel with Hollar's life as a freelance artist and engraver, there continued his commitment to the Arundel Collection and his involvement in the Arundel circle. George Vertue, the eighteenth-century engraver and antiquarian who made the first proper inventory of many of Hollar's plates and talked to one or two people who had known him late in his life, wrote:

> As he grew in Esteem here, his Friends procur'd him the Honour (some little time before the Civil Wars broke out) to teach the Prince the Art of Drawing, and by this Means got into the Service of the Royal Family.

In a footnote he added:

I believe it was Prince *Charles*, having seen a small Pocket Book, with Silver Clasps, mounting the Arms or Badge of the Prince of *Wales*, the Crown and Feathers: Within this Book are several Drawings, Parts of the Face and Heads to begin to learn from with *Hollar*'s own Hand-writing; which Book was in the Possession of the Right Hon. the Earl of *Oxford*.

(1640) In this Year he published Twenty-six Plates, *Ornatus Muliebris, Etc. Londini.*

And the fine curious Cup, from a Design of *Andrea Mantegna*, preserv'd in the *Arundel* Collection.

In the next Year he did King *Charles* and his Queen, and other Prints: Several from *Vandyke*'s Pictures.

It is certain he could not so well enter into that Master's true Manner of Drawing, in his Grace and Touches as other Engravers, some in *England*, and others Abroad, who had studied his Way or Manner of Drawing and Painting; for which Reason he could not obtain *Vandyke*'s Recommendation, nor that of his Admirers (which is no strange Thing) . . . yet *it may be said*, that amongst the imitators of the works of *Vandyke* in Print several are done by *Hollar*, not done by any other Engraver, others as well, and always collected amongst the Works of *Vandyke*.

On these tiny scraps of evidence, in default of any other, it is tempting to build much, and the temptation has not always been resisted. The image of poor Hollar spurned by the court painter Van Dyck, with the implication of some sort of social snobbery at work there, as well as an artistic one, vies uncertainly with the more luminous image of Hollar making copies of pictures in the Royal Collection and teaching drawing to the future Charles II. It is true that Hollar once told Aubrey that Van Dyck's possessive mistress, Margaret Lemon, was a jealous shrew, but that is another matter.

In any case, the idea that Van Dyck had any long-term effect on Hollar's fortunes is implausible, since Van Dyck left England in 1640, returning only

to die almost at once the following year. Vertue is not a reliable informant: the fact that he thinks Hollar was among the Royalist group besieged at Basing House during the Civil War, at a time when all the evidence points to his having already reached Antwerp, rather casts doubt on his other assertions.

According to the inscription on Hollar's portrait etched for Johann Meyssens of Antwerp, it was the Duke of York, Charles's younger brother and the future James II, whom Hollar served. But this in itself makes one feel there must be some substance in the story of him having been employed to teach drawing to one or both of the princes, even though the pocket book with the Prince of Wales crest on it now seems to have been irretrievably lost.[2] The Hollar 'sketchbook' now in the possession of the John Rylands Library in Manchester is almost certainly not the one referred to in Vertue's note, however much one may want it to be, surviving through time and chance. No Prince of Wales crest appears, and the pasted-in contents are probably a collection made by John Evelyn, who was acquainted with Hollar by the early 1640s and may have been given some of Hollar's sketches in a token of friendship.

It seems clear at least that Hollar, in a life that one senses was both busy and happy, was inhabiting a territory between two worlds, physically, socially and also temporally. His daily round took him eastwards, to the book and print-dealers in the neighbourhood of St Paul's churchyard, whose commerce represented the future that was beginning rapidly to arrive. Yet it also took him westwards, upriver by barge or row-boat to the rambling palace of Whitehall at Westminster and to the summer palace at Richmond, where the old world was ordered by patronage and personal influence. These places figure among his early London drawings, including a view of Lambeth across the water done from Whitehall, and a particularly charming scene from 1638 of a richly dressed party disembarking from a small covered barge opposite Richmond Palace. Since the Prince of Wales feathers are discernible, in some copies of this plate, on the roof of the barge, it has been suggested that the two young boys in the party are Charles and his brother James, then eight and not quite six;

the small girl accompanied by a woman would be the Princess Mary. The gentleman shepherding the children have taken off their hats, as if in the presence of royalty – little kings on earth as their father wanted them to be.

So was Hollar too in attendance at this informal, privileged scene? Apparently so, since he drew it – and we know he could work very rapidly – but he, of course, is invisible behind his sketchpad. In a similar way, we know he went often to the Arundels' country retreat, Albury in Surrey; a whole series of prints attest to his presence there. The family arrive in the recognisable coach surrounded by outriders – the same men we have seen gathering in the courtyard of Arundel House – a jolly cavalcade. Or they take an evening walk with the grandchildren along the tree-bordered path by the River Tillingbourne, which the clever young neighbour from Wotton, John Evelyn, will later design into a water garden for one of those grandsons. They admire the sandy 'grottoes' that have been constructed, probably out of old wine-vaults, on the opposite side; the swans drift over to be fed . . . Obviously, Hollar was there. But he is the one person for whom it will be useless to look. He bequeathed us the world of his own time, sometimes in such extraordinary detail, minute in both senses of the word,

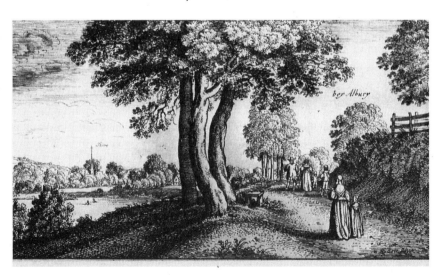

that you feel that a lens powerful enough would reveal more and yet more – every shoe-buckle and button on the tiny figures, every bunch of grapes on distant vines, every sparrow on a remote rooftop. Yet he himself remains, almost all the time, an unseen presence: a shadow on the grass; at most, a fleeting mention in someone's busy record concerned with other matters.

Mistress Tracy was Lady Arundel's waiting woman. Her name suggests some connection with the Anthony Tracy who acted as an agent for Lord Arundel in Italy in earlier days before William Petty was there, but just how they were related is not known. We would like to know about this figure, who is present in the barest outline and whose full name has only come down to us through two separate sources, one providing 'Tracy' and the other the Christian name 'Margaret'. She was to become significant in the life of the man Aubrey described as 'a very friendly good natured man as could be . . .'

We all liked him, women and men too, and that's not such a common thing. Living in a great house like that you are on terms of acquaintance with all manner of people, from the lady herself and her sometimes royal guests to the young blackamoor, the children's dwarf, the gardeners and grooms and all between, but I never knew one as had a bad word to say of Wensel, the name by which he wished friends to call him.

Not a bad word. There was one that, in secret, wished him far off, that I knew, but that was on account of me and I knew too that that one durst not say all that was in his mind to me, for fear I should think ill of him for it.

I mind the day he came to me; that was when my lord and lady were gone to Darking again, to Albury, where the little children had been passing the summer out of the way of London sicknesses, and Wensel had gone with them in the coach.

(Wensel has never been but an indifferent horseman, being short tho' heavy for his height, he says, and for want of practice say I, and gentlemen ride in coaches now far more than they did before. I mind my father, God rest his soul, saying that when coaches first began to be about they were for ladies, children and old people, and that a man would have felt foolish to be thus carried, yet now 'tis a common thing. London town is full of coaches and hackneys, even, for ready hire, though this pleases not the watermen nor the carriers of

chairs, and Mr Peacham has writ a verse on the noise that all the new wheels make on the stones.)

So Will Crowne came to me in the cool of the evening, when I was walking alone in the Roman garden, sniffing at the roses so as not to notice the stench that comes off the river mud at this time of year, when the tide is low so the privies are clear of the water.

And Will falls into step beside me, as one who should have no particular intention, and we talk of this and that, and then he tells me he is soon to be made, by the grace of His Excellency, Red Dragon Pursuivant of Arms in Ordinary.

Red Dragon, indeed. And Edward Walker, that coxcomb, is Blanche Lion. What are these men, to rejoice in such names, like pieces in a game of chess? 'Tis all vanity, and will pass like smoke in the wind or last year's leaves, but I do not say so. I say to Will how honoured he must feel.

Then he tells me another thing. He says that our lady has proposed a match for him and that, if he will, he shall be married soon to a mistress Agnes Macworth, who is the widow of a Levant merchant.[3]

I mind this lady, for I saw her the day she came to call when, no doubt, the plan was hatched. She is a large lady, richly dressed, and I think some years older than William. She has no living children, he tells me, in a tone of satisfaction, and I say that it is surely an advantageous match.

Then he grips my elbow and says, 'But I'll not marry her, Margaret, if you will have me.'

I say, 'But if the Earl and Countess have arranged it —'

To which he says, 'Pshh! They cannot force the matter. Was not the marriage made by Maltravers chosen by himself and contrary, they say, to the King's own wishes?'

He is right, I believe, that His Excellency's eldest son married privily to suit himself, though it was years ago and the trouble it caused the Earl is quite forgot.

Then having no other excuse to put forth, I am distressed for William, for I have to tell him at once that it can never be, between he and I, that he must know that full well in his heart and should not have asked me.

But he asks me now: Why? He is one of the lord's gentlemen and I my lady's chief lady, and both of us discreetly of the true Church — is not that, he says, a fair match?

I want to tell him that, whatever he may say, he and I are very different in our inmost selves, that I know, for all he is still a lad, he is a schemer at heart even as Edward Walker

is; that he privily wants power and influence in ways he will not admit. I do not care for such things and, most important, I can bring no money with me to help him. I made already something the same answer to another, a year since.

The truth is I am happy with the life I have now here at Arundel House, far happier than I ever was as a child with my parents both dead and no real place of my own; I am in no hurry to change matters for any man. Besides, I see here how marriage is and perhaps always must be. My lord and lady pass for a united couple and have in truth done great things together. And yet, as often as not, when he is in one place, at Albury say, or elsewhere, she is here in London town, and then when he returns she goes thither, so that they pass one another like two buckets in a well.

And as if Albury and the other house at Highgate were not enough, she is having Nicholas Stone design her a new fine house in the fields by Westminster; her chambers are full of the plans for it. People say that it is for her, that she may entertain there friends of her own Faith without fear of embarrassing His Excellency. Now that the poor Queen and her friends are not well looked upon, I know not why.

But it is in my mind that this separateness distresses my lord, though I am sure he has said nothing to her, he is too proud. He is looking older of late. I think maybe that long embassy to Germany a year or two agone, when he brought Wensel back here with him, aged him. And yet now there is talk of him heading a force to be sent against the rebel Presbyterian Scots. Poor man.

I said not a word to William Crowne that day of Wensel and he naught to me, yet, if I am honest, he was clear there between us, my good Bohemian friend, with his smile and his pictures and naught else in the world to call his own.

Not long after that, William married mistress Macworth and shifted from Arundel House. That evening in the garden must have been the last time I was ever in his company, almost the last time I saw him. But I mind that evening, for it was later that same night that the Old Stables took fire, and the flames spread to some of the servants' chambers and were only quenched with much difficulty.

It was said afterwards by my lord among others, once he had returned post-haste from Albury, that if there had been some of the new Engines for spouting water nearer to hand, then the fire had been doused much sooner. And my lord made it his business, I believe, to raise the matter in the Privy Council, and so a report was made to the Lord Mayor. This is what life is for such as he. Much greatness but many cares.

He was the most indefatigable man that has been in any Age as his works will testifie . . . Mr Hollar was a very passionate man easily moved. He has often told me, he was always uneasie if not at work. He was one of great temperance, I don't think in all his life time was ever seen in drink but wou'd eat very heartily.

So wrote Francis Place, a country squire and amateur etcher, who knew Hollar well during Hollar's later years.

Aubrey, who was also intimate with him, wrote:

At Arundel house he maryed my Ladie's wayting-woman Mistress ——— Tracy, by whom he has a daughter, that was one of the greatest Beauties I have ever Seen . . .

Aubrey was well connected and must have met many, if not all, of the beauties of Restoration England: if he praises this daughter's looks, so then they were indeed something exceptional. It hardly seems likely that she inherited these from her pleasantly ordinary-looking and rather stocky father (though a darkness in his eyes may have contributed something) and therefore a significant quality is added to the barely sketched form of Margaret Tracy.

Since he was nearly twenty years younger than Hollar, Aubrey was never to meet this first wife, but if she was indeed beautiful herself, then she was a woman in the right situation. The Arundels lived lavishly even by the standards of their class and day, and though the Earl himself may not have cared for fine clothes, the Countess certainly did. Her personal servants would have had access to the kind of materials and other luxuries that would otherwise have been beyond their reach. We know, from the very many examples in Hollar's work, that he loved to depict women in elegant clothes, and that the sensual delights of silk, fur, lace, transparent veiling and soft hair itself received particularly zealous attention from his engraving skills. It is not hard to surmise what drew Wenceslaus Hollar and Margaret Tracy towards one another, and if neither of them had close relatives on hand whose family interests must be consulted, they could follow their hearts'

desire with a freedom not then available to the upper classes. The same year in which they married, a marriage was also arranged between the young Princess Mary, only ten years old, and the Dutch Prince of Orange. The task of conducting this foray abroad on behalf of the royal family fell, once again, to Lord Arundel.

A much later reference in the papers of Elias Ashmole, the antiquarian and collector who became one of Hollar's main patrons after the Restoration, gives a date for Hollar's marriage – 4th July 1641 – but does not say where it took place. Arundel House was in the parish of St Clement Danes, but though the church's records survive for that period, the names of Hollar and his wife do not appear. The explanation may be that they were married in the private chapel in Arundel House by the Catholic rite.

Ashmole also notes the birth of a son to them in April 1643. This seems something of a gap, at a period when the idea of trying to postpone the birth of a first child was unknown. (The Arundel children and grandchildren, like those of the royal family, followed very quickly one upon another in the early years of marriage.) There would have been time for them to have had a baby before the son, and since Aubrey mentions the daughter first, I have taken the liberty of locating her birth in the early months of 1642.

We thought there was no need for haste. We were just happy to be together, there in that household where all was found for us. Were we blind, both of us, or did we just not wish to see where matters were tending? (But then, when the future has become the past, we must think 'It was ever to be so', and yet maybe not . . .) It is curious to think on it now, but when my lord and lady took up with the idea of going to Madagascar, and Wensel and I for a brief while were at odds with one another about this, our dispute was because I was pledged to follow my lady, who has been so good to me, while Wensel was loath to leave his newly gotten place with the young Princes at Whitehall and the other friends he has made in London town.

He said that Madagascar was too far. I told him my lady has shown its place to me on the globe in the Library, and that it is not so far as Brazil, nor yet as the Indies, nor Cathay. (Many people, I have observed, and among them lords and ladies, suppose that all these far places that have been mapped since our grandparents' time must be near to one another, at the

other end of the earth, but I have understood now that there is no end to the earth and many different parts of it.)

Wensel said that already in his life he had parted from too many places and had no wish now to part from England.

So this was the substance of our disagreement, and for a while we did not speak. And then, for some time, he was away with the Earl, at Berwick, and I was sad we had parted so. But then my lord fell ill again, and the Madagascar idea was abandoned. Wensel and I made up our differences, very sweetly, in his workshop, one day when the family were from town and many of the servants abroad in the streets, and all was quiet except for the sparrows

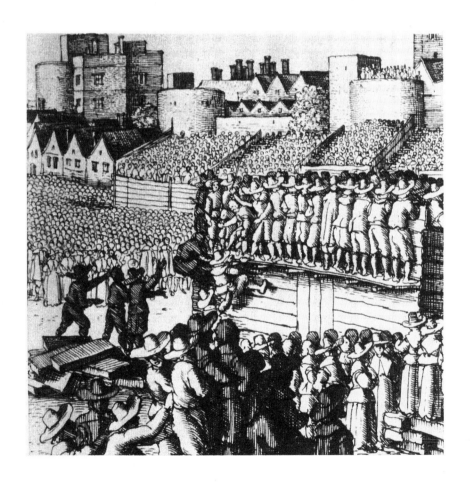

at the open window. I had made some little excuse to come to him there and had brought, in my apron, some of the fine big cherries from my lord's trees, that he had of Mr Tradescant at Lambeth marsh.

And so we were together once more. But we still did not foresee that, Madagascar or no, this pleasant life would all come to an end. Even after poor Sir Francis Windebank had to flee for his life to France (where he soon afterwards died), we did not understand that the Earl and Countess too must be away to foreign parts would they or no, out of reach of the Parliamentarians. We did not think that we, too, would leave in the end, and that, at the worst time, this whole house and gardens, all that the Earl planned and laid out, his Roman garden, his tulip beds and all that cost dear, would be laid waste by rough soldiers and their horses. My lord never came home again to see that. Thanks be to God.

I think now that Wensel, who had known so many wars in his own land, understood more than I what might be betokened by the increasing tumults that beset His Majesty the King. In the last time before we left England, when our two children were both come and thriving (thanks be to God), he made a strange kind of historical map, with the troubles of England and Ireland on the one side and those in Bohemia on the other, and the inscription 'Sed nulla potentia longa est Quo non discorda cives' — 'No good and fair state lasts long but the people must disturb it.' But I think that the very way he foresaw what was to come was the reason he made little of it, perhaps in dread. He would not say, even privily to me, that this or that person or party was in the right or wrong. He walked with care, and any man who wished his prints could publish them, be they for the bishops or for Pym. But I know that he grieved (as did my lord, who presided at the trial) over the terrible execution of the Earl of Strafford in the May of the same summer in which we were married.

How could we, or any other, foresee the far more terrible execution that was to take place in Whitehall a few years hence?

It now seems to me that that year, the year when we wed at last (something in haste at the end, for a reason my good lady well surmised but did not question me for to) — that was the fated year for many things. It opened promisingly, for in the May the young Prince of Orange, who afterwards wed the Princess Mary, was entertained here in the house most royally, with great pomp and ceremony. But satirical pamphlets were appearing in the streets every week. I did not read them, but I would see them lying in the buttery when the men servants had brought them in. When I was a child in the country our servants could not read, but many London servants now can.

There began to be the outcry against the bishops, and an attack by the apprentices on the palace at Lambeth over the water, and then the bishops were imprisoned. (The Archbishop was in the Tower for two years, or more, I think, before he came to trial. I know that the picture of his trial was the very last thing Wensel sculpted before we left, in some haste, for the Low Countries.)

So the time of our wedding was also the time when the family here at Arundel House, likewise Her Majesty up the river, began to lay plans to leave England. Which they all did without fanfare the next year, when the King had raised his standard at Nottingham and the tumults were begun in London, and the theatres were shut, and old friends fell out or passed one another in the street with lowered heads.

Yet when I remember that time, what I recall most is how happy my husband and I were, and how it seemed to us in our union that nothing bad could touch us.

He was ever making little drawings of my clothes, I and those of the other women of the household, and I stood often to him as his figure when he needed to make a fair copy of fashions he had sketched quickly when abroad in the streets or at the Palace of Westminster. This was the time when he renamed a number of the pictures in his Mulierum collection the 'Aula Veneris', the Hall of Love, which was at first a privy name between ourselves, but indeed they were afterwards published under that name.

It was also after we were wed that he began making the beautiful prints of the Four Seasons, which have been much admired. The ladies there represented are all in the latest or Dutch fashions of the time, which my Countess favoured rather than the high-waisted fashions of Her Majesty. In the ones that do not show the ladies' feet I am Spring and also Summer, though, as I told him, I do think I look something too prim and proud and not quite as I am in life. In each picture you can see through the window behind that they were drawn at Arundel House, for Spring shows part of the Old Building and the flower garden, while Summer shows the view from the very end of the house, looking up the bend in the river to Whitehall where the Sun himself reigned still in splendour.

I most particularly affected the Springtime costume, which had a braided stomacher in the new, soft style and much Flemish pillow-lace about it, and I held tulips in my hand, for that was the year, the year of our marriage, when these bulbs were so sought-after in the Low Countries that men made great fortunes and losses by them. In the full-length pictures, which were done something later, Spring is similarly clad, and with tulips, but the face is that of the Lady Catharine, the Earl's oldest grandchild, then a comely girl scarce yet a young lady but, like the Countess her grandmother, plumper than I.

I appear as Summer, with my hair bound up behind, under one of those veils Wensel designs so delicately, and with my shoulders bare as if the dress should almost, like the collar, fall, but with richly ribbon-panned sleeves. My skirt is caught up high and bunched, as is the fashion nowadays, to show all my silk petticoat in the heat. I am seemingly walking in the park that is laid out between the old palace of St James and Whitehall – the Banqueting House that Mr Jones built is clear there to see beyond the trees. In the Winter picture my skirts are again lifted to show my petticoat and very fashionable shoes with rosettes, but that would be to avoid the mud of the season. I wear a splendid fur tippet and muff, all the way from Muscovy, that were given me by my lady as a last gift when she left the country. Wensel drew me when we were standing within doors, but he afterwards placed behind me Cornhill, near the point where it reaches Cheapside. You can see the tower of the Royal Exchange, where Wensel always liked to go and watch the hustle there, and also the old Tun with the water conduit in it, and many coaches, and all the chimneys smoking very lifelike. Only, as I said to Wensel, I don't think that such a well-clad lady should be walking abroad on her own in such a place. He said, 'No one will know her as she wears a mask'; and I said, 'Still more strange. Is she honest, this Winter lady?' – and we were both merry on it.

And when I was too big with our first child, and then our second, to stand facing him

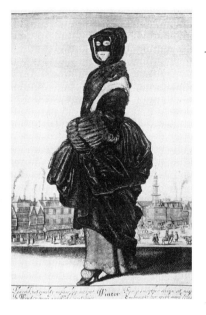

any more, then he used to draw me from behind, from whence the fashion of the held-up skirt and my hair up at the back to match were beautiful too, he said. And thus I appear ever afterwards in some of the little prints, and sometimes in borrowed finery. For, as we said, laughing to one another, what other great lady but I could he ask to pose with her back to him? Those who have their portraits taken must need show their faces.

Wensel's sight is strange. What one eye sees does not accord, he says, with what the other sees and at moments they strive with one another, which is why, for fine work, he will oft-times cover his left eye, which sees best at a distance. But yet he sees more clearly and truly than other men, for it was he who taught me that all things may be beautiful including a big belly. And also — but I must not, for shame, say. But when he designed a beautiful likeness of all my muffs and purses in a soft heap, so real you felt you would slip your hands into them, along with some gloves and lace, and my ribboned fan, this too became something of privy understanding between us. For I comprehended without words spoken that it was not just the finery he was drawing.

Our little girl-child was born near the end of the year in which we were wed — or in the second month of 1642, if we use the new-style reckoning. She was baptised in the true Faith, quietly, at Arundel House but also, for the look of the thing, at St Mary Ovarie, on the Southwark shore: the church was supposed now to be called St Saviour's and the name of Mary suppressed as Popish.

There was much trouble then in London churches about the forms of service used, but Southwark is out of the way on the Surrey bank and the good father there took council only with himself. And later, in Antwerp, Wensel made a print of this same church, with our christening procession going to it, though none but ourselves would know that, with me in front bearing the babe and the wet nurse and our friends following on behind. I used to show that print to my little Meg (named both for myself and for Wensel's dead mother) when we were far away, and tell her it showed her christening day in very deed, transferred magically to paper that it might be kept for all time.

Hollar's son was born on 8th April 1643. He was called James, a common enough name but also, surely, a gesture towards James Duke of York, Hollar's erstwhile pupil. By then, Arundel House was shut up, for the family had gone to the Low Countries to escape whatever was to come. The strife between the Royalist faction and the Parliamentarians had become open: Oxford was being fortified. The Arundels can have had few illusions about what lay in the future, for they had gone to the vast trouble and expense of shipping all the more movable objects and paintings in their Collection to Antwerp – where these became a bone of contention that created alienation and grief between the couple in the Earl's last two years of life.

Elias Ashmole, who noted in Latin the date of James Hollar's birth when he was casting his horoscope years later, stated that he was born at Tart Hall, which was the house near the present site of Buckingham Palace that had been built for the Countess by Nicholas Stone. A contemporary description refers to parts of it being 'the Old House' and others 'the New', as if Stone had enlarged and redesigned an existing building – this may explain its odd and unaristocratic name. No authenticated print exists of this house, which eventually passed to Lady Arundel's youngest son, William Lord Stafford – he who was destined for execution after the supposed 'Popish plot' of 1680, thereby maintaining the long and doleful Howard tradition.

A number of things point to Tart Hall being the house in the background of Hollar's full-length 'Spring'. There is little doubt about the girl being Catharine Howard, an Arundel granddaughter: the same rather

pudgy, determined little face looks out from Hollar's named portrait of her done a couple of years later, and though she can only have been eleven or twelve when he drew 'Spring', a well-born girl of that age would have been decked out as an adult. So the house shown behind her must have an Arundel connection, and Hollar always depicted actual places: it is improbable that this is imaginary or planned-but-never-built.

It is not timbered Albury (part of whose grounds appear in the background to 'Autumn'); nor is it the Arundel 'villa' on Highgate Hill, for it is on flat land with a vague river in the distance.[4] Built apparently of brick with stone dressings, as a further touch of seventeenth-century modernity it has Flemish gables and a distinct baroque influence about the upper windows. Its large doorway has light within it as if it leads to an inner courtyard. The walled grounds before this façade are laid out with stable yards, wrought-iron gates (the latest thing), a sunken parterre garden with an Italianate fountain and steps up to a plantation of trees. Round one corner of the exterior wall a large coach is coming at a good pace with a team of horses accompanied by runners on foot. Is this the Arundel family coach again?

The picture is inscribed as having been both drawn and etched in 1643, the very time when the Hollars were, we know, occupying Tart Hall, presumably with some of the rest of the dispersed household from the old palace in the Strand. An inventory of the house's contents, rediscovered in the twentieth century, shows that it was stuffed at this time with all the paraphernalia of a comfortable household, plus numerous pictures, Turkish carpets, leather hangings, embroidered cushions and similar luxuries. The young couple must have lived in unwonted, if temporary grandeur.

As an odd footnote, only ten years afterwards an inferior copy of Hollar's print was made by another engraver, Richard Gaywood, and in it the house is changed to a quite different one of a much more modest and traditionally gabled kind. Under the Commonwealth, great houses and coaches were temporarily out of favour; indeed most Royalist families had at that time retreated to the country to conserve their diminished means, and to muster what festivities they could among themselves without conspicuous display.

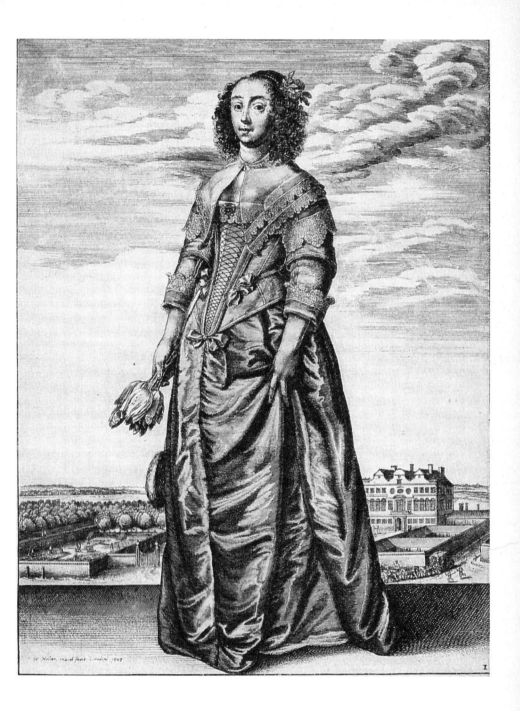

In any case, even among the ordinary people, open celebrations were frowned on under the Puritan influence. During the Commonwealth, Christmas itself was banned. In one of those years several families foregathered at Blithe Hall in Warwickshire, the seat of Sir William Dugdale, whose antiquarian interests were later to make him an important figure for Hollar. A principal guest was Elias Ashmole, who was also to employ Hollar and eventually to marry Dugdale's daughter. He wrote an appreciative poem for his host:

> 'Twas at your house I saw the face and state
> Of aged Christmas (with most, out of date),
> Where holly, joy, sacred mistletoe
> His ancient cognizance and liv'ry show;
> Where, in the brawn, plumb broth, and mince pies,
> Nor superstition nor profaneness lies,
> Where everything such solemn order wore
> As holy festivals did heretofore . . .

The poem goes on to mention the various high spots of the clandestine holiday, but ends with the elegiac note that is frequent in the first half of the seventeenth century:

> But now all these are vanished with the hours
> That brought them forth; thus time our joy devours.

It was partly this sense of devouring, inexorable time and change that led increasing numbers of well-educated men to try, as the century went on, to conserve something of the past by recording it.

Chapter VI

Further Escapes Abroad

By the time their son was born at Tart Hall in the spring of 1643, time was running away quite fast for the Hollars. The Civil War, so long foreseen but not really wanted by anyone, had effectively arrived, though even at this late stage it was hoped that some negotiated settlement would be reached. Soon, the royal family would be scattered, with the Queen and her younger children in France; the palace of Whitehall was progressively abandoned, first to ominous quiet and later to mobs and pillage. The King, accompanied by his two barely teenage sons, had left the capital to rally support in the north and in the west, where Royalist loyalties were strongest. His power base was presently to be at Oxford, where elaborate new fortifications were going up. The Parliamentarians dominated the City of London and most of south-east England. The King's attempt to march on London was abandoned after the inconclusive first battle at Edgehill, in October 1642, and the subsequent routing of his nephew, Rupert, at Turnham Green — the same nephew in whose cause Arundel had made his great, fruitless journey across Europe half a dozen years before.

In the thick of the battle of Edgehill we meet again a figure from that journey, the short, dynamic one of Dr Harvey, as nonchalant as ever about danger close at hand:

the Prince and Duke of Yorke were committed to his care. He told me that he withdrew with them under a hedge, and tooke out of his pockett a boke and read; but he had not read very long before a Bullet of a great Gun grazed open the ground neare them; which made him remove his station.

Aubrey also remarks, elsewhere, that for much of his life Harvey regularly wore a dagger which 'he would be too apt to drawe-out . . . upon every slight occasion' – a dangerous Elizabethan habit which polite society had by then largely abandoned. But:

I remember my old schoole-master Mr Latimer at seventy, wore a Dudgeon, with a knife, and bodkin. As also my old grandfather Lyte, and Alderman Whitson of Bristowe which I suppose was the common fashion in their young dayes.

John Aubrey was born in 1626; he was in his prime at the Restoration, a participant member of the new, almost eighteenth-century world it ushered in, but in his boyhood he would have known old men whose earliest memories went back to the mid-sixteenth century and the Reformation. So does each generation have a foothold in the others on either side of it, but in some eras this straddling of time is perceived as particularly vertiginous, difficult to accomplish within the span of one mortal mind. 'The old world,' said another elderly man at the start of the Civil Wars, 'is running up like paper in the fire.' Actual events no doubt suggested the image. An enormous amount was indeed jettisoned and destroyed, both paper and what it represented, including the notion of the divinity of kings, but in this the 1640s were simply accomplishing a further spasm in the process that had been begun a hundred years before, at the dissolution of the monasteries. Reminiscing about his childhood near Malmesbury, a part of the country where several great abbeys had been sacked in the previous century and their libraries of ancient documents and illuminated manuscripts laid waste, Aubrey wrote, with unusual poetry:

In my grandfather's day the manuscripts flew about like butterflies. All

music books, account books, copy books etc, were covered with old manuscripts, as we cover them now with blue paper or marbled paper; and the glovers at Malmesbury made great havoc of them; and gloves were wrapped up no doubt in many good pieces of antiquity . . . Mr William Stump . . . had several manuscripts of the Abbey. He was a proper man and a good fellow; and, when he brewed a barrel of special ale, his use was to stop the bunghole, under the clay, with a sheet of manuscript; he said nothing did it so well: which methought did grieve me then to see . . . In 1647 I went to Parson Stump out of curiosity to see his manuscripts, whereof I had seen some in my childhood, but by that time they were lost and dispersed. His sons were gunners and soldiers, and scoured their guns with them . . .

It was the same with what has been called 'the stripping of the altars', the dismantling of the whole physical fabric of Catholic worship, replete as it was with statues, relics and rich ornamentation. This began with the destruction of the monasteries, abbeys, chantries and special chapels under Henry VIII, continued under Edward VI and to some extent in the reign of Elizabeth. People might well have felt, in the new century and under the Stuart dynasty, with James I's Authorized Bible and the second reformed Prayer Book in general use, that the transformation was essentially complete. Yet, with the rise of the Parliamentarians and the Civil Wars, a new round of zealous destruction was undertaken. Within a few years, Cromwell's soldiers would be stabling their horses in St Paul's Cathedral and disfiguring surviving Gothic carvings on churches up and down the land – striking off stone heads just as, by the end of the decade, a living revered head would be struck off on a winter morning outside the Banqueting House in Whitehall.

Already, some years before such an extreme sacrifice to the cause of Progress was even thinkable, public crosses were being broken down. The elaborately carved cross in Cheapside, like the one called Charing Cross, had been erected by Edward I in 1290 in memory of his wife's funeral procession. It had been rebuilt by the Lord Mayor in the fifteenth century and had

defied all religious strife since, yet on 2nd May 1643, a month after the Hollars' son was born, it was pulled down. Hollar, attentive as ever to current events and no doubt bent on earning bread for his increasing family, made a rapid record of this, to be paired with another little drawing a week later showing 'the Booke of Sportes upon the Lords day . . . burnt by the Hangman in the Place where the Crosse stoode & at Exchange'. (Hollar for many years retained the Germanic habit of giving capital letters to nouns.) He recorded on the subsequent plate the hats thrown into the air and 'a greate Shout of People with joy' as the cross fell, but it may be significant that he did not sign this work of journalism.

He did his best to maintain the London life he had come to know. In 'the Serene time of Peace' he had contributed engravings to illustrated bibles that were now condemned as 'Popish' – at least, 'an excellent workman Mr Hollard' makes a fleeting appearance in a scathing Parliamentarian reference to these, though the writer seems to have thought that Mr Hollard was based in France, that well-known source of Papist iniquity. Now, in 1643, we find him the etcher of what has been described as one of the key documents of the Civil War – the Solemn League and Covenant, an attempt to drive the Church of England further in the direction of Presbyterianism in order to gain the support of the Scots. This essentially anti-Catholic manifesto was a substantial commission for Hollar, running to eight prints spread over a number of pages, and one must hope he was well paid for it.

What he did not, however, produce in 1643 or any other year, in spite of a persistent myth that he did, were drawings of buildings for a map of Cromwellian fortifications thrown around London. These appeared from nowhere in the nineteenth century and were soon recognised as forgeries – no such fortifications were ever constructed – although this has not prevented their gullible reproduction in many books on both the Wars and on London.

It is true, however, that in 1644 Hollar did etch a major topical work, the so-called Quartermaster's Map, in seven sheets covering England and Wales. It was based on Saxton's important map of 1583, and the name applied to it indicates that it was an attempt by its publisher, Thomas

Jenner, to draw a profit from the disturbances of the times. It was advertised in the title as 'Useful for all Commanders for quarteringe of Souldiers and all sorts of persons, that would be informed where the Armies be . . . Portable for Every Man's Pocket'. You could say, of course, that the production of this map indicated nothing about the probable sympathies of either etcher or publisher, since it would arguably be just as useful to one army as to the other.

You could also surmise that Hollar, as a foreigner, was most unwilling to take sides in a quarrel among Englishmen that was nothing to him. But many English-born subjects were in any case far from eager to declare a particular allegiance. William Lilly, the astrologer, was much consulted at that time by people uncertain which cause to back, afraid equally to miss a good chance or to call attention to themselves unnecessarily. Chance and foregone conclusion seem to have played a big part – the chance of living in one part of the country rather than another, of having neighbours who were Royalist, or Roundhead, and of wishing to remain on good terms with them. When a recognisable ideological or political conviction did intervene, it often split families, with cousins, uncles and nephews, or even fathers and sons or brothers, finding themselves on different sides (though differences were patched up fairly quickly once the fighting was past). For others, again, opportunism must have played a large part. By 1644 William Crowne had thrown in his lot openly with the Parliamentarians, serving the Earl of Denbigh: he quickly rose within their ranks. Another of the youngsters from Arundel's continental embassy, Francis Windebank, son of the exiled Secretary of State, met a less happy fate the following year. A Royalist by family connection and, no doubt, by conviction, he nevertheless surrendered his garrison so readily at Bletchingdon House near Oxford that he was afterwards summarily judged and executed by his own side. A poignant, even heroic figure – he had thought to save the lives of his men – he flits down history, intermittently discovered by later generations.

But by the time young Windebank died and Crowne was one of Cromwell's colonels, Wenceslaus and Margaret Hollar and their children were far away in the Low Countries.

The 2nd July 1644 saw the battle of Marston Moor, the first heavy defeat for the Royalist cause. It may have been this, and fear of worse to come, that finally decided the Hollars to leave, or the trial and impending execution of Archbishop Laud near the end of the year. Or it may simply have been that Tart Hall was finally being closed, its lavish contents sequestered by Parliament along with other Arundel possessions. It was clear that the Arundels would remain overseas, and perhaps the Hollars hoped that by joining them there in a place that Hollar knew and liked already they might renew the old, happy life of sheltered employment. At all events by the end of 1644 some of Hollar's *Theatrum Mulierum* prints were appearing not from Peter Stent but from a printer in Antwerp. At the same period Hollar's name first appears inscribed in the Guild of St Luke in that city as a *platsneyder* (plate-cutter = engraver), a necessary registration without which he would not have been permitted to work there.

It is only by such fleeting, circumstantial traces that the artist can be tracked to Antwerp at all. Essentially, when he left London, he passed from the record, making himself scarce like many other people in England during those difficult years. As a result he went on having a ghostly presence in England, where his prints still sold, and where people who encountered his old associates felt, in hazy retrospect, as if his cheerful, compact figure must surely have been thereabouts too. This is presumably the basis of the persistent story, first put out by George Vertue in the following century and repeated in reference books ever since, that Hollar openly joined the Royalist cause and was a member of the garrison during the protracted siege at Basing House in Hampshire. This Catholic stronghold finally fell to the Parliamentarians in November 1645, by which time Hollar was busy making prints in Antwerp: in any case, one must doubt if the man who had etched the Solemn Covenant would have been welcome in the Basing House. The up-and-coming etcher who *was* there was William Faithorne, with whom Hollar was to work closely in times to come. Also there was Faithorne's master and commanding officer, Robert Peake, the publisher of the 'Popish' illustrated bibles. Many years later

Faithorne was to dedicate a work to Peake, grateful that:

> the honour of having served his late Majesty (under your conduct) in the garrison of Basing hath given me some reputation in the world . . . You chang'd the steel of my Tools into Weapons and the exercise of my Arts into Armes.

Robert Peake had emerged from the debacle of the Basing House with a knighthood.

It may be that Hollar himself, in his later years, with his religious tastes orientated towards Catholicism, and the Stuarts back upon the throne, did nothing to discourage the idea that he too may have played an active role in the Royalist cause.[1] In the same way, he seems to have been content to let Aubrey and others think that he came of persecuted Protestant stock in Bohemia, whereas there is actually considerable doubt about this. He was, after all, 'as pleasant a man as could be'.

The Antwerp to which the Hollars moved was essentially the inner city we see today: the Gothic cathedral with its soaring spire (subject of one of Hollar's best-known prints) still occupies the central position in the town that it did when it began to be built in the fourteenth century, and the street-pattern round it has not changed.

Antwerp was at its peak as a world financial centre in the sixteenth century. By the mid-seventeenth it had survived the trauma of recurrent wars between Spain (who staked a claim on that part of the Netherlands) and the Dutch Republic in the north, and had settled down, more or less, under Spanish and therefore Catholic rule. Much of the booming trade of the previous century had moved away, along with some of the citizens, to Amsterdam, which was quickly overtaking Antwerp in size. However, the general commercial prosperity of the Low Countries, on a scale unknown before anywhere in the world, had left Antwerp a legacy of impressively modern paved streets and new, fine houses. John Evelyn, visiting for the first time, found it a strikingly 'quiet, clean, elegantly built and civil place', presumably in comparison with London and Paris. Particularly admired by

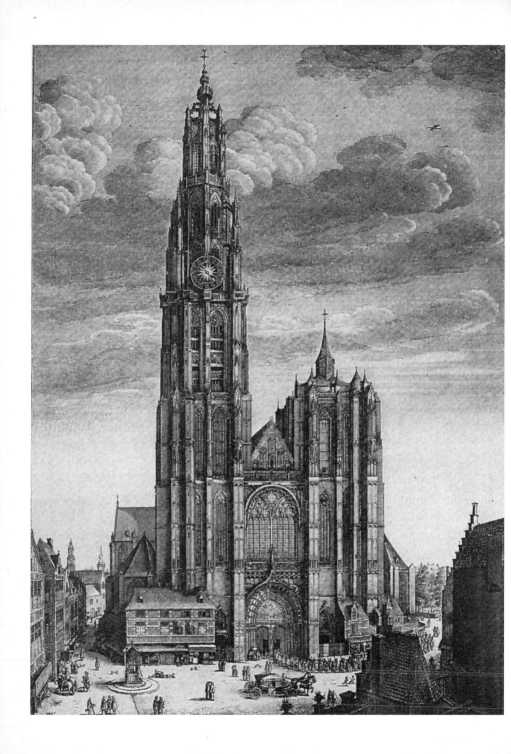

foreign visitors were the homes of the thriving middle class, with their many well-glazed windows, their decoratively tiled floors and tasteful furnishings, all familiar to us today from Dutch paintings. The classic Antwerp house was, like the Amsterdam one, a narrow, high-gabled brick structure, but wealthier owners added stone dressings, creating what local people, displaying the traditional Dutch preoccupation with food, called the 'streaky bacon look'. Three of the grandest houses that survive today, that of Burgomaster Nicholas Rockox, that of his contemporary and friend Rubens and that of the Plantin-Moretus printing family, took the basic Dutch form and elaborated it into something almost Italianate – rather as Lady Arundel and Nicholas Stone in London had transformed Tart Hall. New wings were built, enclosing inner courtyards decorated with parterres and statues; sequences of rooms, large and small, proliferated, replete with leather wall-hangings, inlaid cabinets and arrays of portraits.

The Plantin-Moretus house would certainly have been familiar to Hollar, for the first Plantin, born near Tours in France, settled in Antwerp in the mid-sixteenth century and set up a printing business. He prospered, and became typesetter to the Dutch royal family. Antwerp was then the major centre for map-making and printing; Braun and Hogenburg, whose map-views influenced the idea of what a map should be for the next century, worked out of Antwerp as well as Cologne. Plantin also entered the map field: Gerhard Kremer, otherwise known as Mercator, the first visionary scientific map-maker, lived nearby. Plantin sold his maps and globes, and the original Mercator world-map hangs in the Plantin house to this day. But Plantin also turned himself into the world's first publisher in the modern sense, producing more than 1,200 different books. It was in buying up original manuscripts as copy for these that he by and by acquired an extraordinary collection; this increased in value as the years went by and transformed the owner into something much more than a successful trader. The humanist scholar Juste Lipse was his friend and correspondent. He married his daughters carefully to men who could continue and expand the business, while at the same time making sure it was not split up. The grandson who was in charge of the firm in the 1640s was a childhood friend

of Rubens, and together they created the concept of the baroque book, heavily illustrated, such as the Polyglot Bible with an elaborate portico on its title-page as a gateway to knowledge. No one like Hollar, living in Antwerp and interested in all aspects of printing and reproduction, could possibly fail to feel this reigning dynasty's presence.

Rubens had died in 1640 but his spirit, too, was everywhere in the city. Hollar made only a few prints from Rubens pictures, notably those of lions (animals, with their grace and their fur, always appealed to him as subjects), but he would have been extremely familiar with Rubens's works. Rubens's 'Descent from the Cross' was in place in the cathedral and thirty-nine of his paintings graced the ceiling of the newly-erected Jesuit church that was a triumphant product of the Counter-Reformation: today it is called St Charles Borromeus. The paintings were destroyed in a fire in 1718, but, as the present-day guide-leaflet remarks, 'the interior of the church bears a striking resemblance to that of a baroque banqueting room'. Indeed, another of Rubens's undertakings had been the ceiling of the Banqueting House in Whitehall commissioned by Charles I, a building well known to Hollar. Even John Evelyn, who disapproved of Jesuits, was impressed on his first visit to the church:

> sumptuous and most magnificent . . . being a very glorious fabrique without; & within wholly incrusted with marble inlayd & polish'd into divers representations of histories, Landskips, Flowers &c.

It was later in life, in a more sober frame of mind, that he wrote of Hollar: 'He was perverted at the last by the Jesuits at Antwerp to chang his religion.'

Perhaps Evelyn suspected that this splendidly extravagant church, then called St Ignatius after its Jesuit founder but known locally as 'the Marble Temple', was an important factor in shifting Hollar's sensuous, beauty-loving spirit in the direction of Catholicism. But was it, rather, that among the Jesuits, whose quarters then occupied the entire square facing the church and included a school, the Hollars found another self-sufficient, hierarchical community reminiscent of Arundel House in which they could

feel at home? Whatever the exact religious situation surrounding Wenceslaus's exile from Prague at the age of twenty, now, in his late thirties, when he was in a further exile, it was rigid Protestantism that he fled and the traditional Catholic camp that made him welcome.

I look back now to when I was a little maid-child in Antwerp, and it seems to me that I was always happy.

I know now that we were in Flanders only on account of the Warrs at home (we always called it 'home', tho' England had not been my father's home in the beginning) — and on account of the misfortunes that had come upon the Earl and Countess of Arundel. But children do not question why they are taken to a new place, my father always made it out to be a fine chance for us, and even a merry thing, to be there in such a neat clean city with such good milk and butter and such fine fish from the river close at hand. And as for my lord and lady, by the time I recall clearly I believe he was already gone into Italy. For Lady Arundel, tho' Mother did use to speak of her as if she were much in her company, I do not believe in truth that Mother often saw her. I think I do recall being dressed in my best little gown, with new lace fichu and my coral beads, and my brother likewise (he being but a babe) and being taken to see a large, grand lady in a great house that put me in mind of somewhere I had used to be before. I suppose now that I was remembering Tart Hall, where we lodged, which indeed had been the Countess's own house also. But the lady that I recall may not have been the Countess, for our mother and father were acquainted with a number of the notables who had taken refuge in Antwerp in those years, and I believe that Lady Arundel went afterwards to stay near The Hague, near unto the Queen of Bohemia.

At all events, tho' the Howard family were much spoken of, and always mentioned in our prayers, and I used to like to say I could recollect Tart Hall and Arundel House too (tho' I am sure I could not), I do not think in truth that my father got much preferment in Antwerp through his connection with them.

Yet during those years he made etchings of all manner of things from the Earl's cabinet of rarities, which he had earlier limned, such as strange butterflies and beetles and many shells from foreign parts, and they were pretty. He had brought these and many other drawings with him from London, in his leathern wallet that he had carried on his back since he had left Prague — or so he told us. Mother used to say that he cared more for that wallet than for any of us — that in his shiftless way he might have left one of us children

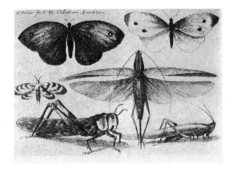

behind by mistake, as did reputedly
Elizabeth of Bohemia when she fled from
her throne, but that he would never forget
his old wallet. She meant it for a joke but,
I know not how, somehow I felt it was
true, and was sad withal. Even tho' I
knew also that Father loved us, as he has
loved all his children, perhaps more than
many men, such is his nature. He never
was harsh with us, not having the English habit so to be.

Rembrandt van Rijn, who was much of our father's age and visited Antwerp at times
from Amsterdam, admired the shells and my father's beautiful work on them. He later made
drawings of shells himself, and one picture in oils: I am sure he would not have thought to do
so had it not been for Father, for such shells were greater rarities then than they are at the
present time when the trade with the Indies increaseth every year.

I understand now that whilst, to our father, Antwerp was another city with a great river
like to many in which he had dwelt before, for our mother the change was much greater. The
houses in which we lodged were not like those to which she had been accustomed in her service
with the Countess, nor yet like those in which she had lived as a child. The first place where
I can recall our dwelling in Antwerp was a high, old house which I believe was near the
quays, tho' I am not quite sure. (Father loved the quays for the ships there, and drew many
a delicate picture of their rigging.) There was much space in this house but scant furnishings,
and we were much afflicted by the mice and rats which came from granaries nearby. I recall

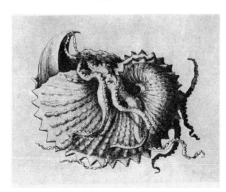

this because, at night, they used to run up
the drawn curtains and over the tester of the
great bed in which we all slept — Mother
would not leave Jamie in a cradle for
fear of them. She was not used to such a
nuisance, as she told me when my under-
standing was grown somewhat: in Arundel
House there had been a man called Dick
whose sole occupation it was to trap and
kill these beasts, and to prevent them too,

and he had accompanied them to Tart Hall. Mother did not know what to do, and wept. I do call to mind her weeping then, as I had not seen her do before.

So Father brought in from the granaries a cat, a fierce brindled mouser who became another Dick — or Dik, for he soon waxed fat. Father does much affect cats: any cat in his house soon becomes tame and learns all too well to take tidbits at his hand. And we got another too; Father called her Korshka, and she I especially liked for she was very gentle

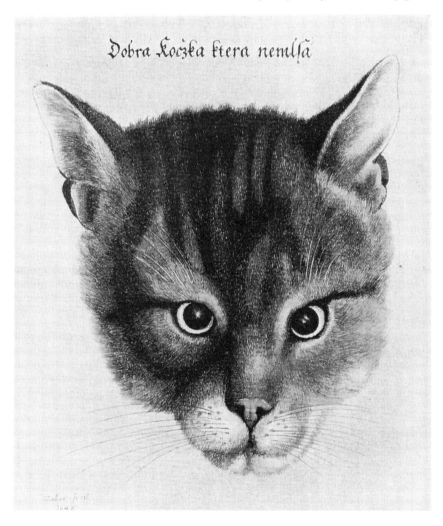

Dobra Koczka ktera nemlſa

and, tho' shy, would come to me. Father made a little engraving of her, for sale, for she had soft grey fur with dark stripes, very pretty. And I liked the picture so well that he made another copy especially for me, and along the top and the bottom he wrote the meaning of 'This is a good Cat, who never picks and steals'. (Dick was a thief, who would have a fish off the table the instant you turned your back to it.) Only, he wrote it not in English, nor yet in Flemish, but in true German and also in the Bohemian tongue. I have the little likeness before me at this hour, and it seems to me now that, as he worked on it, my father's mind was going back to his boyhood, for who in Antwerp would read Bohemian? Not I, his daughter.

At the time, I thought that perhaps the cat could, because she was Korshka, which I understood to be a Bohemian word. I also believed Father when he said she was in secret the cat of the Grand Duke of Muscovy[2] and knew it herself. Such are the fancies in which happy children delight. I believed that animals all spoke, when humans were not by to listen to them, for Father told us fine tales of the castles on the Rhine. There was a Katz castle and a Mouse castle, and a tower where a wicked bishop had gone to escape the rats that plagued him, but they were really the souls of hungry people he had shut in a barn — and much else besides. And because Father showed us the little pictures he had drawn and painted of these places so like to life, and told how he had travelled up and down the river with the Earl of Arundel to see them, I believed that everything else must be the truth also. That beasts might talk seemed to me no more strange than that an Elephant should be real, with his great nose. Father had a picture of one of those too, that he had made in Strasburg and that showed how the ingenious creature ate and bathed itself. Father gave me to understand that he had seen it with his own eyes, tho' I wonder now if that was so. Artists and engravers do like to copy one another (as van Rijn did) and many of my father's engraved works were after those of others now dead, such as Raphael and Dürer.

Later, when I was grown somewhat and Mother was teaching me to read (in English), we moved to another house. And I know this was in Kipdorp, just behind the Jesuits' church, at the sign of the Blaue Enner, the Blue Pail; I was taught to say the name of the house and of the street if ever I should stray and lose my way. Kipdorp, it comes to me now, means a hamlet for chickens; what a strange name for a street, but perchance no stranger than Poultry? Certainly there were chickens about, for the Antwerp streets were not so busy but that chickens and even hogs would roam abroad, as in a country town here in England. Of course I had the Flemish tongue by then, tho' I have much forgot it now. I had it, I suppose, from the other

children in the house, most of them the children of Dik Marieke, Big Marietta, who lived on the street-floor and laboured in the house and at other services for my mother. Jamie spoke the Flemish better than I, for he was much with Dik Marieke and her children when Mother was sick. It was in truth the first language he learnt to speak clearly.

Mother never learnt Flemish, beyond the words she needed with Dik Marieke and for going to the markets. Antwerp was not her place. She would have fared better, it may be, if we had all gone into France, for she spoke a pretty French, and many of the people she had been acquainted with in London were there in Paris. I know that Mr Evelyn during the Wars was travelling in France and Italy, and he became acquainted with his wife in Paris for her father was ambassador there some time. Mr Evelyn has been very kind to me in recent years, and has bought many prints of Father, whom he esteems as an 'indefatigable artist'. Just lately, he has written so in his book 'Sculptura' — I have seen the passage myself, tho' the whole book would be long and hard to read. He ranks Father 'before most of the rest of his choyce and great industry', and also says:

> 'Of Mr Hollar's works we may justly pronounce there is not a more useful and instructive Collection to be made.'

I think the works better than useful and instructive, but Mr Evelyn's approval means much to my poor father, for reasons I well understand.

John Evelyn was indeed in France and Italy during the Civil Wars, a discreet worker for the Royalist cause. In the spring of 1646 he was in Italy, in Padua, where Lord Arundel had for the moment settled. Evelyn's Diary entry for Easter Monday reads:

> I was invited to breakfast at the Earle of Arundels. I tooke my leave of him in his bed, where I left that greate and excellent Man in teares on some private discourse of the crosses that had befain his Illustrious family, particularly the undutifulness of his Grandson Philips turning Dominican Friar, the unkindness of his Countesse, now in Holland; The misery of his Countrie now embroild in Civil War. After which he caused his Gentleman to give me directions, all written in his owne hand, what curiosities I should enquire after in my Journey; & so injoyning me to write sometimes to him, I departed.

To Evelyn, a devout and constant member of the Church of England, Arundel may well have stressed the undutifulness of his grandson, but even if his distress at this betrayal was sincere, the blow should not have come as any great surprise, considering the education the boys had received. Perhaps the embarrassment and disappointment caused by the grandson's public embracing of the Roman faith (a mirror image of Anne Dacre's distress at her own son's joining the Church of England thirty years before) stood for the other more 'private crosses' that were Arundel's lot. In particular, he must have been grieving about his estrangement from the Countess and the fact that she was busy selling off in Holland much of the precious Collection. He had made it over to her as an act of political expediency and had wanted to keep it intact. Long afterwards, Evelyn was to tell Samuel Pepys that these treasures were 'scattered and squandered away by his Countess'. Arundel may also have foreseen the ugly wrangle about property that would break out after his death between Alatheia and their second son, Viscount Stafford. He knew that much of what he had had to leave behind in England would be lost to his descendants, and perhaps destroyed: the history of his family and his own youth was repeating itself there too.

But a more poignant grief than any of these may have been the fact, unmentioned by Evelyn and perhaps at that point hardly mentioned in the family, that the eldest grandson, the Earl's namesake, had lost his wits. The plump-faced little boy in the red jerkin, seen with his grandfather apparently defending him with the ancestral staff in the Van Dyck portrait of the previous decade, had succumbed to an unspecified fever, presumably complicated by encephalitis. Eventually, after the Restoration, this Thomas was made Duke of Norfolk – the title the Earl had hoped, fruitlessly, to regain for himself. But Thomas was to live out the rest of his life apart from the world, maintained in Italy by his younger brothers as 'an incurable lunatic'. Against this fate, neither staff of office nor wealth nor dynastic ambition had been of any avail.

In the September of that year the Earl died. He was sixty-one. He had not seen his wife for many months. According to Lord Clarendon (ever his covert opponent) he died 'under the same doubtful character of religion in which he

lived'. His body was eventually brought back to England to be buried in the memorial chapel by Arundel Castle (much battered and desecrated in the Wars), but few of the other commemorative and charitable provisions laid out in his will were ever carried out, in those chaotic and quickly moving times. His heart and entrails remained in Padua, in St Anthony's basilica, where a plaque in the cloister commemorates him to this day.

In the months that followed, Henry van der Borcht and Hollar, together in Antwerp, designed between them a commemorative engraving representing the death of their patron in allegorical form, complete with the Holbein likeness of his great-grandfather, Henry VIII's Earl Marshal. They dedicated the picture to his widow. But really such gestures belonged to the old world that was rapidly passing away. The system of patronage was dying, along with the big Tudor-style households that had been part of it. Henceforth, Hollar was going to have to make his way in a rather different world, where there were many new opportunities but also many up-and-coming engravers, etchers and map-makers jostling for a place in the market.

My father dedicated his great work upon which he was engaged in Antwerp, his 'Long View of London from the Bankside', to Princess Mary, she who was married betimes to the Prince of Orange. I believe he had known both parties before: Mother used to speak of the time when the Prince of Orange stayed, with great pomp, at Arundel House, when the marriage was being arranged and the painter Sir Anthony Van Dyke made their joint portrait there, with she all in cloth of silver. But I do not think my father ever reaped much advantage from this dedication.

Yet the 'Long View', which some also called by the name of Panorama, has been so very much admired by many people in the years since, and is now, at the present date, rendered still more Useful as a memorial by the fact of the recent Great Fire in London which has destroyed so much of what it shows, that my father still accounts it one of the best works he has done.

I wish I could recall him at work on this great View which, being fully extended, measures near to five yards, but I was very young at the time he was busy upon it. I believe we were yet dwelling in the house near the river with much space (if little else) in which he could lay out all his drawings. The finished article was made, I know, of many different small

views, taken with a piece of charcole or a lead pencil when we were yet in London. Because it was engraved afar off there are one or two points amiss, but very small; the naming of the theatres on the bankside is not just as it should be, but it is still a wondrous thing.

In recent years, what with Mr Reeve in London town making very fine instruments, glasses, telescopes and I know not what, some prattlers who know little of my father and his simple ways have been wont to say that, to take his London View, he must have used in secret some special prism, or reflecting mirrors maybe, to have attained such perfection of truth. 'Tis all vain talk, and if they troubled to visit my father at work they would know it, for he is so little inclined to burden himself with cumbersome devices that I have many times seen him busy with the close work of sculpting in copper with his other hand held before his left eye — the eye that does not see well close at hand. My mother could not suffer to see him look so ill-at-ease, and stitched him fine eye-patches of black velvet to cover that eye, but he used to mislay them as he does many things. Only in his work itself does he take scrupulous care.

Now that he is older, he makes use of a simple viewing glass to spy exact things with nicetie at a distance, but so do many artists. To say that he must have used some elaborate tricks of the new Science to take his views is to speak as if my father's great gift as a limner is not his own. Would they also be persuaded, I wonder, that to take his remarqueable view of the roofs of Windsor Castle, that he has made for Mr Ashmole's book, he must have the secret of flying like a bird and have managed to do so unobserved?

> He was very short sighted (μυοφ) and did work so curiously, that the curiosity of his Worke is not to be judged without a magnifying-glasse. When he tooke his Landskaps, he, then, had a glasse to help his sight.
>
> (Aubrey)

Aubrey knew Hollar well and saw him at work, but clearly his perception of Hollar as very myopic cannot have been entirely correct: had that been the case, Hollar would never have become a landscape artist at all. A further clue is supplied by a letter that Francis Place, who knew him only in his later years, wrote to George Vertue a generation after Hollar's death:

> . . . he had a defect in one of his Eyes, which was the left, so that he always held his hand before it when he wrought. He never used spectacles.[3]

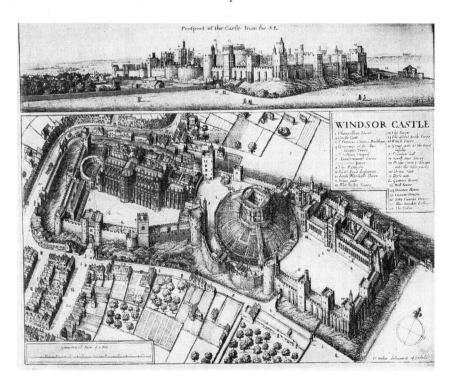

It may have been that Hollar's sight differed so much in his two eyes that he did not have binocular vision, and effectively used only one eye or the other at any given moment. What is self-evident is that, by one shift or another, he did achieve amazing clarity both for distant scenes and for minute things close at hand, and continued to do so well into his sixties. It is possible, though there is no direct evidence for this, that he was to a large extent colour-blind; this would have enabled him to concentrate without distraction on the nuances of light, shade and texture. He never showed interest in colour; even in those of his drawings over which a light wash is laid, it is usually blue-grey or brown, more of a softening glaze than a tint. Some of his late watercolours do employ pale green for grass and pinkish colour for roofs, but entirely conventionally, as if it was not important to him. On one of the rare drawings where tiny splashes of pure colour appear (a view of Shoreham on the south coast), these appear to be used purely as

highlights: three tiny figures in the landscape all wear red, which is not a very realistic touch.

The idea, put forward by one or two enthusiastic commentators in recent years, that he 'must' have used some sort of *camera lucida* or *camera obscura* to achieve the perspectives he did, ignores the complete absence of any mention, let alone description of such a thing, by those who watched him at work. Other aspects of his methods and skills, however, are clearly documented. Richard Symonds, the English Royalist and antiquary, who visited Hollar's studio in Antwerp in 1649, wrote:

> I saw Mr Hollar etching, & he laid on the water [*aqua fortis*, i.e. nitric acid] which cost him 4s. a pound & was not half of an hour eating. it bubled presently. he stirred it with a feather. he lays on the wax with a clout & smooths it with a feather. he makes a Verge to keep in the water after it is cut with yellow wax & Tallow melted to gether. layd it on with a pencil. he always Stirrs the Aqua with a feather.

George Vertue appends to his catalogue of Hollar's work several pages of detailed description of the cumulative stages of engraving and etching. This purportedly comes from Hollar's own pen, but it is more likely to have been taken down verbatim by someone else, for it has the easy rhythm of speech, while the English grammar and spelling are more orthodox than Hollar's.[4] The full description is too long to quote here, but the final section may give some idea of the labour-intensive and repetitive processes of etching, Hollar's own enthusiasm and perfectionism, and the need for this dedication at a time when all the necessary ingredients had to be bought separately. Today, etchers buy the 'ground', the protective coating for the plate on to which the drawing is scratched, as a ready-made blackish paste. Hollar had to manufacture his own ground, out of wax, asphalt (a resinous mineral), putty and rosin, cooked up carefully in a certain order over a small flame and later applied over a layer of soft charcoal, also home-prepared.

> . . . in Winter time . . . you commonly must keep a good Fire when you work, otherwise your ground will leap away.

When you are going to etch, then take some Greenwax, and melt in some little Pipkin, then with a Pencil cover all the four Edges of the Copper, then take more of the Wax, and frame it into long flat Pieces, in shape of a Ruler but nothing too broad, put them along the Edges, where you have done with your Pencil, then you must have a little Piece of Pencil Stick, or some such Thing, made sharp under neath the broad Way, not point Way; with the Help of that make your Wax stick to the Copper, still stopping it as you go along round about it: if the Work be fine, take Aqua-fortis of Three-pence the Ounce, and put it to some Wine Vinegar, but take at least two Parts of Wine-Vinegar to one Part of Aqua-fortis; but if the Work be coarse, requiring much Deepness, then you may take of the Aqua-fortis alone, and such Things as you would have faint, you must pour off the Aqua-fortis off the Plate, and put on in the Room of it only fair Water, and so let the Plate stand till it be dry, which done, melt some Candle Grease with a little of your Ground, and so stop such Places with a Pencil dipt in that Mixture as you would have faint then pour on your Aqua-fortis again, the same as was before, and do that so often as Occasion will require; then lay the Copper on the Fire, till the Ground shall melt and wipe it off with a Rag, then rub the Plate with a little Piece of a Beaver Hat dipt in Oil, and so your Plate is done.

My brother, as soon as he was old enough to apprehend the nature of our father's occupation, had such a fascination for the bottles and feathers and powders and balls of wax and all the other tools, that he must needs be sternly kept from them. And, even so, he did use by stealth to creep up to Father's workshop when Father was elsewhere, and touch Father's things wonderingly with his fingers. That was no doubt how he got the biting Water on his first pair of britches, tho' he would never admit this. Even when the little holes appeared all down one side of the britches, for all the world as if moth had corrupted the stuff while he wore it, he would not confess. And Mother was so vexed at his duplicity and obstinacy, as much as at the britches, that she whipped him with her slipper. Then Jamie, who was not accustomed to being whipped as some children are, being most times a docile and sweet-tempered child, did cry very pitifully and Mother, being soft-hearted, cried also. And when I recall all that now, so long after, it comes to me that my brother was only looking to do, as a young child, what

later as a youth and a man he would learn to do for profit. For he had of our father a true talent for the pencil and the engraving tool, and they worked together. Oh my brother. My brother.

. . . his son . . . an ingeniose youth, drew delicately.

(Aubrey)

Now that I am a woman myself, and living among People of note, such a world as my mother once enjoyed but then lost — I understand why my mother did not well thrive in Antwerp. In London, to keep a house in the ordinary way had not been one of the accomplishments she had learnt. She could make beautiful pomander balls, and she embroidered aprons for me and sang most sweetly, but she never in the first times of her marriage had the ordering of a kitchen. I do recall going with her to market, and that she did not seek out what we needed in the way of fish, bacon, onions, leeks and so forth and bargain for them as did Dik Marieke and the other housewives, but would wander in the market halls like a lady among a display of fine silks and laces, buying only what took her fancy. Then the market folk took advantage of her ignorance; also, the fine fowls and game pies that she purchased cost more than simple food. Even when I was a little maid-child at her side I understood that. They are hearty eaters in Flanders and this well suited my father, but Mother (even when she was not troubled by any sickness) had no taste for pickled herring and plain cheeses such as ordinary folk there daily eat. Her taste was for delicate things, particularly for fruits. All manner of fruits from distant countries, and new sorts of our fruits, were being grown in the Low Countries then, as they are now in England: black cherries, strawberries as big as pigeon's eggs, red and white grapes and, you may be sure, the new pine-apples. Mother delighted in all these things, and all of them were at prices for rich men's purses. We were not rich.

She also delighted in the sugar cakes, with almond marchpane and other dear things, that were being made by then in Antwerp, and did use to buy them for us her children. And my father too was wont to buy these dainties for her by way of little gifts, to comfort her in her troubles, and each time was like a little celebration. He worked so hard in those years (as he does today) he had but scant time to give thought to how the household purse that he filled with such pains was being laid out, and in any case that is not a man's concern. Another time, to gladden her heart, he bought her a yellow velvet jacket trimmed with fur, which was the fashion those years.

As for Jamie and I, we were but careless children, happy to play in those clean quiet streets and alleys, or in the cloister square. And Father was happy too, the times when he was with us, for such is his nature.

I was too young to understand fully then: the many times that our mother was sick were on account of her being with child, or having lately given birth or sustained some accident. Father told me afterwards that, before the last time when we were returned to England, she had been with child a number of times during our stay in Flanders but on several occasions the matter ended in blood and tears, and once the babe was still-born — that, I do recall; we had been promised a new little brother or sister, but when we were brought back to our house by the neighbour who had had the care of us that day, we were told it was not after all to be, as that was God's Will, and I felt as bereft as if a promised doll had been taken from me.

And when at last another babe was born alive, it died later — I recall not when exactly, but a few months later, in a hot summer between two of those cold Flanders winters. Well, 'tis a common thing, the great suffer such losses even as the poor do, Mr Evelyn and his wife lost a number of young children, I am told — but our mother took this loss very hard. She had prayed very much that that babe, a second son, should live. She used to take me with her daily to say a prayer for him in the Marble Temple, that was all white and gold within: she thought, poor lady, that the prayers of another innocent child might avail best with the Mother of God. But the Mother of God never showed any sign of harkening to us, something that does not surprise me now as it did then.

After the babe was dead, a kinsman of my godfather Henry van der Borcht — I think a cousin, but I know not in what degree — painted him quickly as he lay on a little altar that was arranged in our house with red curtains and with a palm placed in his small hand. I have not seen the picture myself, but I am told it hangs to this day in Antwerp, in the house that belonged to the great Rubens, because Matthias van der Borcht (or de Burg, or der Bergh — so many ways these names are written)[5] was of that household. Father had the picture painted as a consolation to our mother, but she was too grieved to look upon it, so he sold it back to the artist.

With the money, he bought her a set of virginals instead, which were coming into the fashion then. We all liked it very much when Mother learnt to play upon them, as she swiftly did, and Father made a picture of her that was afterwards used by a printer in London when he published some court music. (I have it by me now.) I have also a drawing I believe he made at that time with her hair dressed the same way only with a light cap upon it, and in this she

has her kerchief to her face as if she had been weeping. But this I do not in particular recall, being used to her frailty by then. The virginals did most times cheer her, yet they did not accompany us on our return to England. I know not why. Perhaps virginals are unstrung by the salt sea air.

I have another little likeness he made of her, looking sideways and downwards, also taken in Antwerp; her hair is drawn back from her brow, but is otherwise dressed the same. This, now, is how I recall her best, but I think in truth it is the picture I see in my heart, rather than my own faltering memory of her.

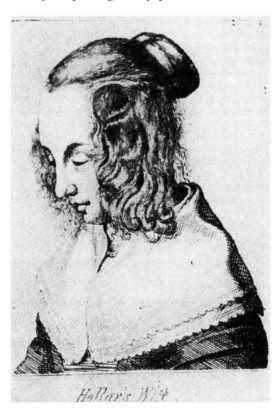

Hollar's Wife.

As I now understand, she was not only sick in her body but also sick for home all the while we were in Flanders. Unlike Ruth, in the Testament, my mother (whose own hair was of a gold like to corn, fairer and more delicate than mine) would not be happy in corn fields that were not her own land, nor could she be fruitful there. My father, who can be happy wherever he has work to do and the eye of Heaven shines, could not foresee it, but Flanders was her undoing.

When we came back to live in London, I was turned eleven years old and, tho' I did not know it till afterwards, my childhood was over and done.

Chapter VII

London Streets

Charles I was executed early in 1649 (new-style calendar). In Amsterdam, Hollar marked the event with an engraving of the King after a Van Dyck portrait, a print clearly intended for exiled royals and continental sympathisers.

The year 1649 was a grim one in England. In the wake of the King's shocking death (a ritualistic event without precedent or sequel, which traumatised even those involved in it) the final phase of the long-drawn-out Protestant Reformation was in the hands of Cromwell's troops. It was logical that, after the regicide, all statues of former royals should be torn down from St Paul's and from the Royal Exchange, but there was also a general destruction of tomb effigies and church carvings. Men were even hired at a daily rate specifically to break stained-glass windows. The numerous saints' days of the old Roman Catholic year had already been suppressed in the previous century, but now the major festivals that made up people's mental calendar, and were interwoven with even older pagan celebrations, came under attack. The processions and rowdy jollifications traditional on Shrove Tuesday and Ascension Day were forbidden, as were the bonfires and City pageants of St John' Eve (midsummer) and various autumn feasts. Mayday was taboo, maypoles were pulled down and Christmas itself might no longer be celebrated, even by attending a church service. On Sundays, under the new Directory of Public Worship, long

sermons were now obligatory rather than rousing singing; many church organs were removed – though it was noted that some of them simply found their way into public houses. Singing or selling ballads in the streets was banned too. Ostensibly, all these measures were to discourage behaviour that was not sober and God-fearing, but they also served the purpose of preventing free speech and the gathering together of unmanageable crowds.

There was a further assault on what was left of collegiate libraries, church books and also vestments. The copes from St Paul's Cathedral (where New Model Army horses were currently stabled) were burnt to extract the gold from them, and silver vessels were melted down to finance the military presence. In Whitehall, the Royal Collection of pictures was ransacked before auction, and many of those depicting the Virgin or Jesus were destroyed or thrown into the Thames, including an altar-piece by Rubens. In an earlier wave of popular aggression on the Palace and on the rookery of old-fashioned lodgings surrounding it, Dr Harvey's accumulated records of his animal dissections and observations had fallen victim to the general destruction:

> . . . he often sayd, that of all the losses he sustained, no greife was so crucifying to him as the loss of these papers, which for love nor money he could never retrive or obtain.
>
> (Aubrey)

How fortunate that Hollar, wise in the nature of war and revolution, had carried his hoard of drawings away with him to Antwerp.

Yet after this spasm the country settled down, more or less, into the gritty years of Parliamentarian rule, and by 1652 many exiles, including Hollar, were returning. The royal family remained in France, except for an abortive attempt at return made by Prince Charles in 1651 from which he only narrowly escaped. But families who had been sundered by political disagreement wanted to patch up their differences, and Royalists were anxious to salvage whatever of their property had not been distrained. In 1652 Parliament eased the way by passing an Act of Pardon and Oblivion, in the best tradition of pragmatic amnesty.

We do not know exactly what made the Hollar family return to London then, but one factor was probably Antwerp's continuing decline as a world city and therefore as a place to find wealthy customers. The Peace of Münster in 1648 had finally brought an end in sight to the inconclusive running disaster of the Thirty Years War; Hollar was evidently present when this was proclaimed in June at Antwerp Town Hall, since, with his press-photographer's eye for currently marketable events, he made an engraving of the occasion complete with one of his lifelike crowds. But part of the price of the Peace, which recognised the independence of the northern Netherlands, was that Spanish hegemony over the southern part was confirmed and that the River Schelde was closed to merchant shipping; in its stead, the port of London became a world trading centre. With the Arundels gone, and much of Hollar's work on the Collection now used up in publication, there can have been nothing now to hold him in Antwerp but relations with a few dealers. He returned to the banks of the Thames and never really left them again.

It may also be that he had already made contact (perhaps through recommendation by Evelyn, or by Arundel's old librarian Junius?) with William Dugdale. Dugdale was a Warwickshire gentleman-antiquarian who was then compiling the historical record which he published in successive volumes as the *Monasticon Anglicanum*. He was, if not actually a Catholic, a high Anglican attuned to the value of old records and buildings. Many monastic manuscripts that, in Aubrey's words, 'flew about like butterflies' and were almost as vulnerable as butterflies were salvaged by Dugdale. He and Hollar were to form a fruitful partnership which lasted, on and off, many years, and produced plates of castles and great churches in many parts of England whose seventeenth-century appearance would otherwise now be lost to us.

We know from publishing evidence that Hollar was back in England by the last months of 1652. He may have made a brief voyage to reconnoitre the situation the year before. There exists a set of views of the Channel Islands, engraved by him and possibly drawn by him also, though as they are all from the vantage point of a ship offshore they hardly prove he landed there.

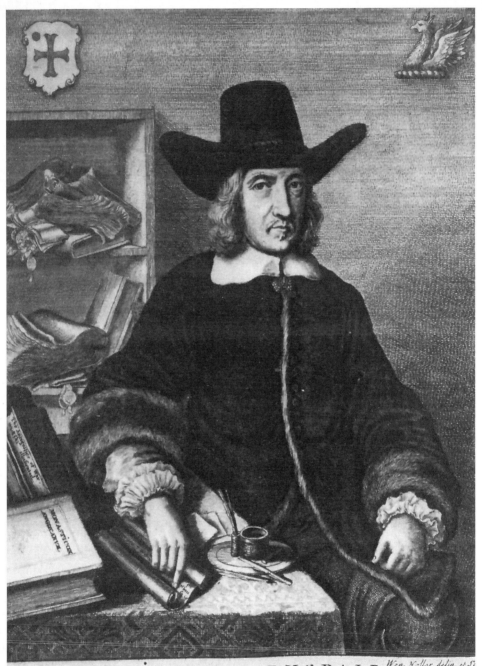

GULIELMUS DUGDALE Wen. Hollar delin. et S...
Ætatis. 50. A. MDCLVI.

There has been a persistent tradition on the isle of Jersey that he visited the place around 1650, as a secret agent for the future Charles II, who was then planning his abortive raid on England. But though it is true that the islands served as a staging post at that time for ships crossing the Channel, and so for Royalists in transit, the idea that the 'friendly, good-natured' and essentially unworldly Hollar was a credible spy is probably romantic fantasy. One Czech enthusiast even has him 'arrested for treason' when he lands in England, but this is based on a misreading of a later letter. Hollar's only known brush with the law was a much lower-profile affair.

It is true that Hollar's acquaintance with the royal family went back to Charles II's childhood, and that later, in the 1660s, he felt confident enough of his reception to approach his restored monarch personally for support in a great map-making project. The royalty and nobility of Stuart days had not yet retreated into those secluded palaces and closed circles that have characterised later generations of British aristocracy: society was much smaller and more heterogeneous than it later became, and a country squire, Oxford cleric or self-made merchant might be on familiar terms with the inhabitants of the rambling, open palace of Whitehall in a way that later became impossible.

Hollar, by virtue of his occupation, knew or had access to many people, who were happy to refer to him as 'the ingenious' (meaning 'clever, skilled') or 'indefatigable', or yet 'my very good friend' (John Evelyn) or 'my old friend' (Edward Walker). But it seems clear that once he had returned to England near the beginning of the 1650s Hollar did not much move in court or wealthy circles. There are no more pictures from him after this of ladies in the height of fashion. Instead, he was sought out by men such as William Dugdale, Elias Ashmole, John Evelyn and indeed John Aubrey, who were aware of the battering that venerable buildings had suffered over the last two or three generations and wished passionately to have them recorded before 'no stone was left upon stone'. These men were educated members of the upper classes; they obviously did respect and value Hollar, and no doubt were always careful to treat him as an equal on account of his Arundel connection and his prized family crest: Evelyn, in the long note he appended

many years afterwards to his briefer diary entry, is careful to categorise him as 'the son of a gentleman'. And yet, in the very protestations of friendship, some ambiguity remains, a hint of patronage in the modern sense of the word. One prospective client wrote to Dugdale:

> I shall not question the price, so it be well done. I know Mr Hollar is an excellent person and deserves all encouragement, nor shall I be wanting or unwilling to pay him liberally for his labour.

Both artist and artisan by temperament, Hollar hung socially between two worlds. It has been remarked that he was, by nature, no entrepreneur: he did not set up a publishing business of his own, but worked for other men, including dealers who were perhaps more astute in business than he was. Francis Place, who knew him only towards the end of his life, wrote that he:

> . . . had a method of working not common. he did all by the hour in which he was very exact for if any body came in that kep him from his business he always laid ye hour glass on one side, till they were gone. he always receivd 12d. [one shilling, a twentieth part of a pound] an hour.

These are the habits of an artisan, almost of a day-labourer. It would be astonishing to find the gifted, original and much-esteemed Hollar reduced to turning out plates on this basis. It is more likely that he used the hour glass in order to decide himself how much he should charge for the finished product. For it is clear that, for much of the time, when working on his own commissioned architectural studies, he was respectably remunerated as an artist, with an agreed fee rather than by the hour. Over the true state of his finances, as over his social status, a considerable question-mark remains. The story that he was chronically hard up – 'always indigent' – comes from Francis Place, who regarded him as having been exploited by dealers such as Peter Stent and John Ogilby, but such posthumous assertions are common in the annals of artists. Place and Vertue were keeping Hollar's memory alive in the fifty years after his death, when he had fallen into the trough of obscurity, so it was perhaps natural for them to regard him as having been

neglected in life too. Certainly the few Hollar-documents that have survived betray some preoccupation with money troubles, but then the same could be said of a great many people at that time – including John Aubrey. Large debts were almost the mark of a gentleman about town. Aubrey's own suggestion that it was because Hollar was 'shiftlesse as to the world' – i.e. that he lacked business acumen – that eventually he 'dyed not rich', may be nearer the truth.

He produced an enormous amount of work, year in, year out: that in itself should have secured him a comfortable living wage. 'He hath donne the most in that way,' said Aubrey, 'that any man did, insomuch that I have heard Mr John Evelyn RSS say that at sixpence a print his labour would come to £ . . . (*quaere* John Evelyn).' I do not know where Aubrey and Evelyn got sixpence (half a shilling) from, since this sounds more like a retailer's profit on prints. Hollar may, on occasion, have had a cut of such profits, but it is clear that essentially he was paid a set sum for each engraved plate. Aubrey mentions elsewhere £4 or £5 as being the usual price-range for fine work; the Dugdale correspondent who was prepared to pay Hollar 'liberally, for his labour' offered £5 for one. From Dugdale himself Hollar received £70 for about twenty-five plates, and £200 for a series of studies of old St Paul's that are among his most exquisite mature works. In the late 1660s he seems to have got £50, and then £100, from Charles II, on advance of works to be undertaken.

These sums were not, of course, very large by the standards of upper-class families running extensive households and keeping coach and horses, or yet those of the even wealthier international merchant class. They were, however, quite substantial sums by most ordinary people's standards, in a London where basic food purchases were counted in a few pence or in fractions of a penny and where labouring families lived on less than £20 a year. It is this huge range in costs that makes straight comparisons with the finances of our own world almost impossible. Samuel Pepys, who by the 1660s held an important job in the Navy Office and kept a comfortable house including several servants, found that £7 a month covered his household bills, though a fine new outfit for himself or his wife might cost two or three times that sum.

An ordinary tradesman or artisan might get £60 a year or more, as did a clergyman. One listing of the time (admittedly a provincial rather than a London one) puts 'Persons in Liberal Arts and Sciences' in the same category as clergy. Lawyers did rather better, depending on their sphere of operation. Meanwhile, a well-off artisan-trader with several apprentices, a class by then plentiful in London and its suburbs, would count his earnings at £200 or £300 a year. This was as much as might be received by a member of the gentry, such as John Aubrey, who did not work.

For most of his lifetime, Hollar probably averaged half as much again as the clergyman or 'person in liberal arts', but then he had his materials to buy.[1] The question is, did he and his family live the lifestyle of 'middling sort', content with a modest comfort? Or was his life, in spite of his incessant labour, complicated by aspirations to something more carelessly prodigal and generous, in the style of a gentleman?

The England to which the Hollars had returned by the end of 1652 was flourishing again economically, but in other respects it was not a comfortable place.

> I remember he told me that when he first came into England . . . that the people, both poore and rich, did look cheerfully, but at his returne he found the Countenances of the people all changed, melancholy, spightfull, as if bewitched.
>
> (Aubrey)

John Evelyn, returning from a discreet exile at the same period, had something of the same experience. He wrote back to a friend in France that the landlord at the inn in Rochester had been lacking in respect, sitting smoking at their table, and that small boys in the streets on the way into London had pelted their coach with mud and stones – 'You would imagine yourself among a legion of devills, and in the suburbs of Hell.' Later that same year, just after his young wife had returned from France to England, pregnant with their first child, Evelyn was set upon by footpads when riding alone from Kent to London. He was robbed, tied to a tree and narrowly

escaped having his throat cut. He later got most of his property back, thanks to powerful friends and the ineptitude of the robbers, who had pawned his rings for a trifle and kept the tickets. One of the men was taken, but Evelyn, 'not willing to hang the fellow', declined to give evidence.

> . . . In the End, upon some other crime he being obstinate & not pleading, was press'd to death . . . I was told he was a bloudy rascal, & had murdered severall of his Majesties Subjects being a souldier in Ireland.

Such an experience could have befallen a well-to-do traveller at any time in the seventeenth or eighteenth century, but it is also the case that the Civil Wars had destabilised society. Parliamentary rule was, in intention, repressive and moralistic, but in practice there was an increase in crime, drinking and social disorder. Youths who had enlisted on Cromwell's side, perhaps with some notion of a more equal society or simply in hope of a good fight, found themselves turned loose on their own resources. Many members of the old ruling class were indeed dead, gone abroad, at logger-heads with one another or eking out a reduced lifestyle in the countryside and, according to Evelyn, failing to educate their children properly.

London was in rather a mess, with many big houses shut up and their valuable contents left to deteriorate. Years later, Evelyn found the Arundel marbles that had been gathered 'with so much cost & Industrie . . . miserably neglected, & scattred up & downe about the Gardens & other places of Arundell-house'. Many of the conduits that had been installed in earlier centuries to bring water to London from the river, or from the hills around, had become blocked or holed, so that streets flooded and paving disintegrated. Another sign of the times was the proliferation of new warehouses, shops and small industries, invading gardens and yards and often the streets themselves, including the spaces of Whitehall, bringing dust and smoke along with them. Evelyn complained especially of 'Brewers, Dyers, Lime-burners, Salt and Sope-boylers', and of the pollution they brought to 'the Imperial seat of our incomparable Monarch'.

These developments might be ugly but they were a sign of London's increasing trade in the wake of Antwerp's decline. Many new wharves were

being established along the river, and taverns to go with them. At the same time London had, before the Wars, been developing briskly westwards with new houses both planned and unplanned. As it turned out, the Wars and the Commonwealth only created a temporary lull in this unstoppable urban growth.

Already, in James I's reign, Elizabethan regulations intended to curtail expansion were being ignored or circumvented. In Tudor times, the Strand had been a pleasant suburb, but by the 1630s fish-stalls and sheds were complained of there and also 'newly erected tenements'. The line of old, great houses on the south side with access to the river – Arundel, Somerset, Savoy, Salisbury, Durham – was effectively hemmed in by development on the land side. Further north, ribbon development arrived, and houses with back gardens, interspersed with inns for travellers, began to stretch up through Clerkenwell and also along Holborn, due west towards St Giles-in-the-Fields. Here too new buildings were going up in and around St Martin's Lane, an ancient cartway which ran down from St Giles to Charing Cross to meet the Strand at its west end. St Giles's Field itself (where the Seven Dials District would be laid out at the end of the century) was turning into a green island surrounded by built-up roadsides, market gardens and drying grounds – sure signs, in any city, of further buildings to come.

The first major planned development, in this whole district between the two cities of London and Westminster, had taken place in the 1630s. The Earl of Bedford, whose own Tudor house was on the north side of the Strand, got permission to lay out the forty-eight acres of one-time convent and gardens as far as Long Acre to the north, and stretching eventually from Drury Lane to St Martin's Lane east to west. When Hollar arrived in London near the end of the decade, this developing area of Covent Garden was the newly fashionable address with 'houses and buildings fitt for the habitacons of *Gentlemen* and men of ability'. The implication was that though these were row-houses, like those that lined the streets of old London, their appearance, appointments and spacious rooms gave them a superiority which put them in a new class. Water could be piped from a conduit to pumps in their back yards, a modern luxury in a world where it

was normally fetched from a street conduit-mouth or drawn from a well or cistern.

The stream-lined neatness of Covent Garden's high, brick houses, the prototype of so many later ones, may have owed something to the Dutch example, and the arcades round the piazza at street level seem to have been inspired by the recently constructed Place des Vosges (then Place Royale) in Paris. The basic concept, then new to London, of laying out houses round a spacious, formal Italianate piazza came from Inigo Jones. It was this mixture of influences that was to beget the classic square that later became London's hallmark. In Covent Garden, the urban architecture of the next two centuries was just beginning to take shape. Hollar's picture of it, which indeed shows people of quality going about their affairs, was probably made before he left London in 1644, since it does not show the tree which, with a rather English touch, was later planted in the centre of the piazza.[2]

The laying out of the boggy pasturelands of Lincoln's Inn Fields, south of Holborn, with a surround of Italianate houses, was also a Jones-inspired scheme. That too was under way, though more slowly, by the late 1630s. Another of Hollar's views made before he left London appropriately shows

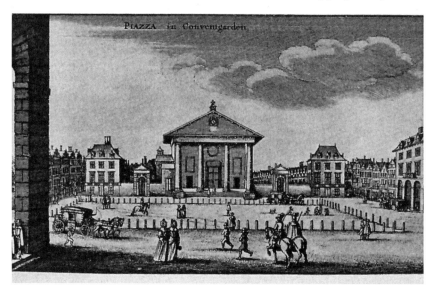

troops drilling on the wide open space, but a certain woodenness and over-uniformity about the houses create, exceptionally, an unreal impression. Indeed, the finished houses did not eventually take that form. It has been suggested that Hollar, encouraged by Arundel who had been concerned with the development of the Fields from the beginning, drew the picture as part of a prospectus advertising the future delights of the proposed square.

Hollar had a long relationship with this particular segment of London; it was the one on which he chose to make a start for a great projected map of the entire city. It is my belief that on his return to London, in the early 1650s, he lived for some years in a house on Holborn near the north-west corner of Lincoln's Inn Fields (see map, page 145).

When a new building boom got under way after the Restoration in 1660, further elegant squares with adjacent streets were laid out – Leicester Square, St James's Square, and also Bedford Square, which was the start of the great Bloomsbury expansion. Leicester House itself had already been built about 1632, but local working people had continued to use Leicester Field in front of it for pasture and for laying washing out to dry; they protested, unsuccessfully, when the land was transformed into the gardens of the developing square. There were several other large houses scattered in the still-rural Piccadilly and St James's Palace area, including Tart Hall on the far side of St James's Park, and Piccadilly House itself (built by a *nouveau riche* tailor) near the site of the present Great Windmill Street. Of this property, Lord Clarendon wrote that just before the Civil War it was:

> a fair house for entertainment and gaming, with handsome gravel walks with Shade, and where were an upper and lower bowling-green whither very many of the nobility and gentry of the best quality resorted both for exercise and conversation.

Exercise and conversation in pleasant surroundings tend to lead to assignations for less innocent activities. A century after its building, Covent Garden, though still a good address, had become notorious for its bath-houses and 'stews'. As for the Piccadilly–St James's area, soon after the Restoration it became the most fashionable district of London, with earls

and dukes buying houses in the new St James's Square, yet the contest between exclusive grandeur and various forms of disreputable fun was still present. St James's Park, which had been redesigned and much embellished, was a favourite royal walking place. By night, it became notorious for illicit meetings, a convenient hideout, according to the rake and poet Lord Rochester, for all kinds of sexual activity.

We know something about Hollar's work in the years after he reappeared in London. We know that although he had the important Dugdale commissions, and later ones from Ashmole, he continued for a dozen years after his return to make prints for Peter Stent. He also worked for a new publisher called John Ogilby, an energetic and far-sighted man from a well-bred but impoverished Scots family. In the melting pot of the Restoration, Ogilby worked as a dancing master for a few years before becoming an entrepreneur in the book business, one of the first of his kind.

But what of personal events and of the texture of Hollar's daily life? What of his wife and children, and where did they live?

A few, a very few pieces of paper do provide some clues, although the picture remains conjectural. The registers of the church of St Giles-in-the-Fields harbour a little key information; it would appear that when he came back from Antwerp, Hollar had an association with that parish for a number of year. Francis Place claimed that in the mid-1660s, at the time of the Plague of London, Hollar was living 'in Blumsbury', which would fit, since the parish of St Giles was then a large one, extending all along Holborn from what had earlier been the edge of London and covering a substantial area to the north of it.

The church is today an oasis surrounded by roads, pubs, theatres, cafés, eighteenth-century Seven Dials, nineteenth-century New Oxford Street and the mid-twentieth-century Centrepoint skyscraper, but the site is a very old one; there was a medieval religious house and leper hospital on this ground. The church became a staging point for condemned prisoners on their way from Newgate gaol to Tyburn (present-day Marble Arch), and continued as a parish church after the hospital was closed at the Reformation. In 1623,

when the district was becoming a sought-after suburb away from the noise and smells of the narrow City streets, the church was handsomely rebuilt. As the century went by, and the parish became so heavily populated and so built up that it was effectively part of the new, greater London, the number of dead in the land around the church and under its floor increased enormously too. Eventually the whole structure was undermined by this constant digging and by deposits of decaying Londoners. In the early eighteenth century it was pulled down once again to construct the graceful Flitcroft building with a spire that is there to this day.

It is the intermediate church, which stood for less than a hundred years, that Hollar would have known. By a happy chance St Giles, almost unique among the London churches, has retained possession of its own baptism, marriage and burial registers, many of which long pre-date the present building. So you can, by permission, sit in the Vestry, which was built only a generation after Hollar's death, and turn the tough parchment pages of leather-bound books from the oldest church, which was there long before he was born. In the wood-panelled quiet a clock ticks, the fire witters in an old grate, and beyond the twelve-paned windows the grass stretches across the mainly invisible graves of the forgotten but recorded dead. Many of them also lie further off, under the side streets and alleys of Charing Cross Road, for the original graveyard was much bigger than the present railed garden. Somewhere out there, underneath modern London, is the dust of perhaps 200,000 people. Among them is Margaret Tracy – 'Margaret, wife of Wencislaus Hollar'. The faded ink date is given as 10th March 1653, but the registers at the time were kept in the old style, with the year ending at Ladyday, 25th March, so we would say she died in the spring of 1654.

The early death of a wife was common then, as in all the eras before our own. Hollar himself had lost his mother when he was half the age his son James was at Margaret's death. But nothing indicates to us that either fathers or children suffered less from such a bereavement than we would today, or that they did not find themselves confronted by similar practical problems. Hollar was left with (at least) two children still of an age to require maternal care. He had no family in England to step into the breach. Yet the plates he

made for Dugdale in the 1650s indicate that he frequently travelled to distant parts of England – to Warwickshire, Yorkshire, Lincolnshire and the West Country. Just how he managed to combine this activity with parental responsibility seems a question worth asking.

It is not, however, one to which those who have studied Hollar as an artist have addressed themselves; on the contrary, the few gleanings and suggestions that have been produced regarding these years in London all incline to show Hollar as a lone figure.[3] George Vertue, who never knew him personally and got most of his information from Francis Place, claims that in 1654 Hollar 'lived in the house with Mr Faithorne, Engraver, near Temple-Bar'. The date is precise in the margin of his note, so this statement probably has a basis in truth. William Faithorne was the young print and map-maker who *was* in the Royalist garrison of Basing House, and was imprisoned during the last years of the Civil War. Elsewhere in his Notebooks Vertue writes that Faithorne, who had been banished after he was let out of prison and had gone to France, returned in the early 1650s and by that time had a wife and three children.

> Faithorne's wife was Sister to the famous Captain Ground. So he lived next ye Sign of the Drake against the Palgraves head without Temple Barr. In this house he continued several Years, where he sold prints not only of his own doing, but had great store of Italian, French and Dutch prints which he dealt in. Here also Hollar lived some time & did many Plates.'

So here we have a fellow print-maker in similar circumstances who, unlike Hollar himself, was attracted to an entrepreneurial role. Temple Bar was then an actual wooden barrier with a gate in it, marking the limit of the City going towards Westminster. It stood a hundred yards or so east of St Clement Danes church – familiar territory to Hollar. Many of the wooden houses of old London were occupied by several families on different floors: did the whole Hollar family lodge there along with the Faithornes when they came back at about the same time from Antwerp? But no, apparently not, because Margaret Hollar died as a parishioner of St Giles-in-the-Fields, not of St Clement Danes. Might Hollar and the children have come to

lodge with their friends after her death, as a solution to Hollar's domestic problems? That is possible, and it is tempting to believe it, but, if so, they must have moved again a year or two later, because when Hollar got into trouble with the Commonwealth authorities for attendance at a foreign, Catholic chapel in January 1656 he was cited as a parishioner of St Bride's. St Bride's is not far down Fleet Street from a point just 'without Temple Bar', but it is *within* Temple Bar and therefore within the City of London and in a different parish. It was the friend who stood bail for Hollar, a tailor, who was stated to be of St Clement Danes and therefore of Middlesex. Being a parishioner was then not a matter of choice but of precise geographical location. In a world with no watches and few clocks, church chimes ordered the hours, but far more importantly the churches themselves ordered men's daily lives. Almost all aspects of London life, including public nuisances, scandals and sexual immorality, were governed by separate parish groups, each with their own officials and each with powerful church wardens in charge.

Six months after his trouble at the foreign chapel, Hollar married again, on 3rd July 1656, in St Giles-in-the-Fields, where Margaret had been buried something over two years before: it was a sequence quite usual for the times. His new bride, Honora Roberts, must herself have been a parishioner there, even if he had not been one in the intervening period. He figures on this occasion as 'Wenceslaus Hollar gent.' The register gives her name as 'Honor', though in a document she signed many years later there is an 'a' on the end. We do not know when she was born, but such a name hardly suggests a Roman Catholic family and *might* indicate Puritan leanings. The wedding service would have been the low Anglican one, heavily influenced by Presbyterianism, which was all that was authorised under the Commonwealth.

We know nothing to indicate if Honora shared her husband's taste for Catholicism – or anything else about her for that matter, except that they had 'severall children' together (Francis Place mentions there were two daughters) and that she survived Hollar. Even more than her predecessor, she remains one of those fugitive names for whom speculation or imaginative construction must fill the shadowy outline.

The new couple made their home in St Giles's parish, for another of those fleeting indications of Hollar's whereabouts occurs that same year or the following one in a note William Dugdale wrote to one of his contacts:

> Mr Hollar, who is to receive the 5 L. for the Lord Darcye's Plate, lodgeth the next House to a Chirugeon in Holburne, opposite the upper end of Gifford's buildings.

Hollar's modern cataloguer situates Gifford's buildings (built 1631) on the north side of Holborn but does not take the matter further. However, the *Survey of London* volume for the parish of St Giles contains material of 1609 relating to:

> one messuage . . . with appurtenances in the tenure of Thomas Green, and one cottage with appurtenances with garden, in the tenure of Thomas Roberts, situated in the parish of St Giles in the Fields.

A surveyors' sketch map makes it clear that these were on the south side of Holborn, just opposite, indeed, where Gifford's buildings would later come. That area, about halfway along Holborn, was mainly unbuilt in the first decade of the century; St Giles was still genuinely 'in the fields' and the population of the parish cannot have been more than a fraction of what it would become over the next forty-five years. This makes the appearance of the surname Roberts, in the very place where Honora and Wenceslaus were later to live, significant. It suggests that Hollar may have married into the ranks of a well-established local family.

Could it be that on his return from Antwerp, with his children and his perhaps already ailing wife, Hollar settled everyone in lodgings in the Roberts' house? The 'cottage' mentioned in 1609 had evidently had upper storeys added by the mid-century, a common practice in those days, for it was now part of a run of buildings along that part of Holborn. These houses, some still with long back gardens, others with their gardens partly built-over, appear clearly on the unique sheet of a never-completed bird's-eye map that Hollar planned some years after coming back to London. They are also, by a further happy chance, described fully in a survey made

in 1650 when, in the aftermath of the Civil War, the title to many parcels of land was in dispute. By this date the run contained no less than three inns, one with extensive stabling and another with a bowling alley. Two adjoined houses near the western end seem to be the most likely candidates for Hollar's future abode and that of his neighbour, the 'chirugeon'.[4]

Houses of just this kind, high, narrow, but often with extensive rear additions, timber-framed, with projecting upper storeys and dormers, lined the London streets at the time. An idea of what they looked like can be got from the surviving ones that form Staple Inn, on the same side of Holborn further east, where the road begins to descend into the valley of the buried Fleet. Tall, but a little stooped and bowed, their timbers picked out in the black gloss favoured by preservationists in the early twentieth century, they confront, with gnarled unconcern, the variations of Gothic terracotta, glass and concrete that now surround them.

As for Hollar's house and the others alongside it, they were probably replaced in the end by others in Georgian or Victorian brick. These in turn were swept away by the construction of Kingsway in 1905. If the ghosts of dormers, vegetable and flower gardens, bowling alley, stables and inn yards are still there, they are deep in the gulf created by the building of Holborn tube station.

It is possible that Hollar's earlier arrangement with Faithorne was simply to provide himself with a studio to work in during the day, away from the distractions of family life. This would explain Margaret Hollar's death that same year taking place in St Giles's parish, not in Clement Danes. Perhaps the later St Bride's location, too, was essentially a workshop. Was the family always based, rather, in Holborn, and was it therefore the Roberts family, including Honora, who took charge of the motherless children while Hollar worked and travelled frenetically to keep everything going? Maybe this was the practical foundation of his second marriage. It may also be that, in the early years of this marriage, he regarded it as a purely domestic arrangement to be kept separate from his working life.

A certain weight is given to this speculation by the fact that, when

another address crops up, in one of just two letters from Hollar to John Aubrey that have survived, it sounds as if he was once again making use of studio space somewhere away from the family home. Hollar knew Aubrey, through Dugdale or through his earlier Arundel connections, by the beginning of 1656; the letter in question is undated,[5] but was probably written in the late 1650s or early 1660s. Hollar was apparently near Arundel House again, but it is not the same address as Faithorne's and the directions given are not those you would be likely to give to someone calling on your family:

> Sir. I have been told this morning that you are in Town, and that you desire to speak with mee, So I did presently repair to your Lodging, but they told mee that you went out at 6 a clock that morning, & it was past 7 then, If I could known Certaine time when to finde you I would waite on you. My selve does lodge without St Clemens Inne back doore as soon as you come up the Steps & out of that doore, is the first house & doore, on your left hand, two paire of Stayres into a little passage right before you, but that I am much abroad & yet enough at home too,
> Your most humble Servant W. Hollar.
>
> If you had occasion to ask for mee of the people of the house, then you must say the Frenchman Limmner for they know not my name perfectly, for reasons sake otherwise you may go up directly.

Hollar's hideout appears to have been just off St Clement's Lane. The Inn has disappeared, but a truncated piece of the lane survives today between Portugal Street and the Aldwych, where the London School of Economics rears up. From there, Hollar could have walked across Lincoln's Inn Fields to the Holborn house in a matter of minutes.

Maybe the 'people of the house' were just ignorant and regarded all foreigners as French, but it has been suggested that Hollar was not in fact anxious to be identified. If this missive dates from before the Restoration in 1660, it is possible that he was still being harassed over his religious practices. Or was he hiding from creditors? Evidently he expected Aubrey, who was much pursued for debt himself, to know what the 'reasons sake' was. Nothing very lurid or scandalous can have been going on in his life, or

the pertinacious Aubrey, who outlived Hollar by twenty years, would have mentioned the fact.

Is this simply another instance of Hollar, that 'very honest good, simple man' (Evelyn's words) with a passion for visual accuracy, telling one thing to one person and a rather different story to another? There seems something more complicated there, and possibly perverse, than the patrician Evelyn cared to notice. Social insecurity? A disorganised desire to set everyone at ease and respond to their expectations? An ingrained habit, carried over perhaps from family tensions in childhood, of keeping different relationships separate from one another? Or a taste *per se* for drama and secrecy, for hiding away from prosaic demands – as if somewhere, in some other place or land or identity, a true refuge might be found?

Chapter VIII

Gardens, and Other Rarities

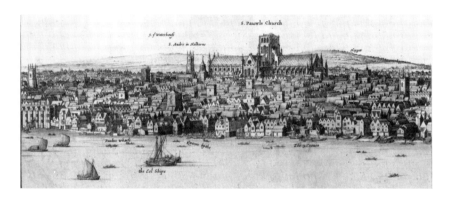

The only other extant letter in Hollar's diminutive handwriting, which remains artistically neat even when he is dashing off a note in a hurry, is undated and unaddressed but was probably written to William Dugdale:

Sir. I having had Expected you heere at 6 of the Cloke; according to your owne appointment, (for you sayd that you must goe first to Sir Wingfield Bodenham) I was Carefull to bee heere, for I did much Longe to speake with you about an Expected Urgend Occasion, haue also appointed Mr Aubry, (who would also first speake with you) towards that Houre, therefore hauing made haste homewards, I came a halve an hour after five, and was told that you were heere and gone, which troubled me verry much, Now my business is this, that whereas (as you may remember) I was taken by Souldiers, Coming from a Chapell, and carried to Hixes hall. There to be bound at Sessions, haue afterwards troubled Mr Bishe, to sollicite for mee, not to appeare there, who brought mee Word from Mr Greene, that

I was released upon that I did not appeare, but now hee that was bound for mee, is arrested Body and goods, or else to pay 10lb and hath already payeth 29 Shillings to the Baylives, to for beare him Longer, for they came with a Cart before his house, at which dooing I much marwell as well that I was soo deceiued, beeing told that I was released my Name being Still in the Book, and Henry Gray my Friends, who was bound for mee, which beeing found there, it serueth to trouble us, as also that a Stranger should be soo abused, who is otherwise free, in that behalve, for I have spoken with others that were taken with mee, and esdcaped at that time with a matter of 3 Shillings a peece, who haue better purses than I. Therefor Sir I pray you to Consult with Mr Bishe speedily, what may bee doone to make sure & finall end of it, for although for the present, the Baylifes have taken their bribe, to say that they cannot finde us, yet that doeth not Crosse out our names out of the Booke, which may trouble us a nother time a non, So hoping my request shall bee fulfilled. I remaine your humble Servant W. Hollar This Sunday at 6 Cloke.

Hixes (Hick's) hall is the Quarter Sessions Court, built earlier in the century in St John's Street, Clerkenwell, by a well-to-do silk merchant and Justice of the Peace who felt that magistrates ought to have somewhere more imposing to sit than the customary room over an inn. Sure enough, in the Middlesex County Records for 6th January 1655 (1656, that is, in our terms), the Feast of the Epiphany, we find Hollar, along with Henry Gray, a 'Middlesex taylor', called to answer:

> for being present at the hearinge of a masse at the lodgeings of the Venitian Ambassadour situate in Charterhouse Yard . . . at the time of the elevation of the host and other ceremonies then and there used.

Sir Wingfield Bodenham and Edward Bysshe were both lawyers; Bysshe, too, was to receive a knighthood from Charles II soon after the Restoration. He was a barrister at Lincoln's Inn and was married to the daughter of a John Green, Sergeant at Arms, who is presumably the 'Mr Greene' mentioned. So it seems that, through Dugdale, Hollar was provided with

enough sympathetic and influential contacts to escape from this scrape. However, one senses his fear and distress that he, as a foreigner, might be receiving more unfavourable treatment than the others who were caught along with him, and also his frantic concern that there had been a misunderstanding and that messages had gone awry. Apparently Henry Gray was a kind neighbour who stood surety for him, and then was arrested in turn for his good deed. This tale of corrupt bailiffs, being paid on all sides to hold off but giving no guarantees that they would not soon be back again, has the ring of absolute truth in the London of the Commonwealth. The restrictions that Puritan interests attempted to enforce, in their aim of building a utopia, gave many opportunities to the 'melancholy, spightfull' people that Hollar noted on his return to London.

I told him 'twas a foolish thing to attend a Papist Mass in that ambassador's chapel. I knew he saw there men he had met at Arundel House with whom he liked to renew acquaintance — but, as I said to him at the time, these people are foreigners under the ambassador's protection: 'tis a different case for such as thee who are settled to earn their bread here in London. And him such a gentle, peace-loving man at heart, never one to seek trouble. 'This must stop,' quoth I, 'or I'll not marry you.' In truth, I did not mean it, for I loved him dearly, but my father was annoyed by this business, more especially as Wensel hid every time one knocked at the door, and I admit I was put out by it myself.

I do believe he learnt his lesson, for after that there was no more talk of the Mass, and the next summer we were wed like ordinary folk in our parish church. But for the longest while after that to-do with the bailiffs he was anxious that they might discover his real place of abode to be here in Holborn, not in Fleet Street at all, and even when he removed his workshop to next St Clement's Inn he still had a care that strangers should not know how to find him nor the people of the house know well his name.

For sure, it was like that for all under Cromwell, and under his son Tumbledown Dick: you never knew who might be watching you and telling on you for a little bit of merrymaking or for nothing at all but leading a decent life according to the old ways. No one was secure, whatever their station; Mr Evelyn himself, I believe, was taken in church one Christmastide and had to pay a price. All that ended, God be thanked, when King Charles was restored to his rightful throne that merry day in May and men breathed easy again. But not Wensel.

Somehow, I know not how, his fear of being found has continued. Now he says it is because he does not want to be bothered with shop-keepers' bills he is not yet ready to pay, and 'tis true we seem ever to have more debts than money put by — but then so do many in this city of London.

Nay, I have come to believe that Wensel is ever-anxious not to be easy discovered for some reason within himself, born of himself — or perchance of some dire mishap in youth, in the wars in Germany — and even now he cannot say what. As a tree bends to the storm, so will it grow.

Father said it was a shame and a folly, acting as a schoolboy afeared to be whipped. Father is much of an age with Wensel, perhaps but three or four years more. He did not want me to marry him, though he has now grown used to him and sees how hard he works and how that exacting labour tells on him. In truth, I think that Father did not want me to marry at all, but wished to keep me at the house to tend him in his declining years. But, say I, I can look after two men as well as one, and did Father think in truth that I, a woman of nigh thirty, whose betrothed of many years is dead, was going to be taken to the altar by some young gallant? Wensel is not quite twenty years older than I and he is strong and healthy yet. We suit each other, and 'tis not every couple in London town who can say that.

My betrothed was a Parliamentarian, a friend from schooldays of my brother John, he who keeps the stationers now in Drury Lane. He and John were both hot at that time for the Parliamentary cause; they joined the trained bands. My Jack lived through the Wars while I waited for him, but he was wounded and his health was undone and he afterwards died from a fever. For all that we were very close some whiles, he was a God-fearing man and we were never together as man and wife. Now, I think his young life was spent without profit, for who now, in these different times, gives a thought to the high ideas of those who would found a Commonwealth, except to say Good riddance?

My father and brothers think Wensel a foreigner, easily moved to laughter or distress, who makes a great to-do of any trial, and so he is — but they do not see what deeper things he confronts and keeps within his heart with courage and will not even speak them. I saw this when Margaret was beginning her journey to her long home, and the way too was long for her, poor lady. It was in the late summer of the year before, when they had but recently come to lodge with us, Mr and Mrs Faithorne having not space enough for all in their house by Temple Bar. My brothers John and Samuel both being settled with their wives, elsewhere in the parish, there was room and to spare in our house and they came with William Faithorne's recommendation.

'Twas a Sunday, some two weeks before Michaelmas as I recall it, fine, golden, harvest weather, with the leaves just beginning to turn. Wensel wished to go to Hampstead to see the Hollow Tree there, a wonder with a turning staircase of forty-two steps within: he had the idea to sell a print of it, which he soon afterwards did. He purposed to take Margaret and Meg and Jamie with him for some country air. Margaret being with child again, he had agreed with our good surgeon-neighbour that his man take them up the hills, the surgeon having no need of his horses that day. But when all was readied and the little coach before the door, she of a sudden laid down on the bed and begged his pardon, saying she could not go. And in truth she looked whey-faced, like one starving. So, as the servant girl was by to 'tend her, I said I would go in her stead and bring with me the two little ones of my brother Sam, whom I was minding for the day: 'twould be an outing for all of us, I said, and so it was.

The little ones enjoyed riding in the coach, which they never did before, and so did Jamie. Meg was quiet, and I had a care to let her be and treat her as a young lady, for she was of an age not to want me by. I could tell she was anxious for her mother, and perhaps might feel it too that I, so to speak, would be taking her mother's place — tho' that was then not at all in my mind. I was just happy, seeing the reapers in the meadows round St Pancras cutting the last hay of the year, and the stubble fields shining in the sun. We stopped to drink milk at a farm near the Mother Redcap, and then went up and up the steepest hill, with Wensel and I on foot now and only the children riding, since else the slope and the great ruts in the mud would be too much, said the man, for the horses. By and by we saw all London spread out below, with St Paul's at its heart, and not obscured so much by the smoke of great chimneys, it being the Lord's Day. 'Twas Wensel, the foreigner, who pointed out to me each steeple and great house and named them, and I, the Londoner, who listened to him.

And at last we came to the tree, which lies not far from the right-hand side of the way, near to where the little town of Hampstead begins, and it is indeed a marvel, a work of both nature and man. The children ran up and down the stairs inside, coming out on to the turret built at the top and talking of setting up house there; even Meg became quite gay. And Wensel laughed and joked with them and said how happy we should all be, there among the leaves in a safe castle, and how Meg should be the lady of the castle and the boys mount guard. A gingerbread seller came by, and he bought us some little cakes, and by and by he got out his paper and a lead pencil and set to work. (It was the first time I ever observed him closely at work: his drawing and shading of the foliage was very fine, and the print he made from it is a beautiful thing.) Yet all the time, in despite of my own happiness, it was in my mind that

The Bottom aboue ground in Compaſs is —— 28.foote | B·The Height to the Turret is —— 33.foote | Six may Sitt on., and round about roome
The Breadth of the doore is —— 2.foote | 11·The Lights into the Tree is —— ·16 | for foureteene more——
The Compaſs of the Turret on the Top is —— 34.foote | 18·The Stepps to goe vp is —— 42 | All the way you goe vp within
The Doore in Haight to goe in is 6.foot· 2.Inches | 19·The Seat aboue the Stepps, | the Hollow Tree——

there were other thoughts constantly with him that he did not avow. Something dark lay at the back of his eyes. He was anxious about Margaret at home, half-foreseeing, I think now, all that was to come.

She died the next spring. The babe she was carrying, with much pain and sickness, would not come, and at the last she was taken with strange fits. Wensel wanted to call upon his friend Dr Harvey, a most skilled physician, but he was old by then, and sick with the gout, and could not come. Then the midwife said that the child was surely dead within, so we called our neighbour, the surgeon, but by then a high fever was already upon her and there was naught he could do.

I had been so anxious for her, and had cared for her to the best of my ability, as if she had been an elder sister to me, and she so grateful, that when she went I truly mourned her. The summer that followed was a drought summer, desperate hot, with water lacking in the

conduits and the water carriers raising their prices eightfold, to twopence a tankard. Oft-times I caught myself thinking of Margaret and how much more she would have suffered, and feeling glad for her that she was now far away, in a better place well above that hot, blue sky.

After that, Wensel and I took our time, not to put any one out of humour. We were old enough, God knows, to be reasonable people, and so it was more than two years afore we wed. Tho' I will admit that Wensel's passionate nature, and my own weakness for him, had made us man and wife in the sight of God afore we stood before the altar in St Giles. William Faithorne and my brother John stood witness, and Meg was my bridesmaid. She had turned fourteen then, the prettiest thing imaginable, and through the good offices of Mr Aubrey, who knows all the world, she went afterwards as maid-in-waiting to my Lady L———, who had known her mother and had taken a fondness to her.[1] So my anxieties on her score were appeased.

With Jamie, I had no such doubts. A lad is different, and this lad had lost his mother and was glad to accept such mothering as I could offer. I believe I had understood by then, what has become still more clear to me as the years have passed, how much Wensel had suffered from the loss of his own mother (another Margaret) in Bohemia, when he was but six years old. He told me once, as we lay abed, and there were tears in his voice, this man of fifty years, that it had grieved him terrible as he grew up that he could no longer truly recall the sound of her voice or the lineaments of her face, and it grieved him still. I believe that his father's second wife, of whom he would not much speak to me, was unkind to Wensel and favoured her own child (as so often is the case) and that his father was wont to take her part. I have come to think that this was the true reason, much more than the family's difficulties in those troubled times or yet the father's firm desire that his son should become a lawyer, that made Wensel forsake his home and his people and become a wanderer for so many years.

I know that he does still have love in his heart, for all he does not speak of it, for the city where he was raised. I have seen drawings of it, that he has kept all these years through many changes of abode. I bethink me how it would grieve me if I should never more know London town. Once, on waking, he said in bewilderment, as if not fully roused from a dream, 'I came from St Clement's to the river . . . And I found I was nigh to the Charles Bridge' — only he said not 'Charles Bridge', which he told me afterwards, but another name in his mother's tongue. And when the Queen of Bohemia, she who was turned off her throne, poor soul, at the last came back here to make an end where she was bred, Wensel was much moved.

John Evelyn's Diary, 17th February 1662:

> This night was buried in Westminster the Queene of Bohemia (after all her sorrows & afflictions being come to die in her Nephews armes the King) & this night, & the next day fell such a storme of Haile, Thunder & lightning, as never was seene the like in any mans memorie; especialy the tempest of Wind; being South-west, which subverted besides huge trees, many houses, innumerable Chimnies, among other that of my parlor at Says Court, & made such havoc at land & sea, as severall perished on both . . .

It was in the two years immediately after his second marriage that Hollar drew and etched for Dugdale his series on St Paul's old cathedral. Unlike his London pictures, and unlike many of the interior scenes of churches then being painted in Holland, these are not peopled with men, women and dogs: they are minutely observed architectural studies. The prints, which combine exquisite detail of the stonework with the nuances of light, darkness and depth, show Hollar at the peak of his artistic achievement. The perspective views of the inside of the great building are particularly fine, and so is the shadowed vaulting of St Faith's, the extra parish church that was established in the medieval crypt. These works of art must have been done under pressure, for Hollar was engaged on other commissions for Dugdale at the same time, for his *Antiquities of Warwickshire*, and also on maps for his history of reclamation work in the Fens. He had more work in hand too, including some run-of-the-mill print-making for the volumes of *Virgil* that the enterprising Mr Ogilby was producing, numerous commissions for coats of arms, and – when he could find the time – two portraits of the Tradescants, father and son, for Elias Ashmole's catalogue of their Museum in Lambeth.

Nevertheless, the first edition of the St Paul's series was published in 1658. Dugdale used the method, common at that time, of getting well-to-do acquaintances to subsidise his publications by paying for specific plates, which were then dedicated to the individual concerned. Too long an interval between donation and publication and sponsors became restive. Or

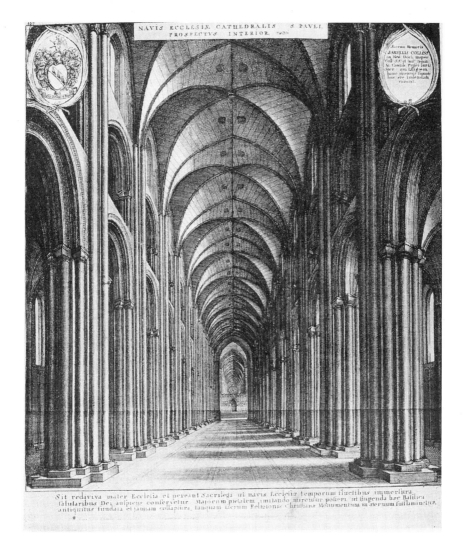

they might die or disgrace themselves in some way, or lose their fortune, and then the dedication on the plate would have to be recut.

Much of the intention behind the pictures of St Paul's was to show it from all angles, complete with its most prominent monuments, before some disaster befell. The fabric of the great church was known to be in a poor state: the wooden steeple had been struck by lightning and

collapsed in flames in the previous century – though one of Hollar's plates shows it *with* a spire, as there was a plan under discussion for its rebuilding. (That plate was for the gentleman who 'would pay liberally for his labour' since Mr Hollar was 'an excellent person and deserves all encouragement'.)

Embellishments to the whole building had been made under Charles I by Inigo Jones (who else?), but these, as Hollar's pictures show, were more cosmetic than structural, clothing the Gothic detail in an Italianate dress of pilasters and putti. During the Civil War, the lady chapel at the east end had been partitioned off as a 'preaching hall' and the rest of the church used a billet for Cromwell's trained bands and their horses. This cannot have helped the building's state of repair, but already, under James and Charles I, the nave had been more a place of fashionable promenade, complete with shopping stalls, than a place of worship. The greater part of the damage had probably been done by the many decades of neglect that preceded the Civil War. Dugdale also took the view, as did John Evelyn, that London's increasing smokiness, from the burning of the brownish coal that was brought by sea from Newcastle, was bad for St Paul's, and for London stonework in general.

As religious debate in England subsided, and the Commonwealth drew towards its low-key, ignominious end under Cromwell's son, concerned men were able to focus their own and other people's attention on churches as venerable buildings, rather than as what they might represent in men's furious hearts. Below his main view of the nave (which appears in idealised stone bareness, without any of the commerce cluttering the side aisles) Hollar engraved the following message: *'Wenceslaus Hollar, Bohemus, hujus Ecclesiae (quotidie casum expectantis) delineator et olim admirator memoriam sic preseruauit. Ao. 1658'* – 'Wenceslaus Hollar of Bohemia, daily expecting the collapse of this church, of which he is the drawer and long-term admirer, thus preserves its memory.'

Neither Hollar nor Dugdale, however, nor their sponsors, could have foreseen the historic value that would accrue to this series of pictures only a few years later, after the Great Fire. In Aubrey's words: 'Of that

128

stupendous fabric of St Paul's cathedral, not a stone [is] left on stone, and lives now only in Mr Hollar's etchings.'

Jamie took much interest in his father's works on the cathedral. He himself was put to school in St Paul's churchyard, so he knew every corner of the place as young boys will. There were tales among the boys that the tower would fall one day because its corner stones were so corrupted with horse-piss, and that Dr John Donne would rise out of his tomb in his grave clothes (for so the tomb represents him) and damn the present generation — and I don't know what else. Jamie was but an indifferent scholar, but his love of limning and drawing was, like Wensel's, true, and he was eager only to become his father's apprentice.

'Let the boy leave his studies,' said my father, 'and join ye next to Clement's Inn. Of what good will Latin and Greek be to him?' Father had no Latin nor Greek, having made his way in the paper and quill business by his own quick mind. He never understood how it imported to Wensel, with his memories of his own upbringing and of other times, that his son should be raised a gentleman, with other gentlemen's sons. Indeed, at moments I was afeared that my Wensel, my kind and gentle husband, might commit the selfsame error as his own father before him, and try to force Jamie into a way he would not wish to go. Jamie left little drawings and carvings everywhere, as if they were droppings and he a fearless mouse — on the bedposts, on the inside legs of the chairs (but that was before we got the new ones, covered all in studded leather), on any scrap of paper he could obtain, and on the walls of the jakes in the garden — which luckily made my father merry, as otherwise there would have been trouble. Wensel at times became irate, that he saw not in his son the love of hard work that is his own. But when Jamie was suffered to enter the workshop, then he put japes and idleness aside and worked with a will.

His son . . . an ingeniose youth, drew delicately.

<div align="right">(Aubrey)</div>

. . . a hopeful son, about seventeen . . .

<div align="right">(George Vertue)</div>

. . . had a son which was very promising in his way.

<div align="right">(Francis Place)</div>

There is a Hollar engraving of a very young man, with a thick head of hair, a scant moustache and a knowing, amused look, which was confidently stated by a twentieth-century Czech collector to be Hollar's son. However, there seems no supporting evidence for this, and the portrait almost certainly dates from the early days on the Continent, years before James's birth. I think it is Hollar himself.

It would be wonderful to find, lost in some archive, a small drawing or etching signed 'J. Hollar'. But the only time I have come across such a name it was appended to an obviously eighteenth-century work, probably of Dutch origin.

In the first years of our marriage I believe I was in company with Jamie more often than with his father, for Wensel continued in his extreme busyness and oft-times was travelling the country with Mr Dugdale or Mr Ashmole or another. It was only right he should do this, for he earnt a living for all of us — tho' I believe he would have done it anyway, for he has always relished his work and feels happiest when his labour is demanded on all sides. Also, he needed to be out in the world meeting persons of quality, and maintaining his bonds of friendship with them for his work's sake. He could not, after all, meet such at my father's table.

This troubled me somewhat. It hath always done so. With me, tho' I believe we are happier than very many couples are, he had had to provide for a young family once more at his advancing age — for my own little wenches at last were born, and lived, to my great joy. But it is not only that matter. It is in my mind and heart that, in truth, for his own advancement, he should have married a richer wife the second time. Someone of gentler birth, with a family of weight behind her, who could go out readily in society with him.

I would not like for you to think we were a family of no consequence. We come of good Hertfordshire and Bedfordshire stock, and have cousins[2] there yet. My grandfather Thomas came here to Holborn nigh to London at the time of King James, in the market gardening business, and prospered. We count it a pity, now, that he did not buy more land in the parish then while it was to be had cheap; I've heard tell that Drury Lane in those years was a country way with cow-liers and pastures. Grandfather did not foresee that it would become as close-packed with houses and side alleys as any City parish.

My father Edward set up in the stationery business and prospered also, what with the new learning and books and papers much in demand. 'Twas he who caused the upper storeys

to be added to our house, and also built the workshop in Drury Lane. John has this manufactory and shop now, with several apprentices under him, and is of late made a freeman of the Stationers' Company in the City. Samuel has begun to trade in silks and ribbons, for he has formed an association with another cousin of ours, remet through a happy encounter — Gabriel Roberts, a merchant of the Levant Company, established in the City. These kinsmen are much richer than we, and have a fine house and garden in Hackney,[3] but they are good, open-hearted people and our association with them is a happy one.

Gabriel has now a young man of the Verney family with him learning of the trade with Smyrna and Aleppo; such are these stirring times, when the sons of noble families are put to occupations like any other men's sons, and thrive thereby. (Tis true, they say the Verneys lost much in the Wars, being stalwarts for the King throughout.) And Gabriel has hinted that, when Sam's little Thomas is grown, he may take him into the merchant business too.

So I think that we here in Holborn may hold our heads high. And yet, and yet . . . When he was first come to England Wensel taught His Grace the Duke of York to draw, and was acquainted with his brother too as a little lad. So when His Majesty King Charles came riding back into London that happy day, with the sun shining on his brow and the people throwing oak leaves under his feet in memory of the time he did hide in an oak tree in fear of his life, Wensel was so delighted. I believe he truly thought that the past had returned, and that soon he would come and go at the court as before. But the past never returns, neither the good times nor the bad, and though he and Mr Ogilby made fine prints of both this procession and of the Coronation, and sent them to His Majesty and were thanked for them, His Majesty, I think, has many other things to do than summon the friends of his youth.

I would that I were more able to help Wensel, but at the same time I think that some of the great people whose favour he needs are no better, if truth were told, than many an honest tradesman. It also seems to me that some time there are privy wrangles and envies between one fine family and another that Wensel chooses not to see. I liked very much Mr Tradescant, whose death we now lament. Wensel took me to see his cabinet of rarities that is called the Ark, at Lambeth, some months before we were wed, for it was in that same year that Mr Ashmole's description of them was printed, with Wensel's portraits of the Tradescants. We often visited them after, and they us. Mr Tradescant, having much travelled himself, did call Wensel Vas-clave, after the foreign manner. He always treated me with great civility and Father too, taking an interest in Father's ideas for the grafting of fruit trees. Mr Tradescant has journeyed greatly, to Virginia and other parts, and has

beautified his Lambeth garden (which was his father's before him) with plants brought from many far-flung places.

I am very sorry he now lies in the churchyard of St Mary's that is near to his garden: he was Wensel's age, not a year between them. But I am sorrier still for the way Wensel suffered himself to be drawn into witnessing a Deed drawn between Mr and Mrs Tradescant and Mr Ashmole, for it seems the couple were not easy in their minds about the matter at the time, only were greatly urged on by Mr Ashmole, their sometime close friend. And now John Tradescant is gone, and Hester, his wife, is like to have to cede all the Rarities to Mr Ashmole, which seems not right and so say I. But yet perchance it was what Mr Tradescant wanted? So says Wensel, who never wishes to think ill of men he would respect, no more than it would have occurred to him to excuse himself when Mr Ashmole wanted him to stand witness in such a delicate matter. And now, I think, he is loath to look too closely into it, for he does much work with Mr Ashmole, and is like to do more . . . Verily I think that, in this world, there are nests of vipers at work and honest folk might do better not to walk that way.

The saga of Elias Ashmole's involvement with the Tradescants, which Hollar evidently observed at close quarters, is an odd one, admitting of more than one interpretation. Ashmole was a lawyer by trade, with interests in antiquarianism, heraldry, astrology, alchemy, mathematics, coins, seals, poetry and much else besides. A Royalist by conviction, he had a talent for getting on in life, even in difficult times. At the Restoration, he came into his own. He was made Windsor Herald of the College of Arms, and with the help of his friend Sir Edward Bysshe, the new Garter King, he acquired his own coat of arms. He was called to the Bar and soon occupied several lucrative Government posts. Before 1660, he had already embarked on researching his great work, celebratory of worldly glory, on the Order of the Garter (eventually published in 1672). Hollar supplied the plates for this, including his breathtaking aerial view of Windsor Castle, a triumph of calculated perspective from a viewpoint he could never actually have adopted, either in reality or by any mechanical device.

Hollar also supplied the two engraved portraits, of the father and son, which were the frontispiece to Ashmole's catalogue of the Tradescant Collection. Excusing a delay in the publication of the book, for want of

these plates, John Tradescant explained in his Preface: '. . . I found my kind friend Mr Hollar then engaged for about tenne Moneths.' It is probable that Hollar had first met this John Tradescant many years before, at about the time John Tradescant I died, in Arundel House days. The Tradescants had acquired a property across the water at Lambeth, with no other houses as yet nearby and fine views. There were other points of contact too, for John Tradescant I bought this Lambeth house from a family which, like his own, had Dutch origins, and Hollar made portraits of some of this same family while he was in Antwerp. In addition, Hester, the second wife of John Tradescant II, came from a family of artists (de Critz) who would have been well known to Hollar. As for the Ashmole connection, Ashmole seems to have made the personal acquaintance of John and Hester Tradescant by 1650, when his Diary records a visit to them, but in the small world of educated seventeenth-century England he would certainly have known about them before.

The Tradescants were, each in turn, royal gardeners, and passionate collectors of new plants and curios from around the world, in the best adventurous, acquisitive traditions of their era. The father went as far as Russia in his search for the new and the strange; the son made journeys to Virginia and to the Canaries. To them we owe such modern staples of English horticulture as the Virginia creeper, the lilac, the yellow jasmine and the plane tree, besides many of our fruits in their present cultivated form. Under the son, the Lambeth garden was extended and embellished with vines, a holly walk and glass beehives. The Tradescant cabinet of rarities, now named 'the Ark', continued to grow too, once word had got around among merchants and sea-captains that further exotic objects were welcome there. Outgrowing its original turret room, the Collection now invaded most of the house, which was expanded to accommodate it. Visitors, both distinguished and ordinary, were welcome too, for the Tradescant creation was, in effect, the very first public museum – the word that Ashmole applied to it.

His catalogue lists a huge number of objects we would now class as ethnic, and which were particularly appreciated by the serious-minded John

Evelyn. There was also a whole mausoleum of stuffed exhibits, the baleful prototype of so many eighteenth- and nineteenth-century collections:

> a salamander, a chameleon, a pelican, a remona, a lambado from Africa, a white partridge, a goose which has grown in Scotland on a tree, a flying squirrel, another squirrel like a fish, all kinds of bright coloured birds from India.

There were also:

> a number of things changed into stone . . . the hand of a mermaid, the hand of a mummy, a very natural wax hand under glass . . . a picture wrought in feathers, a small piece of the wood from the cross of Christ.

Another visitor commented on 'Pictures to be seen by a Celinder' — a device related to the *camera obscura* — '80 faces carved on a cherry stone', and tiny carved utensils kept inside a hazel nut. There were even some royal heirlooms graciously contributed by the Stuarts, including Henry VIII's hawking gloves and stirrups and Anne Boleyn's silk nightdress.

Was John Tradescant II ever moved to reflect on the limitations of laying up all these treasures upon earth? His first wife died young and the son of that marriage, who should have become John Tradescant III, died in 1652. The daughter married, but had no children and seems to have died quite soon herself. Hester, Tradescant's second wife, did not bear him any children either. In these all-too-common personal sadnesses lay the roots of what became a major drama.

Mr John Evelyn, I know, did much admire Mr Tradescant's works. He himself is engaged in laying out a most splendid garden at his house in Deptford, that he had of his wife's father, full of plants from France and Holland. He plans to have glass beehives, like Mr Tradescant's, and also to train and clip thick hollies into hedges. I know this from the one occasion when Wensel and I were bidden to this house, Sayes Court, to dine. Mr Evelyn, I am sure, truly values Wensel's work and has always spoken well of him, so I was pleased to go with him.

To hire a waterman to take us safely all the way, Wensel and I went by hackney coach as far as the stairs below London Bridge: Wensel would not have me walk through the mire

of the streets in my new slashed-ribbon silk gown that he had had me order for this instance. (We said to each other that this grand dress would serve for keeps, yet I have scarce worn it since, not having much occasion to. Also, I was with child again afterwards, and since then my girth has never quite returned to its former state. Maybe I should have side pieces set in the gown, and yet I am loath to do so. I will ask Meg her opinion.)

Mistress Evelyn, a sweet-faced lady much younger, I think, than Mr Evelyn, was very friendly, and I enjoyed walking in the grounds before dinner and having the new plantations explained to me. But the dinner I did not enjoy tho' the neats' tongues and the loin of veal were especially delicate. The meal seemed to me so long, with such a hubbub of people of quality talking of foreign places and sights that I wot not of. Wensel, who has travelled much, was very happy, that I could see from afar (we were not sate together, which seemed strange to me, but is, I am told, the Fashion). Mr Pepys[4] of the Navy Office was there, who admires Wensel's work too, said Mrs Evelyn to me. Mr Pepys's lady (also young) is of French blood; she was discoursing near me in that tongue with the Ambassador from thither, and little I could add to their conversation! Mistress Pepys was very fine, in black moirey, which was that summer the latest fashion come from Paris, and an overskirt of silver lace.

The talk among the other gentlemen was much of the Indies: it seems that as the King is to marry the Portuguese princess, or so the word goes, then she will bring an island in the Indies full of spices as part of her dowry, and the gentlemen seemed to think this a very fine thing. There was some discussion as to whether this isle, whose name means 'Good Bay', be in the East Indies or the West, but Wensel, who knows very well the use of maps, spake up and said it be in the East Indies, near to Surat whence the silk comes. 'Then Mr Hollar,' quoth another, 'shall go there for us and draw the pagodas and the naybobs.' They all laughed, Wensel too, tho' I was not sure but that there was not a hint of mockery there. And I, stupid as I am, having drunk an unaccustomed amount of French wine, conceived then and there at the dinner table a terrible dread that he would go there indeed, if anyone should ask him to and pay him to do so.

So I suffered in mine own thoughts, while all around me the company ate candied peel with exclamations of joy. But then I recalled of a sudden that once, in the first year of our marriage while the Commonwealth still held sway, we had been walking in the Strand (Wensel's favourite street, his old haunt) and had been accosted by a gentleman. 'How now, Wensel,' he said, 'so you are come again into our country? But I am on the point of leaving it. So goes the world.' Wensel presented me to him, and I could tell by the gentleman's face

that he had not known of Margaret's death. He looked quite took-aback, but did not like to comment on the matter. He was a Mister William Crowne, who had been with Wensel at Arundel House, and before that on the famous journey through the Rhineland. He had prospered, and was then the Member of Parliament for a country place — I forget which — but was leaving it all, he said, for a bright prospect in Nova Scotia, beyond the ocean. 'For,' said he, 'Our Lord and Master the Earl of Arundel thought of seeking to mend his fortune in Madagascar, did he not, so why not I in the New Scotland?' I guess now that he saw the Commonwealth would soon fall and that he was saving himself betimes from loss of place. He spoke so persuasive of the riches that he and his partner would garner in the New Scotland, in the beaver fur trade, that I became convinced of a sudden from Wensel's warm manner that he, Wensel, would take a fancy to go there too.

Which was a piece of foolishness on my part. For when he and Wensel had bade each other Adieu, shaking hands most heartily, Wensel said to me, 'He was a right enough boy in times gone by. But I like not much his looks nor his proud bearing now. I wonder if his rich wife still lives.'

'He made no mention of her,' said I. 'But belike she'd go with him to the New World?'

'Or belike as not,' quoth Wensel, 'for he was induced to wed her for her money, and mayhap that was all the happiness he got of her and he has now spent it all. This venture of his may also be a manner of parting from her.' And he took my hand up and kissed it most tenderly, as if to show the difference between Crowne and himself, which did comfort me and conjured my foolish worry.

Wensel did much profit by the occasion at Mr Evelyn's, I am sure, talking in the German tongue to one guest, receiving compliments on his gravings of St Paul's from another. We tarried till the light was fading and many wax candles were brought in by the servants. I was tired, and would fain have been gone before, but we needs must linger till others were leaving too, for safety together when dark might come and so as to be sure of a trustworthy boat, found for us by Mr Evelyn's man. Wensel said our goodbyes and thanks most merrily. Yet all the long way back to London, chilly now inside our cloaks as the stars came up, and no sound but that of the oars in the water, he was unwontedly quiet.

I have never been to Sayes Court again, though I believe Wensel has been there in the way of business, and Meg, calling by to see us one Sunday not long ago, was full of talk of a visit there. Wensel was always intent that she should take her place among persons of quality, so I

think he takes much comfort from her present situation. Myself, I dare not speak of such delicate matters to him, and never shall.

Some miles up the river from Sayes Court, at Lambeth, another house and garden had been, for the whole of the previous decade, the focus for a highly concentrated ambition. A crisis was now brewing.

Who was to inherit the Tradescant Collection and care for it? It was essentially the same question, in other circumstances, that had shadowed Lord Arundel's dying thoughts regarding his own Collection. This time, the question had inevitably been in the Tradescants' minds, but apparently much in Elias Ashmole's as well. The relationship between the two families in the 1650s was intimate, almost oddly so. In 1649 Ashmole, then a widower, had married a rich widow nearly twenty years older than himself. The couple did not find life together easy, and after they got to know the Tradescants, Mary Ashmole formed the habit of going to stay at the Ark as a house-guest. For a period in 1652 she and her husband were both there together, patching matters up after an 'astrangement', so they were in the house in September when the fateful death of nineteen-year-old John occurred.

One can see that the bereaved father, who could not realistically hope for a new son and heir (Hester was now nearing forty) might well look in his distress to Ashmole as a substitute. Ashmole was learned, in the omnivorous way of the largely self-taught; he loved making lists of things. He was ten years younger than Tradescant but far more worldly-wise; he had a genuine passion for ancient and curious objects. He would seem a natural custodian for the Ark, and indeed he was to spend part of his time during the next four years cataloguing it. In 1659, the year his *Museum Tradescantianum* was published (mainly at his own expense) he recorded in his Diary near to an entry on going with Hollar to Windsor:

Dec 12. Mr Tredescant and his wife told me they had been long considering upon whom to bestow their closet of Rarities when they died, and at last had resolved to give it unto me.

14. This afternoon they gave their scrivenor instructions to draw a deed of gift of the said closet to me.

16. 5.30 pm. Mr Tredescant and his wife sealed and delivered to me the deed of gift of all his Rarities.

What these brief entries may have represented in reality varies according to whom you believe. It seems that on the evening of 16th December 1659 the Tradescants did indeed sign the Deed and that this was the culmination of a fairly protracted Ashmole campaign. But the Tradescant account of events was that Ashmole came to the house accompanied by witnesses (including apparently Wenceslaus Hollar) and produced his own document to be signed, without the Tradescants having studied it.

Hester's own version was that the first she knew about the plan was when her husband came home 'distempered' (that is, rather drunk) in company with Ashmole and four other men she did not know. The detail about drink having played a part in Tradescant's unwariness has a ring of truth, but it seems unlikely that Hester did not know the other men at all, or that the Deed had not been discussed in her presence before.

Both John and Hester signed the Deed in front of Ashmole, either then or two days later, but, according to her own account, when Hester saw the symbolic shilling change hands on the deal she immediately began to wonder if they had done something prejudicial to their own interests. While her husband was fetching his cloak and his guests' cloaks to see them to the waterfront, she asked Ashmole the pertinent question as to what right she would have over the Collection if, as was likely, her husband predeceased her. Would she and Ashmole be joint owners? Upon this, by her own account, Ashmole willingly left the Deed with them for them to study it further – perfectly fair, one might think, except of course that the signatures had already been placed on it and the seal applied.

Once they had had a chance to read it through on their own, Hester, according to her own later testimony, told her husband 'that she thought he would not have suffered himself to be so much abused and threw the said writing to him'. She also claimed that the next day, in a sobered mood, John

Tradescant agreed that Ashmole 'should never have a groat of him'. What certainly happened is that John finally cut his own signature and the seal out of the Deed with the pruning knife he carried in his pocket, and that both husband and wife thought erroneously that they had thus revoked the Deed.

In the euphoria of the Restoration, John gave some thought to the possibility of giving the collection to the Crown, but decided that the amiable Charles II might not really take good care of it. In 1661 he made a will containing this deposition:

> I give, devize and bequeath my closet of Rarities to my dearly beloved wife Hester Tradescant during her naturall Life and after decease give and bequeath the same to the Universities of Oxford or Cambridge, to which of them she should think fit at her decease.

The following year he died, no doubt believing that he had sorted the matter satisfactorily. However, his death, the key event under the terms of the Deed, was the signal for Ashmole to renew his claim. No sooner was the will probated than he brought a case in Chancery against Hester 'for the Rarities her husband had settled on me'. Among the witnesses Hester called for her side when the case eventually came to court was Hollar. She said that she had burnt the Deed – a foolish admission, whether it was true or not. The court, presided over by Lord Clarendon, found for Ashmole.

Twentieth-century views have varied as to whether the court was correct in Law and had little option in their judgement, or whether Ashmole was blatantly favoured by his fellow lawyers and cronies. (That was Hester's view.) Similarly, the saga that followed over the next fifteen years may be read as a disgraceful tale of the harassment of an honest widow by a devious scoundrel – or as a justified attempt on Ashmole's part to extract from a neurotic woman what he genuinely believed to be his due, without alienating her entirely. Ashmole, in fact, thought that John Tradescant had made a third will, which reverted to his original intention by specifically exempting his 'closet of rareties' from his bequest to his wife, and that Hester had suppressed this will. He may also have perceived that Hester's main preoccupation, unlike her late husband's, was with the supposed

monetary value of the rarities; he must have been anxious to stop her selling off bits of the Collection piecemeal. (This was the same problem that arose between Lord Arundel and his estranged wife.)

It is worth recording that John Evelyn and Samuel Pepys, who were fellow members with Ashmole of the Royal Society, did not regard him as villainous. They found him intelligent, dynamic and very hard-working, though perhaps a little naïve in his attachment to outdated ideas of natural history and alchemy, and in what Evelyn called his 'addiction' to astrology. (It will be recalled that he first appeared in this account casting James Hollar's horoscope.) Nor presumably did William Dugdale disapprove of Ashmole, whom he had known for many years, as he accepted him as a son-in-law. Aubrey, a shrewd though tolerant judge of character, described him in a letter as 'a mighty good man and very obliging', though with a hint of irony as if he thought Ashmole rather full of himself.

Modern commentators have noted, as if this were a black mark against Ashmole, that all three of his marriages were either socially or financially advantageous, but this was such a usual approach to matrimony among the better-off classes at the time that one should perhaps not judge his entire character on this. It is, however, quite possible that as a lawyer, and a man bent on making his way in the world, Ashmole regarded legal manoeuvres as something akin to an absorbing game of chess, without essential moral content. He was also, for years, embroiled in a Chancery case with his second wife's children by her previous marriages. He won that in the end too. Maybe he genuinely did not imagine that Hester Tradescant would take her defeat as hard as she did. Her end was not a happy one.

You may say that Ashmole honourably followed Tradescant's wishes, even though the will that stated them was set aside, for today some of the rarities that have survived the effects of time and changing ideas are in Oxford, where their collector wanted them to be. They were kept first in an elegant, purpose-built house in Broad Street next to the Sheldonian, and today are in a museum-gallery in Beaumont Street. There you can still see, among numerous later and irrelevant additions, Tradescant's carved fruit stones, an American Indian mantle of deer skins that he had from a sea-

captain, and even Henry VIII's glove and stirrups. However, the bulk of his prodigious collection of natural-history specimens, such of it as has not disintegrated into dust, has gone elsewhere, while other collections of art and antiquities have been added to the museum. His rarities have become only a very small part of a far more extensive holding, over which a few of Lord Arundel's surviving marble statues preside in the entrance hall.

The name of the building is, of course, the Ashmolean. Ashmole, as ever, achieved what he wanted.

Chapter IX

Restoration Hopes — and a Hope Destroyed

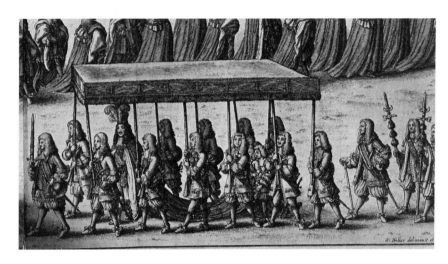

After Charles II's triumphal return to Whitehall in May 1660 his reign was officially backdated to the execution of his father. By this reckoning, he had ruled more than eleven years already, and the Commonwealth was wiped out as if it had never been. Re-erected maypoles turned, fireworks illuminated the sky at the Coronation and the Great Conduit in Cheapside ran with wine. As a further entertainment, in the following weeks those regicides who were still alive were arrested, hanged, drawn and quartered. The corpse of Oliver Cromwell was subjected to the same treatment, as a salutary lesson for others that death was not the end. Bits of the various bodies were stuck up on pikes at key London sites, though it was to be the last era in which this practice was felt appropriate. By the end of the century, decapitation itself would be consigned in England to the past, as would legally sanctioned torture.

On a more refined level the King and his companions in exile brought with them from France extravagant habits and extravagant fashions to match. Men-about-town, or rather about the burgeoning new suburb near St James's Park, began to rustle around in wide-legged Rhinegraves or 'petticoat breeches', accompanied by billowing linen shirts and linings and many yards of ribbon for garnish – an oddly effeminate style for a court whose most notable characteristic was rampant heterosexual activity. Less flamboyant subjects continued to wear ordinary breeches closed at the knee. But people of all kinds, from ageing, faithful Royalists who had been eking out their reduced resources in the countryside, to chancers such as William Crowne back from Nova Scotia and social climbers such as Elias Ashmole, flocked to London to see what Whitehall might have to offer *them*.

Hollar, too, was not slow to adopt the mood of patriotic euphoria and hope for personal advancement. His younger colleague William Faithorne, he who had fought and suffered for the Royalist cause at the Basing House, was nominated 'Engraver on Copper to the King': this may have left Hollar feeling slighted and goaded him into uncharacteristic action. A proposal engraved by him, dated 26th July 1660, is the unique example we have of him planning a substantial undertaking himself rather than responding to other men's initiatives. Taking a leaf out of Dugdale's book, he was attempting to get prominent citizens, including the King, to sponsor him. A copy of this proposal, apparently belonging to Sir Edward Walker (then newly appointed Garter King) travelled at some unknown date across the Atlantic and now lies in a library in New England.

Propositions Concerning the Map of LONDON and WESTMINSTER &c: which is in hand by Wentsel Hollar.

This Map is to contain 10 Foot in bredth, and 5 Foot upward wherein shall be expressed not onely the Streets, Lanes, Alleyes &c: proportionately measured; but also the Buildings (especially of the principall Houses, Churches, Courts, Halls, etc) as much resembling the likeness of them, as the Convenience of the roome will permitt. Example whereof is in Considerable part to be seen;

The charge thereof being found by Experience to be wery great and too heavy to be borne by the Author himselve alone, He makes this proposal following.

If any Gentleman or other Worthy Person be inclined to encouradge arts, or things of that nature, would please (out of his free benevolence and Generous mind, not standing upon Profit, but for the Honour of this famous Cittie, and his owne) to contribute to this laborious Peece, the summe of 3 lb, in a maner as shall follow: he will thereby be oblidged, in way of gratuity, to put every such person's Coat of Armes and Name as a Benefactour, in a Convenient place of the Map designed for that purpose. And the Worke being finished, to deliver to each of them 2 such Maps printed, full and Compleat.

The maner of the payment is desired to be thus; 20 Shil. now – to help on the Worke, and to support & maintaine the Charges which doe occur, as well as his Family or otherwise, and at the sight of their Coats of Armes in their places, 20 Shill. moore and at the receit of their Compleate Maps the last mony is to be payd.

At the bottom, on the surviving copy, Hollar has written in his own hand: 'I acknowledge that I have received of Sir Edward Walker, the Summe of 20 Shilles vpon the Conditions aforesaid. Wenceslaus Hollar.'

Edward Walker was considered by a number of others in public life to be self-absorbed and tiresome, and he quarrelled with his fellow heralds, but he seems to have been a faithful friend to Hollar. Hollar also succeeded in interesting Evelyn in the map-enterprise – Evelyn mentioned it approvingly in his *Sculptura*, published in 1662. The King himself made enthusiastic noises, writing to London's Aldermen to suggest that they contribute, and apparently expressed himself happy to name Hollar as his official 'ichnographer'. But, in spite of these high-sounding promises, no royal money was forthcoming in the early 1660s, a usual pattern with the King, who was chronically short of money to finance his own prodigal lifestyle.

An odd divergence of scholarly opinion surrounds this projected map. There exists in the British Museum one sheet of what would be, if we

possessed the whole thing, a wonderfully complete, detailed and realistic map-view of the whole of London. This one sheet covers the Strand and Covent Garden, Lincoln's Inn, Holborn and St Giles-in-the-Field, all that district which Hollar had made most his own. It displays features which would date it around 1660, to within a year or two, including the re-erected Strand maypole – rendered in Hollar's own exquisite lettering but approximate English 'the Meypoo'.[1] Like all urban plans of that time (though this was not to be the case for much longer) it adopts a bird's-eye view; yet, by making a careful accommodation with perspective, it has all the qualities of a flat map too, showing every street and lane in coherent proportion to each other. This sophisticated combination of lifelike visual representation and schematic exactness would seem to reflect precisely what Hollar claimed for it: all the townscape is 'proportionately measured' but the buildings themselves are not mere rectangular symbols; they are pictured in something nearer to isometric projection, and do indeed 'resemble the likeness of them, as the Convenience of the roome will permit'.

Personally, I have no doubt that this sheet is the surviving fragment of what would perhaps have been Hollar's most splendid work of all and which we know, from a later reference in a letter from him to Evelyn, was never finished. This has also been the opinion of most of those who have written about his prints, including one modern authority,[2] who has described it as probably the finest example of a map-view in existence. It is certainly far finer and more architecturally realistic than Faithorne's contemporary map-view, useful though that one is.

Yet one American scholar,[3] to whom we owe the recovery and publication of Hollar's Proposition, bizarrely speculates 'which map is meant?' In addition, Hollar's modern cataloguer[4] finds nothing remarkable about the single sheet, and claims, regarding the proposed map, 'There can be little doubt that this major undertaking, if it exists at all, is represented now by the Ogilby and Morgan map of 1667' – a statement which seems implausible for several reasons. To begin with, Ogilby and Morgan's map was published not in 1667 but in 1677, the year

after Ogilby's death. It bears the heading 'Actually Surveyed and Delineated by John Ogilby'. It is a detailed, conventional ground plan in the modern sense, probably substantially overseen by the cartographer William Morgan. A fine piece of work in its own right, it displays few of Hollar's more individual strengths and qualities. The dedications in the cartouches are not his, and his signature is nowhere to be found. To believe that this plan is directly related to his original proposal, one has to ask: why on earth would Hollar, so celebrated by that time for his subtle artist's eye, have wanted to devote large amounts of time and money to a huge project demanding only basic, journeyman engraving and dependent, rather, on the skills of a mathematical draughtsman? Hollar worked a good deal for Ogilby, knew Morgan, and may thus have contributed in some minor way to the map's construction: it is thought that he drew in the ships on the river (picture work), and the lettering within the ground plan of the Tower appears to be his. But essentially the Ogilby and Morgan plan relates, not to the world of which Hollar had made himself visual master, but to that of the new learning and the new London that came after him.

My father bestowed on me a fine print of the first part of his Great Map that he has drawn, urging me to show it to the King. I do believe he think that, because I dwell in Whitehall now with Lady L———, I am continually running in and out of His Majesty's presence. Well, and that might so one day be — but I'll say no more of that, for the while, and to tell truthfully I am half afeared even to think on it, wondering into what way I have strayed, and telling myself at times that no good may come of such fancies . . . But, for the Map, my lady had graciously displayed it in her chamber to her friends, and all pronounce it Very Fine so I hope to do good to my father thereby.

They all see, you may be sure, that my father is hoping to gain some advantage from the Royal purse (and why not, when so many others do, for far more slight reasons?). I wish they might understand that that is not all his purpose, and that when he speaks of 'the Honour of this famous Cittie', our London town, his words come from his heart. He was born and raised far away: no kinsmen nor friends from that place, distant now too in time, remain to him. Once, when I was yet living in Holborn, I have seen him wax angry, when a neighbour,

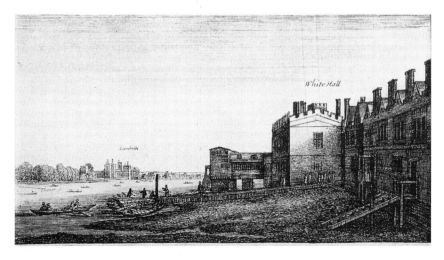

in jest, mocked his way of speaking. 'Does that buffoon think I may change my accents at will?' he said. 'I can no more do that than change my stature.' 'Tis true he speaks with the tone of those from beyond the Rhine, and writes with his own strange idea of English names. Yet he has made London his own place, far more than most of those bred to the town. When he seems, as he oft-times does, so hard-pressed, it pleases me to think that, even after he is dead and gone, people may take pleasure and profit in looking at his little pictures and say, 'See, the Royal Exchange' (or perchance 'the view from Lambeth' or 'the King's palace') 'was thus and thus in his time, and thanks be to him we may now know this.'

It is my Good-mother Honora's idea that my father should seek the payments for his Great Map in three parts. For Honora knows, none better, that when Father has money in his pocket he supposes himself a rich man and does not count how he may spend it. I recall that when we were first at the house in Holborn, lodging on the upper floor, the furniture there was just as it is below — sturdy, oaken stuff, tables and joint stools and chests that have served Honora's father well and his father before him. I think in truth that Honora herself was well used and content enough with these old things. But my father was looking to please her, I suppose, and remembering other days, for after they were wed and I was gone into my lady's service, he bought a carpet, come all the way from Turkey, and some new hangings of fine striped stuff for their parlour, and four new chairs with seats and backs in leather, and even some plates of blue and white from the pottery in Lambeth which are in the China style. I like well these things myself, for they are the new Fashion and I am accustomed to such at

my lady's side. (Our small apartments in Whitehall are now furnished with a finely draped bed for her, and a truckle bed for me, and two pretty new cabinets lackered after the latest style, besides other things.) But I do not think new things were so necessary in Holborn, for they do not entertain persons of quality there. Honora is not proud; she minds her pots and pans herself like any housewife and, tho' she does not say so, I think she might rather have put the money by.

I know – for this she did tell me – that it was for none of her asking that my father called upon the celebrated physician Dr Chamberlen, when my first sister was born.[5] He and his son, who attend the ladies here at the court, are known to all the world as having some device for easing birth – none knows what, for they keep their secret close. Now having seen my poor mother suffer with a babe caught fast within her – which has quite decided me not to marry, even should the chance come to me, but that is by the by – I can understand my father's concern. But yet I think in truth that he called on Dr Chamberlen in memory of his old friend that other Monarch's Physician, Dr Harvey (who died some years since), and also because Dr Chamberlen has attended many ladies of quality in their labours. To speak more clearly yet, there was no real need to send for such a great and costly person to attend upon Honora, a big-boned woman who gave birth to Sarah and then to little Paulina without too much pain or peril – as she herself said to me. Besides, she was ashamed to have a man present, which seemed to her unnatural.

Honora is a good enough creature, and has always been at pains to be good to me. Too much so: I see clearly her anxiety on that score. But, like my father, she eats very hearty, and of late has become fat. Although she might leave many chores to the servant, she is always bestirring herself at the kitchen fire and even at the washtub. To speak the truth, there is often a stench of labour about her person.

No doubt I would not notice this so much, but that here at the court the ladies all use powered alum for the goussets, and rose-water and many other confections, and gentlemen use pomade and perfumes too, so we are all sweet together.

With modern hindsight, it is difficult to think of the first years of Charles II's reign without feeling the looming presence of the two events which were to mark the capital in the mid-1660s, the Plague in 1665 and the Fire the following year. These twin disasters are traditionally seen as the final end of medieval London, which had survived tenaciously through the Elizabethan

and early Stuart era, and as a necessary paroxysm to bring about the creation of a new metropolis of brick and stone and drains, where the new learning could flourish.

In reality, London was transforming itself before either disaster struck, and there were very many able men in whose minds the future was already arriving. The Royal Society, which took its inspiration from the polymath Francis Bacon, dead now for a generation but often invoked, received its charter in 1662. It counted among its founding members Evelyn, Aubrey, the chemist Robert Boyle (of 'Boyle's Law'), Lord Brouncker, who was a mathematician and a firearms expert, the experimental scientist and microscope-inventor Robert Hooke, and young Christopher Wren, who was a distinguished astronomer and mathematician as well as an architect, and who was involved in plans to restore St Paul's before the Fire made all such projects obsolete. A few years later the young mathematician Isaac Newton joined them, already famous for his work on the reflecting telescope; so did another mathematician and engineer, Jonas Moore; so did John Flamsteed, the founder of the Royal Observatory in Greenwich Park; and so did Edmond Halley (of 'Halley's comet').

All these progressive-minded and enormously energetic men, who laid the foundations of the world in which we live today, were going about their daily lives, exchanging views, building new instruments, making drawings and diagrams and architectural plans, doing experiments and recording each other's experiments, in the first years of the Restoration. In that series of hot, dry summers and remarkably cold winters their collective sights were fixed on a future of exciting possibilities that they saw opening before them. Although predicting the future was still a more or less respectable science, they could not be aware, as we who are watching them are aware, of the blows about to fall upon their city – blows that would for ever, in Londoners' minds, separate the old world from the new.

For some London citizens, once the shocks of Plague and Fire had been assimilated, fresh professional opportunities were born out of disaster. But for certain others the losses sustained were to be permanent and irreparable.

*

We think we know what the Plague of London was like. Thanks largely to Daniel Defoe (whose *Journal of the Plague Year* was not an actual journal but a first-ever documentary novel cleverly constructed a generation later), we have a graphic image of shuttered streets with crosses on doors and the occasional shaky scrawl 'Lord have mercy upon us'. We see bonfires laced with saltpetre burning at corners, bodies laid out there uncoffined or piled high on dead-carts that rumble by to the cry of 'Bring out your dead!' We see no one in the streets but searchers, old women with masks and wands going like apparitions from house to house checking for plague-spots, the dreaded 'tokens', to a background of ever-tolling bells.

Some streets of London, it is true, must have been like that by the late summer of 1665. But the Plague did not strike all at once, or affect all parts of the town the same. Some parishes got off more lightly than others, some sections of the population were more susceptible than others — not, however, that you could count on your money or your clean-living ways necessarily to save you, if your own quarter of town was particularly badly affected. For some reason, the outlying areas, which included Southwark, Aldgate, Blackfriars, the Fleet valley and Holborn, were worse affected than the City itself. The mortality rate was particularly bad, quite early, in Drury Lane, which was then the main way from Temple Bar to Holborn and St Giles-in-the-Fields. There has been a persistent story that the Plague started in the warehouse of a cloth merchant in Drury Lane, whose apprentices unpacked bales of cloth come via Amsterdam from Turkey. This sounds, however, like a classic myth of sickness arriving from afar like a strange enemy. Bubonic plague (which is in any case spread via black rats and flea-bites rather than by airborne contamination) had been endemic in England for several hundred years: there had been bad plague years earlier in the century, some of them centring on different towns up and down the country. The Great Plague of London was simply the largest and most terrifying outbreak of all, and it was not for some time apparent that this would be so. A few plague cases, or supposed plague cases, each summer were not uncommon. Conversely, the early cases in each parish were not necessarily diagnosed as such. To those not immediately affected, the plague

was invisible, a matter of hearsay and rumour, until the moment they actually passed a corpse in the street.

Reading the diaries of those months in 1665 kept by Evelyn and Pepys the impression is not of a town wholly blighted, but of a gradually accumulating unease, a creeping but patchy malaise. During that summer many people slipped away to the country, but others continued their lives more or less as usual, relying anxiously on impregnated handkerchiefs held to the nose and on briskly thinking of other matters. England was currently engaged in a trade war with Holland: the Lord Chancellor was bemoaning the lack of adequate funding for this and vainly asking 'Mr Pepys, what is to be done?' The King himself, Pepys recorded at the end of April, 'do now know me so well that he never sees me but he speaks to me about our Navy business'. Pepys was very happy with the way his own financial affairs were going, and he had a smart new silk suit, which had cost £24. He was occupied in fixing up an important marriage for a friend's daughter. He had much on his mind and only fugitively does he mention 'the sickness' when it is forced to his attention:

> It struck me very deep this afternoon going with a hackney coach from Lord Treasurer's down Holbourne, the coachman I found to drive easily and easily, and at last stood still, and come down hardly able to stand and told me he was suddenly struck very sick, and almost blind, he could not see; so I light and went into another coach, with a sad heart for the poor man and for myself also, lest he should have been struck with the plague.

That was on 14th June. Near the end of the month he recorded seeing himself, for the first time, houses sealed up, and Whitehall and the court as being 'full of waggons and people, ready to go out of town'. The royal family left then, and by the end of June the Inns of Court, too, were almost empty and the Royal Society stopped its meetings at Gresham College in the City. Pepys and his wife lived in the City, in Seething Lane near Tower Hill; they and their servants were all in good health, but in mid-July Mrs Pepys departed with her personal attendants to Woolwich, well down the Thames. In August, alarmed by the enormous weekly Bills of Mortality and

the increasingly deserted City streets, Pepys followed her there, though worried as to how he would continue to fulfil his professional duties.

That same month the Plague appeared in some places well outside the confines of London proper. It reached Greenwich, next to Deptford, and the equally busy Evelyn (who was engaged in trying to get money out of the royal coffers to feed the sick and wounded seamen off the battleships) sent his pregnant wife, children and most of the servants to his brother's family seat at Wotton in Surrey – 'Being resolved to stay at my house my selfe, & to looke after my Charge, trusting in the providence and goodnesse of God.' In early September he recorded a journey through the City to St James's as 'a dismal passage & dangerous, to see so many cofines exposed in the streetes & the streete thin of people, the shops shut up, & all in mournfull silence, as not knowing whose turne might be next'. On another visit in October he found 'multitudes of poore pestiferous creatures, begging almes' – no doubt the mass of Londoners who, in happier times, made a living on the streets selling anything from asses milk or lavender to rabbit skins and old clothes.

The epidemic did not fully abate till winter set in. Pepys and Evelyn and their households escaped unscathed, but both had servants who suffered plague-deaths in their immediate families, and Pepys's own physician, Dr Burnett, had died of it – 'which is strange, his man dying so long ago and his house open again. Now himself dead. Poor unfortunate man!'

That summer Hollar was busy and preoccupied too. A letter he wrote at the beginning of August, addressed 'for Mr Aubry', seems characteristic of him in various ways. It also resonates with the fugitive tones of seventeenth-century speech:

Sir, I have now doone the picture of Mr Hobbes [the political philosopher, author of *Leviathan* and other works], and have shewed it to some of his acquaintances, who say it be werry like, but Stint has deceived mee and maketh demurr to have it of me, as that at this present my labour seemeth to bee lost, for it lyeth dead by me. However I return you many thanks for lending mee the Principall, and I halve a dozen Copies for you, and the

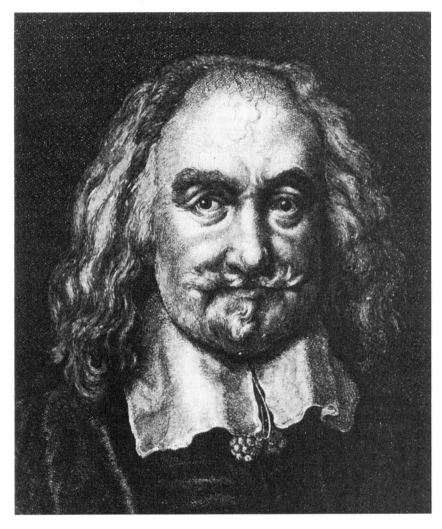

Painting I have delivered to your Messenger who brought it to mee before, your humble servant W. Hollar the 1 of August 1665.

This is the letter of which the date has been misquoted as 1661 (see note 5 to Chapter VII), so obscuring a significant detail: the 'Stint (Peter Stent) of whom Hollar complains was then a doomed man. Perhaps he was already too worried about sickness in his neighbourhood – and no doubt the virtual

cessation of his trade which must have accompanied this – to respond positively to Hollar. A garbled reference to this time was made long afterwards by Francis Place, who wrote that Hollar:

> Lived in Blumsbery all the time of the Plague butt suffered extremely for want of Business which old Peter Stent made an advantage of, purchasing several of his plates for a trifle.

In a time of sickness, people do not buy pictures. But all that can be said for certain is that Peter Stent himself, Hollar's long-term employer and print-dealer, died of the plague on 29th September of that year in his house on Snow Hill, not far from the rank-smelling valley of the Fleet, leaving a wife and daughter behind him. His stock was bought by John Overton, another print-dealer living nearby, who also adopted Stent's inherited trademark 'At the sign of the White Horse'.

Another small but perhaps telling detail is that Hollar's letter, surviving in Duke Humfrey's Library in Oxford, looks very faintly blurred, as if it has got damp at some point and then dried out. A heavy rainstorm while it was being carried a short way to Aubrey's lodging, which at that time was above a stationer's shop in Fleet Street? But little rain fell in London during that dry and desolate summer. People had become wary, by August, of the supposed contamination any letter might carry. Various remedies were recommended, including passing the letter through the steam from boiling vinegar, toasting it before a fire and pinning it up to air. Perhaps Hollar's folded missive was subjected to one or all of these procedures?

In the circumstances of that summer, Hollar's description of the *Leviathan* print – that 'it lyeth dead by mee' – seems oddly pregnant. Did he, too, have the Plague much in his thoughts, but was not going to mention it?

In this month of June, people here in Holborn do now begin to say openly, what before they durst not speak – that the sickness is among us.

Some say that the dreadful plague, of which the numbers sick do increase day by day, is due to one thing and some another – to goods coming from afar, or to infected vapours rising

from graveyards, or perchance to the people's sins. This last I do not believe: whyfore should the Lord think that there be many more sinners in one part of town than in another? Or why should he leave old sinners alive and let innocent babes die at their mothers' breasts, or good husbands and wives die leaving a houseful of children to perish without their care?

Our good apothecary and neighbour at the White Hart, William Boghurst,[6] maintains that keeping a very clean house, and partaking of none but very fresh milk and meat, and taking great care which water is to be drunk, be sovereign remedies against the sickness. I wish he may be right, for his own sake, for he is a man who does not fear to sit by the beds of the sick and even the dying. But 'tis true he counsels his own tinctures and lozenges too; my father Edward says that apothecaries are but tradesmen like any others, wishing to sell their wares, and that their wares are mostly paste and slops.

Mr Boghurst also sets great store by eating fruit for the body's sake: he told me so when I encountered him in the street the other morning. With this unnatural hot weather for the season, the cherry crop is here already, though the fruit be but small. I was fain to buy some from a seller crying her wares. But then I bethought me: I know not what hands have picked them. And my brothers and their wives decry much fruit eating as being like to put discordant humours in the body, especially in children. They put much faith in a pot of charcoal kept burning, with balsam of sulphur and herbs, to cleanse the house — tho' this do fearfully increase the heat within doors — and also in drinking of white wine possets night and morning, made with camphor, ginger, juniper and a little powdered hartshorn. My Good-sister Ann hath given me the receipt, with many pressing instructions. My brother John has also, this week, in his shop in Drury Lane, placed a bowl of water mixed with vinegar, with the intention that coins from customers should be passed through this in the taking. But my brother Samuel says that this will serve little purpose and merely afright customers. In truth, I think his customers are already too afrighted by the sickness that is in our parish to come buying their ribbons there, for his trade be already much diminished.

For my part, I feel that the unseasonable heat and drought (which were betokened already, perhaps, by the comets that appeared this past winter?) are causing the plague to wax. For we heard the first cases spoken of in the parish as soon as the frosts broke in Lententide. There was very little rain in April before Easter Sunday, and none at all from Easter till Whitsuntide and then but scanty showers. (My father has spent much time and labour watering the vegetables in the garden with well-water, that they may not wilt away, but the well we share with our good surgeon neighbour is now going down so he may not long continue, which much grieves

him.) Already, the first days of this present month of June were as hot as an August day or hotter – a bad, unnatural heat, with lightning in the sky on the Sabbath eve, yet still no rain fell. Wensel being absent from the town, I watched the lightning from our chamber window for a long time, my heart heavy with foreboding. On the morrow, at the church, I met our good parish constable Mr Green. He told me that in the Bills of Mortality for the week past 43 persons in London and the parishes around were accounted dead of the plague, of which full 31 were in our own parish. The next week we heard 112 were dead of it, of which 68 from our parish; this was when my brothers, both there in Drury Lane where the sickness mostly is, began their fires, their possets and water bowls. May the Lord God protect them and theirs.

. . . Now at this time Wensel has returned from Windsor – passing on the road, he says, the waggons and carriages of those taking refuge thither. Wensel is not afraid of the plague for himself, or will not say that he is: he passed unscathed through plague-ridden lands when he was young. He and Lord Arundel and the others even entered dwellings in towns on the River Rhine to find all lying dead of the plague and unburied within. (I am cold and half sick even to think on it.) He took no hurt then and thinks he will not now. But he has taken it into his head that I and the little wenches should leave London, as many are now dying. I am, in secret, much relieved to hear him say so, not for myself but for my dear children.

I could not, in any case, have prevailed upon Wensel that we should remain, for when he has an idea fixed in his head there is no shifting it, and he acts very swiftly. He walked to Islington the next day, and found us a lodging there on the hill, a little way up from the Waterhouse that is at the New River Head. He would brook no further question, and would not even argue the matter with my father, but just said 'twould be so.

So we travelled here by cart the next day, with our own bedding and some pots. After our goodly house, this cottage room is narrow for me and the little ones, and dear enough, but that is because so many people are seeking to lodge in Islington and thereabout now. I would fain go to visit our cousins in Hackney, which is not so far, but fear that they may be wary now of guests come from St Giles, and with reason.

Although the fields hereabouts look just as parched as those of Blumsbery (and what will the horses and cattle eat next winter, if no hay can be cropped?), the air here is sweeter than in the town and linen stays unspotted with smuts when it is spread out to dry. The water in Myddleton's conduit I am sure is good, for it cometh all the way from Ware, and Wensel says that he will come up very often to see us and to partake of the water himself. Many people

in these anxious times speak of its excellence. Wensel has plans to make some plates of the Water House to sell — and also, I can tell, for his own pleasure, for he dearly loves such ingenious contrivance. He has already taken some views of it in little drawings, standing in its round pool amid the fields with London in the distance.

I should be still happier if all of us — Father, Wensel and Jamie too — should be here, out of harm's way. However, men, unless they be nobility, scorn to run from infection as women and children may. Peter Stent's wife and daughter are sent to the country, I hear, while he himself stays at Snow Hill, and Mr Aubrey is in London also. Father will stay in Holborn with the servant to care for him. And to care for the cats, says my Sarah. I would fain not tell her the poor creatures must be killed for fear of the infection. Dogs are being slaughtered in their thousands, we hear. Wensel is just now absent again from town, drawing ships in Rochester harbour that are prepared there to fight against the Dutch.

Jamie — James, I should say — will mind the workshop by St Clement Danes. He has oft-times lodged by there these past two years, for he leads his own life as a young man will. I have feared me, sometimes, that he be spending his father's money in the new coffee houses, but 'tis not my business and such places are more healthful at this time, mayhap, than the low taverns of Clare Market or yet by the river.

We have just received word through kind Mr Aubrey that Lady L——— has taken Meg with her to stay at Oxford, whence much of Whitehall is gone. Thanks be to God.

. . . The Bills for this past week, the third one of June, have just been published. More than one hundred have died of the plague in St Giles in the last seven days alone, and some cases are now in Holborn, though I know not how near to our house.

They say, here in Islington, that the bells of St Giles have tolled so much these last days that people are continually afrighted and the bell ringers worn with fatigue. So the bells are now to ring no more, however many die. And the graveyard, 'tis said, has been dug so much that it resembles a ploughed field, and there is talk that one great pit for all shall be dug instead.

Oh, are we to be reduced by the times to this, that men, women and children shall be sufficed to pass like poor beasts into a common hole hugger-mugger, no bell, book nor candle for each one, just a few words muttered over all? Perhaps I was mistaken and therefore at fault before, perhaps indeed the Lord is angry with us.

My brother John, the last time I saw him before coming here to Islington, made much of the fact that there was no plague in the land whilst the Commonwealth lasted. He is open now

in his disapproval of the way the King's return has brought all manner of sin back into fashion. He even points to the new theatre in Drury Lane as one reason for the great sickness in that neighbourhood. Thus Mortal Sin leadeth to mortal sickness. This also the preacher said yesterday, the Sabbath, at St Mary's church in the upper street of Islington. John and his wife Sarah place much faith in prayer. My dear brother and his family, may God preserve them. And dear Samuel and Ann and their children also.

At the end of the fourth week in June 143 deaths from plague were listed in the Bills for St Giles-in-the-Fields. In the parish registers for that month are recorded the burials of John Roberts on 23rd June, and George and Grace, his young son and daughter, on the following day.

On 4th July Edward Roberts was buried.

On 21st July Sarah, John Roberts's wife, was buried, and five days later his remaining daughter Ann. During the week that ended 25th July, 323 deaths in St Giles's parish were attributed to plague. Among them was that of the parish clerk, so that the subsequent burials appear to have been recorded later, all together — mass registration of mass interments. Plague deaths in the parish for the whole of July had reached more than 1,000.

The 2nd August was declared a day of fasting to atone for 'God's displeasure against the Land by Pestilence & War'.

On 4th August Margaret, the daughter of Samuel Roberts, died, and on the 8th his son Thomas. On 10th August Ann Roberts died. Samuel himself does not appear to have died.

The surgeon did not die. Nor did Mr Boghurst. Nor did the Rector, Robert Boreman, who, like the apothecary, ministered to his fellow citizens throughout. But William Green, the good-hearted parish constable of High Holborn, died with £44 owing to him for money he had spent from his own purse on food for the sick and destitute.

By September, when torrential rain at last fell, extinguishing the fumigation fires lit at street corners and turning to mud the churned surfaces of the now ominously stinking graveyards, the plague had moved on to other parts of London. The figures for St Giles were much reduced. But to some of the survivors that can have been of little comfort.

Other, nearby districts where the plague had done its worst were Long Acre, skirting the north of Covent Garden, and Clare Market, which was the nexus of the small streets and alleys round St Clement's Lane.

. . . his son by [Margaret Tracy] dyed in the plague, an ingeniose youth, drew delicately.

(Aubrey)

he had a son which was very promising in his way, he died young.

(Francis Place)

Amongst his Misfortunes (*a real Loss*) was that of a hopeful son . . .

(George Vertue)

It was not only work and money that preoccupied Hollar that summer. And he who had been one of the most assiduous recorders of current events in the past, and who was to depict the Fire of London within days of its extinction, has left us no pictures of plague-stricken London at all.

By an irony, or in some sort of personal compensation, that summer of 1665 did produce a series of Hollar's most charming and tranquil views. They are drawings that he made of the Water House in Islington and its surroundings, taken from six different points of the compass as if the place fascinated him. (He was also partial to the tidal water-wheel and pump under London Bridge, which figures in a number of his views, and to another pump erected by Arundel House, though no one could pretend that Thames water was clean.) The Water House was the head of the New River, the artificial river cut via a meandering, carefully surveyed route from springs in Amwell and Chadwell in Hertfordshire, to finish up in these open fields above Clerkenwell and the City. It was decanted there, through a controlled system of sluices in the Water House, into two great basins, an inner one and an outer one, and thence, via a series of cisterns, into wooden pipes of hollowed elm and so to London back yards.

This visionary scheme of early seventeenth-century modern plumbing is usually credited to Hugh Myddleton, MP, Alderman and jeweller to James

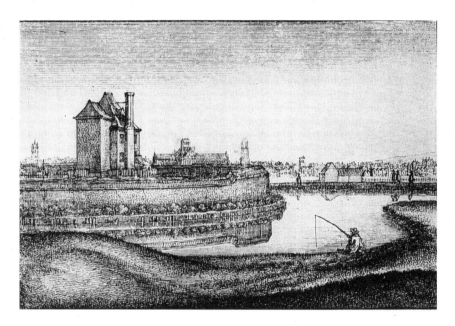

I, who bank-rolled it. His statue, august in late Elizabethan dress, stands today in the busy centre of Islington, presiding over restaurants, antique shops and street markets. But Aubrey always maintained that the true credit should have gone to a Mr Inglebert:

> the first Inventor or Projector of bringing the Water from ware to London . . . This Sir Hugh Middleton had his picture in Goldsmythes'-hall, with a Water-pott by him, as if he had been the Sole Inventor. Mr Fabian Philips sawe Inglebert afterwards, in a poore Rug-gowne like an Almes-man, sitting by an apple-woman at the Parliament stayres.

Though people did indeed go to Islington for fresh water, there was a Spa house a few hundred yards away containing a mineral spring, also considered good for the health. It appears in two of Hollar's views. Four of the six views show what seems to be a dried-up stream-bed between banks — probably the overflow for the outer pool which, in that drought summer of 1665, was not needed. The distant trees are in full leaf; the water in the pools lies glassy-flat without a breath of wind; a man is

fishing; isolated couples sit or stroll. The impression is of a hot, late afternoon, for the shadows are deep, but on one plate storm clouds seem to be massing.

The New River had been ceremonially opened in 1613, and for the next two hundred and fifty years the Water House, with varying additions in the way of engines powered by wind or steam, played its role in London's water supply. By the mid-nineteenth century, open reservoirs where one might fish and picnic were becoming a thing of the past, but the site remained in watery use as filter beds, and finally as the headquarters of the Thames Water Authority. Only in very recent years has it lost its long-term connection with the world Hollar depicted, and a vestige of his Water House, with later accretions, is still to be found at the back of Amwell Street.

Chapter X

Casualties of the Times

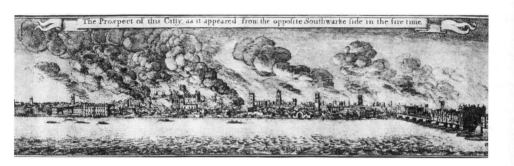

The Prospect of this Citty, as it appeared from the oppofite Southwarke fide in the fire time.

. . . Till the Restoration of the King he was certainly fully employed, and might then have soon amended his Fortune, with the Return of so many of his Friends, and the Restoration of Peace and Freedom; but the Smallness of the Price paid him by the Undertakers of these Works kept him still low . . . taking Advantage of the poor Man's Necessity in the Sickness time, 1665. which put a Stop to all Works of this Kind; and the Fire of *London* happening the Year after, so stagnated all Affairs of Prints and Books, and reduced him to such Difficulties, as he could never overcome.

(George Vertue)

Between last year's end, when my Lady and I returned hither from Oxford, and this year's end, the Great Fire in London seems to stand, as 'twere, a mark point, dividing the one time from another. In people's minds, many things are changed, even as the Fashions here at court are entirely changed.

There is yet much talk of the Fire, every person recalling just where or how they first heard news of it, and telling their own tale or that of their friends — how this one took in another's goods to save them, and had his own house burnt the day after; how that lady was obliged to

pay as much as thirty pound to have her things removed by a carter or a boatman – though, to be sure, all tales are at bottom the same tale. In truth too, the Fire in the city, for all its dread effects on commerce and fortunes, passed by us here at Whitehall. For all that there were great fears for one day that the flames would reach us here, I never saw them, nor did my Lady.

I can speak of the smoke and the glow in the sky, which banished the difference between night and day, making all continually like to a red, angry dusk or dawn, but with unnatural heat in the air. I can speak of the distant noise to be heard all the time like a great wind, increasing as the flames came nearer to this side, with the sound of falling timbers and roofs borne to us on the real wind that blew, and then the reports, like cannon fire, of houses being blown up with gunpowder to stay the flames. I can speak of the black smuts, of ash and cinders mixed with unburnt plaster fragments, that rained upon us like an evil shower of hail even here in the gardens of Whitehall, making all filthy, and of the pieces of cloth and paper, many half charred, that blew everywhere – it was said afterwards that on the strong gale papers were carried as far west as Windsor. Alas, much of the stock of the printers with whom my father deals, that was stored for safety's sake supposed beneath St Paul's, must have been among these tattered leaves on the wind.

I recall well – who does not? – seeing the river hard by here thronged with boats, half jammed together, in a confusion of shouting lightermen and distressed voices, as London people tried to make away with their things upstream. Indeed, many of the richer sort landed here at the Whitehall stairs and took refuge with members of the court, where some of them are still lodging to this day, as confined for space all together as caged linnets, awaiting till their houses can be rebuilt. Lord S—— told me that the goldsmiths transferred all their money hither in chests, and merchants their bills and records. But others say that much of what these papers represented perished in the store houses of the Royal Exchange. The East India Company's stock of pepper was stored in vaults there, and when that fine building was consumed by the Fire, the scent of the burning spice made the eyes water and stung in the nostrils.

They said that the Lord Mayor was quite overborne by events, standing hatless in the street, crying, 'Lord, what can I do? People will not obey me', desperate to persuade the people to have their houses which were in the path of the fire pulled down, which of course they would not. They say that in the end both the Duke of York and His Majesty played a fine part in ordering matters, and that His Majesty returned from thence all grimed with smoke himself.

I can picture him, such a dark man as he is even new come from the bathhouse and in fine array.

But what I most chiefly remember for myself, as we stood in the garden close near our apartments with our eyes ever turned in apprehension to the east, were flights of birds arising above the red glare, continually circling. And when they flew nearer to us we saw they were flocks of ravens and pigeons and doves, borne up on the heat, some of them tumbling in the air as if drunk on account of their singed wings. And when some few doves landed near us, then they staggered and could not walk, and we saw their feet too were singed and charred. We heard afterwards that these poor creatures had been loath to leave their dovecotes and their accustomed roosts among eves and chimney pots, and that many had thus been overtaken by the flames. For birds and animals, like humankind, are wont to think of their homes as places of safety, and so die there come what may.

On the Wednesday, as Fate turned on the turn of the wind, Holborn was spared. The flames had leapt the Fleet valley the day before, and we heard of two houses taking fire near to St Andrew's church, and to the south of there 'twas all burnt as far as Fetter Lane and the Temple, but St Giles's parish escaped unscathed.

Yet how thankful I am that last winter, when the Plague had done its worst there, I induced my Father and my Good-mother Honora, with many entreaties, to rent out the house in Holborn to another and to remove to lodgings here in Westminster, nigh to Whitehall. For now that there be so many that have seen their houses destroyed in London itself, such accommodations are near impossible to find, or only at an excessive rate.

It was Honora I chiefly sought to persuade, since the house in Holborn is now her property and she was desolate there from the loss of all her own kin save Samuel, the ribbon-seller. 'My little sisters will be better here in Westminster,' I said. 'The air is better, less soot and no smells of piggeries or breweries; they will cease to grieve and ask for their cousins and their other playmates who are no more.' In truth, I meant: *You* will cease to grieve so and to oppress my father with your sorrow — he who has had sorrow enough of his own.

My father oft-times takes decisions sudden, and keeps his own counsel. He has never been one to weigh matters with open prudence, saying, 'On the one hand this — but what think you of that?' And in the time after my poor brother's death he did naught but work like a man driven; even my Good-mother scarce saw him. Yet I know he does take note in his own heart of what is said to him, so I represented to him how a nearness to the court would help his business to prosper — how Mr Ashmole is here these days, and Mr Evelyn and Mr Pepys

often, and how important it is that such persons and their friends should know my father may be found near to hand. All of which is true. But I also wished to draw him from the society of shop-keepers who are not of his standing. A scenographer royal should not be associating with ribbon-sellers.

Samuel Roberts has lost not only his family in the Pest but much of his trade. And now, I fear, his prospects will be still poorer, for this autumn the King has put on new garb and declared his resolution of setting a fashion in clothes which he will afterwards never alter, and the whole court has followed him. Rhinegraves and ribbons are all forgot; instead, the gentlemen are in long, comely vests, after the Turkish mode, and surcoats in the place of cloaks, with Spanish-cut breeches in the same colour gartered at the knee, and all not pinked but plain velvet — His Majesty says that pinking of white upon black makes men look too much like to magpies. For myself, I find it a very fine and elegant fashion, and hope it may indeed be the definite one, just as the fine new streets and houses now being planned to rebuild London will be the lasting form the city will take.

Yet, I ask myself, of what shall we speak when there is no more need to talk of the latest fashion? Of our soul's health? Hardly, here at the court.

Almost 437 acres had been reduced, by the Fire, to a wasteland of blackened walls a few feet high, studded with burnt-out churches lacking their steeples. Many Londoners suffered the loss, not only of their homes and personal possessions but of their stock in trade as well. Innkeepers lost the accommodation which was their livelihood, and also their provision of wine and beer; merchants of other bulky, combustible materials such as oil, cloth, coal and tobacco lost goods representing huge sums. Property owners lost, along with the houses, the rents which were often their only source of income.

Among the most spectacular losses were those of the stationers, book- and print-sellers. The area round St Paul's was their traditional quarter (as indeed it was three centuries later, when the incendiary bombs of the London blitz produced another holocaust of paper). When the Fire declared itself to the east, many of them carried their stock into their parish church, St Faith's, in the crypt beneath the cathedral. They believed, not unreasonably, that this underground stone structure would be a place of

safety, and even blocked up the doors and windows for extra fire-proofing. But by Tuesday evening, almost three days after the Fire had first declared itself as a trivial bakery blaze in a lane near London Bridge, the roof of St Paul's finally caught the flames. Wooden scaffolding that had been erected for Wren's repairs caused them to spread rapidly. The conflagration was fierce and lasted for hours, helped on its way by all the merchandise of the shops in the nave. The flames are said to have made the night sky round about so bright 'you could read a book by them' – but the tons of books that were down below became fuel themselves, when the roof finally fell in and the floor above St Faith's gave way. By morning, the whole edifice was a smoking ruin.

Everything in it and under it was lost, as were stocks that had been stashed away in other churches and in Stationers' Hall nearby, with 'all the great booksellers almost undone'. John Ogilby, who lost his house in Shoe Lane near the western limit of the Fire as well, was left with barely £5 in the world – though, true to form, he was prospering again a few years later. Many copies of Dugdale's expensive books were lost, including three hundred of his *History of St Paul's Cathedral* with Hollar's prints, together with five of the original copper plates. As a further blow, Dugdale's third volume of his *Monasticon Anglicanum*, to which Hollar had also contributed, was only beginning to be printed and now the manuscript copy was burnt. Dugdale was so discouraged for a while that he thought of abandoning the project, but he was sufficiently dedicated to rewrite his volume, and published it some years later.

However, on many people the awful destruction of the Fire had a galvanising effect, and these included Hollar. Within days, with the ashes hardly cooled and fires still smouldering away in some cellars, a number of different, individual plans had been drawn up for London's rebuilding. These all tended to the classical and visionary, bearing only a slight relation to previous street-patterns (plans by Evelyn and Wren) or sometimes no relation at all (those by the cartographer Richard Newcourt and the scientist Robert Hooke). Human attachment to concepts of ownership and rights being as it is, few features from the plans got further than the drawing

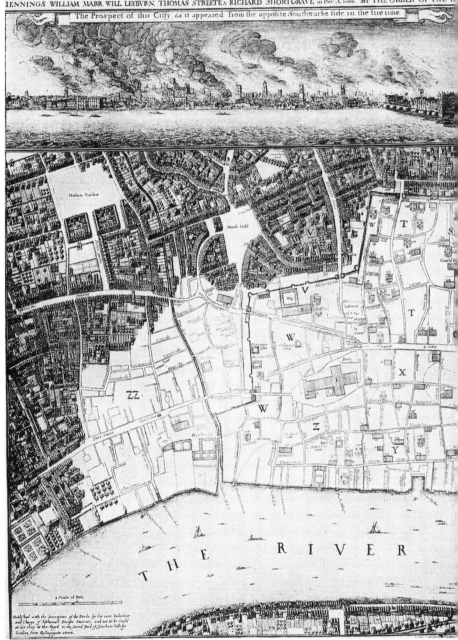

The Prospect of this City as it appeared from the opposite Southwarke side in the fire time.

THE RIVER

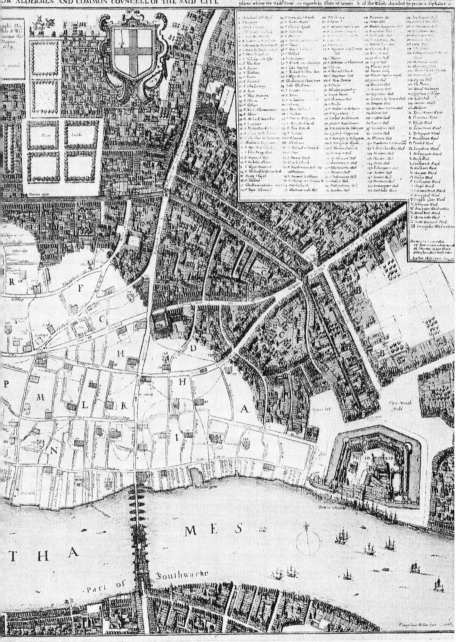

board.

Hollar, with his own attachment to place and to specific detail, was not the man to depict visions. But he felt passionately that there was a role for him; the fires were hardly out when he was at work on pictures of the devastation, including Before and After views from across the river in Southwark – his accustomed vantage point. The Fire had burnt from the early hours of Sunday, 2nd September to late in the night of the 5th. By the 10th Hollar was renewing the representations to the King that he had made concerning his Great Map project half a dozen years before. Nothing much had come of that in 1660, in spite of royal promises, and now the London he had proposed to 'depict in its entirety' lay in ruins around him, but he hoped to turn this disaster to his own advantage. Innumerable legal documents had been burnt: London, he pointed out, was going to be badly in need of reliable plans on which land claims could be based.

In response the King, ever ready to give an amiable reply, requested the Lord Mayor and Aldermen of London to assist Hollar, along with a genealogist and member of the College of Heralds called Francis Sandford, in any way they could, saying that he had appointed them to take 'an exact survey of the city, as it now stands after the calamity of the late fire'. The result of this was a remarkable combination map, which has been reprinted in every era by historians of London and of disasters. It shows the one unburnt portion of the City proper, and also its undestroyed outskirts, in bird's-eye view (like the projected Great Map), while the centre is in two-dimensional street-plan mode. The inscription explains '. . . The blanke space signifeing the burnt part & where the houses are exprest, those places yet standing.' Another edition has the superscription 'cum privilegio Regis'. Prominent buildings are numbered or letter-coded, and a key lists all the destroyed City churches and Livery Company halls. It is marked 'Sould by Iohn Overton', whose address is variously described as 'little Britaine, next doore to little S. Bartholomew' and (added by another hand than Hollar's) 'neare the fountaine tavern without Newgate'. Both indications point to the same area of streets, behind Smithfield, immediately north-east of old London wall, where the fire was indeed stopped by demolitions, so it is

likely that Overton just missed being burnt out.

On 22nd November, Pepys (whose own house, emptied hastily of goods, had narrowly escaped the Fire), wrote in his Diary:

> My Lord Bruncker did show me Hollar's new print of the City, with a pretty representation of that part which is burnt, very fine indeed; and tells me that he was yesterday sworn the King's servant, and that the King hath commanded him to go on with his great map of the City, which he was upon before the City was burned, like Gombaut of Paris, which I am glad of.

Evelyn also saw this print, and wrote to a friend in December that since it seemed to be 'the most accurate, hitherto extant, has caus'd me something to alter what I had so crudely don' – that is, his own plan for rebuilding London.

The reference to Hollar being 'sworn the King's servant' refers to the fact that, the previous month, having presumably completed his first draft of the burnt-area map, Hollar petitioned the King for official status as His Majesty's Scenographer. This would, he said, protect him 'that no person may copy or cause to be copied such things as he may produce by his own study wit or industry'. (One wonders if Ashmole, that keen lawyer, had a hand in helping Hollar to word this?) He also added that the title would assist him towards finishing his Great Map – seizing the opportunity to remind His Majesty again of this. He received the coveted title, for which he had to pay a set fee, but apparently no particular long-term benefit.

The following year, when the immediate professional opportunities provided for him by the Fire were past, Hollar made one more attempt to ask the King to help to complete his 'monument and masterpiece', saying that he had already spent seven years and run £100 into debt for it. (Perhaps in paying others for the time-consuming work of taking precise measurements?) The Great Map seems all along to have been the central aim of his labours, with the Fire prints incidental to it. He also enlisted the help of Evelyn, who paraphrased Hollar's petition and forwarded it to

appropriate people at the court:

> . . . has made numerous plans of places in Europe, monuments, ceremonies &c. to illustrate history, and a plan of London before the burning, which none can complete but himself. was sworn on these account ichnographer to the King, and paid his fees, but has received no benefit nor salary, to encourage him to finish his great work of the city. Mr Williamson promised to get him some present from the King, towards his great work of the city, but failed, and his task is in danger of being unfinished, and the ancient record of the city irrevocably lost. Begs some support. Wishes to offer Williamson some of his works. Thanks for his kindness whilst in the service of his late patron, The Earl of Arundel.

The Williamson with whom Hollar needed so painfully to ingratiate himself is surely Joseph Williamson, who was then the Keeper of the King's Library in Whitehall and who had, that same year, been appointed President of the Royal Society. But it is hard to see just how kind he could have been to Hollar in the Arundel House days, since he was only a child at the time. Most of the influential people to whom Hollar had to look for help and employment these days, including Ashmole, Pepys, Evelyn, Arundel's grandson Henry Howard, and indeed the King, were many years younger than himself.

Well might the antiquarian-minded Evelyn support Hollar in pointing out that the record of the City was in danger of being 'irrevocably lost'. The City itself was lost, in its previous form, and more materially-minded men no doubt felt that this made Hollar's previous work on it not more valuable but much less. Hollar petitioned the King that 'now the city being destroyed, no man living can leave such a record to posterity of how it was as himself'. But that very reference to his Great Map's essentially historical quality probably did not help him. In 1667 new buildings were going up all round. King Charles had many other things on his mind, and calls on his empty purse, than funding records for posterity.[1] So, inevitably, had the sympathetic Pepys and Evelyn, busy respectively with the Naval Office and with the need to create a military hospital.

Aubrey, whose own turn of phrase seems to be echoed in Hollar's petition, would certainly have helped him materially if he had been in a position to. In later years, in his own *Naturall history of Wiltshire*, floating the idea of a book describing all the landed seats of England, he wrote:

> If these views were well done they would make a glorious volume . . . it would remain to posterity when their families are gonn and their buildings ruined by time or fire, as we have seen that stupendous fabric of Paul's Church not a stone left on stone, and lives now only in Mr Hollar's Etchings . . . but so few men have the heart to do public good to give 4 or 5 pounds for a copper plate.

Such a sum was, as he also pointed out, 'an inconsiderable expense to . . . persons of quality'. But Aubrey, who elsewhere modestly attributed his preoccupation with old stones to the fact of his being 'an idle fellowe', was not of that sort of quality. The landed gentry from whom he came were impoverished; and he was perennially failing to marry a rich wife who might have rescued him from his difficulties.

We hear no more of Hollar's 'monument and masterpiece' after that year — a sadness and a loss for posterity indeed; for Hollar himself, perhaps, a stifled tragedy. He was now sixty years old, with no son to follow him, and even he, with all his energy, must have realised that stamina, health and hope are finite.

They say that Mother Shipton, a wise woman out of Yorkshire in times gone by, foretold the burning of London, and the Contagion the year before also. Mr Richard Head (whom I have met when I was with my Lady at Oxford) writes so in a book that is much the fashion here at Whitehall. Certainly, as the years turned towards the three sixes, and the comets were seen, there were many who prophesied that disasters would take place and that it was written so in the Bible. But then, if all is fore-ordained, are we not then mere playthings of Fate, and appeals to God are but the vanity of flies if flies would appeal to men?

I have heard more than one gentleman here at the court say so. They count themselves followers of old Mr Hobbes — for whose great book (which I have not read, for it looks to be long and hard) my father sculpted Mr Hobbes's likeness. These court gentlemen be, in the

main, great gamesters and drinkers, men without scruple, the likes of Richard Head indeed and John Wilmott, the young Lord Rochester, and little Johnny Crowne the latest playwright, and I would not place myself only beside such rake-hells. But it is said also that His Majesty much likes to dispute with Mr Hobbes, whom he calls his bear. And Mr Aubrey, my father's firm friend, is also a great disciple of Mr Hobbes whom he knew from his boyhood in the West Country. I believe that Mr Aubrey concurs with Mr Hobbes that the Last Judgement is but a childish notion. Yet I have observed that Mr Aubrey is no less kind a man to others for thinking that.

I remember, too, Dr Harvey; and how my father took me to see him last when he lay dying of a palsy, in that fine house in London near the Dutch church, that 'scaped the Fire and where Mr Ashmole now has his office. Now Dr Harvey was a man of great wit and cunning, knowing many things about our mortal bodies that others do not, and I saw that on his death-bed he was concerned not at all with his immortal soul but rather to bestow on his nephews a few trifles as mementoes, that he might not be forgotten. I do not think that he believed he was bound for Heaven, any more than poor beasts are, for I myself have heard him say another time that we humankind are but animals with a conceit of ourselves.

And I cannot help but feel there is an intelligence in such reasoning, which is not found in the minds of such devout believers as Mr John Evelyn, however learned they may be. This troubles me much.

My father, too, likes to invoke Fate, but his notion of Fate is that it is benign. It pleases him to recount how Fate decreed that he, a Bohemian, should become a man of London and make his life here. I dare not ask him if 'twas Fate, long ago, that brought Lord Arundel to Cologne and to my father's door, then was it not Fate also that closed another door — that of the lodgings in Clare Market, nigh to the workshop, where my brother was wont to stay? For one of the people of the house took sick, in the September it was, and so the house was sealed with a great padlock and Jamie within it. My Good-mother Honora has told me that our father came each day to the door, bringing food and money to be passed in through a hatch and phials of physick from Mr Boghurst also. The watchman was always there and no one from within could come even to the threshold. And I was in Oxford all the while and never even knew.

We none of us set eyes upon my poor brother again — was that not Fate too? We may not even visit his grave. All in the house died, we believe, and so many died in that street at

that time that all were cast into one common pit, I know not where. And if my father knows, he will not say. He never speaks of these things.

I know it distresses my Good-mother very much to think that my brother, whom she had come to love almost like a son of her own, has no known grave, and was perhaps not even decently laid to rest. But she comforts herself with the thought that she will see him again, in some better world, somewhere above the blue firmament, along with all her own kin who perished at that dreadful time.

I wish very much to believe this too. For my own mother's sake I would wish it, she who had me baptised a Catholic. Oft-times, I can believe. But then, in the nights, when I am awake and the wind sighs and the rain beats senselessly on the panes, and on the just and the unjust, then I think:

There is nothing, truly, above the sky.

The sky is not the floor of Heaven, it is not a firmament. The new Science, of which we hear so much these days, teaches that to all with eyes to read or ears to hear.

And I think that I shall never, ever, in any place meet my dear brother again, nor yet our mother. And the twain of them, also, are apart from one another and alone in darkness for ever.

. . . I have, of late, been so troubled by these thoughts — I mean, not only troubled by the thoughts themselves, but also troubled at other times by their sinfulness and my own abandonment to them — that I have confided something of my distress to little Blagge.

Margaret Blagge is one of the Maids of Honour, formerly to the Duchess of York and now to our poor Queen Catherine. She is very different in spirit from the generality of the Maids, of whom the light joke goes that they are neither Maids nor Honourable. She is some years younger than I, but she is so Good, so devout and yet withal so kind and frank, that I felt quite drawn to open my heart to her as we sat sewing together. I knew that my words would remain with her and not be divulged to another. I can bear that she should know the secrets of my soul for she is too good-hearted to scorn me, but others would not be so gentle were they to hear of it. In particular, she promised of her own accord that she would not divulge a word of this to Mr Evelyn, for all that he is her especial friend and she is his 'seraphick', as the term goes.

She listened to my folly with real attention, but said simply at the end that I am perhaps mistaken to think that, if the heavens are not as men once supposed, then Heaven is no more.

But she had well understood the drift of my discourse, for she told me then of how much Mr Evelyn himself, despite his firm Belief, had suffered at the loss of one little child in particular. She said that he still mourns this son, even after these many years and the birth of another. Mr Jeremy Taylor, who is Mr Evelyn's confessor, and who himself lost children in sad circumstances during the late Wars, at that time wrote to Mr Evelyn, and he cherished the letter and has shewed it to Margaret. She quoted a part of it to me from memory. I had her repeat it, to commit it to my own heart:

'Remember, Sir, your two boys are two bright stars . . . Their state is safe, and Heaven is given them upon very easy terms . . . Do but consider what you would have suffered for their interest; you have suffered them to go from you, to be great Princes in a strange country . . .'

Her eyes were bright with tears as she repeated this, and mine too no doubt. I wish I could truly believe in that strange country. It must be very far.

She also told me that Mr Taylor had bade Mr Evelyn be especially good to his wife, so that he might be more to her than many sons; indeed, after the loss of this child and another baby, he took her on a journey to many parts of England by coach to distract and cheer her. I was glad to hear it, for we see Mr Evelyn so often now round and about Whitehall; his fondness for Margaret Blagge is a matter of common comment, and I have sometimes asked myself how this must appear to Mrs Evelyn? 'Tis said that she tried court life herself for a little while at the Restoration, but it did not please her — or it did not please Mr E. on her behalf. The other Maids consider that he has a forbidding countenance somewhat like a schoolmaster and they are inclined to pity his wife.

I am sure for my part, knowing Margaret as I do, that her friendship with Mr E. is a sinless passion, a true meeting of souls, but you may be sure that people there are a-plenty to smirk behind their hands at 'little Blagge' and 'lofty Mr Evelyn', who is more than old enough to be her father and who constitutes himself her religious mentor.

I also hear — tho' I did not say this to her, and she said naught to me — that she is privily promised to Sidney Godolphin, a very fine and decent gentleman tho' one more abroad on embassies than at home. I cannot think that, for all his religious fervour (or perhaps on account of it) this will entirely please Mr Evelyn.

She was for witt beauty, good-nature, fidelitie, discretion and all accomplishments, the most choice & agreable person: that ever I was acquainted with . . . She had more particularly honord me with a friendship of the most religious bonds, & such, as she has often protested, she would even die for with cherefullnesse.

(John Evelyn, in his *Diary*)

. . . *I should so like to have a man as a true friend, as my dear brother was to me and as I believe my father is, in his own distracted way, to my Good-mother Honora. But here at the court, tho' I meet so many and the years go by, I feel I have as poor a chance of such a friendship as I do of marriage. For Seraphick bonds are not, in general, the way of the world, and, as to marriage, who here will marry me, without a fortune as I am? My Lady took me in to be her waiting woman for love of my mother's memory and as a favour to Mr Aubrey, but it is not she who will try to marry me off, for why should she when I suit her so well? I am a servant when we are in fine company, and a comfort when I am alone with her — 'Good Hollar, fetch my shawl that I believe I have left in the garden' . . . 'Margaret, my child, you will not fail to brush Blondine this morning? The poor little creature was disordered in her stomach last evening' . . . Nor do I receive from her as much as some might think my due in the way of dress. More than once, to my shame, I have had to have recourse to my father's purse, and his ready generosity in such things, to clothe myself fittingly. It is a necessity here at court, and this he well understands.*

Lady L—— herself has but slender means with which to keep up a becoming style, she being a widow, and with a son in sparkish garb now in Whitehall too and looking to find some corner, if you please, among the Gentlemen of the Royal Bedchamber. And here, to be fair of face (for it would be foolish to pretend I am not) does not turn men's minds to matrimony but rather to their livelier desires. And it is hardly our Sovereign who sets a model for wedlock, for he is as inconstant to the Queen as he is to his other ladies, but that is another matter of which I should not speak . . .

Mr Aubrey, I know, has always admired me, ever since he met me as a little maid in my father's house. But Mr Aubrey has no fortune either; indeed, he is lately entangled in a Suit at Law about money, together with a lady he had earlier intended to wed. We hear that he has gone into Oxfordshire to stay with friends, out of the way of creditors.

*

. . . For all that my Lady would never countenance a match between her son and myself, she is not averse to his 'squiring me, especially at the theatre. For a while, I did not comprehend why my Lady is happy for Lord L—— to be seen in my company. Only now that I have grown in years and worldly wisdom do I fully understand that some men, especially when young, are lovers of boys, not women. For all they may pretend to sigh at the feet of Mistress Castlemaine or Palmer — or little Roberts, who gives out that she is the daughter of a country parson, and is said to be a connection of mine by my father's marriage, but I would fain not know that.

So my Lady is happy enough that her cherished boy should be thought to be attentive to me and perchance enjoying my favours. More knowing tongues may thereby be stilled, and, like a sprat to catch a mackerel, I am to be the means by which a fat heiress may be — not 'courted' but 'caught' for him.

I am sure that my poor father, when he got me my place in Whitehall and was so glad for me, did not foresee that I should be used in this way. For all that he himself is even now in the company of the great Lord Arundel's grandson on the high seas, I think he has never truly understood the ways of the world. Has he not married twice in his life for love, as he has more than once told me? He has gained thereby love, no doubt, but no profit, only great expenses and cares that weigh on him continually.

I cannot hope for love, that I know. But while my blood is yet young and hot, surely it is not such a great sin to want something other? Is my whole life to be dry desert, until I am an Old Maid in the corner?

The King, I know, has noticed me. Surrounded though he always is by others, yet when I am in his presence at receptions, in the gardens or yet at Church, I feel his black eyes upon me. They are drawing me to him.

Times I tell myself that my stored Virtue is my chief quality, and that he is but a man like many men, with a ready purse, a big —— and a healthy constitution, caring so little at bottom for others that he minds not even my Lady Castlemaine's inconstancies.

And at other times I know that he is my Sovereign Lord, the sun in the sky round which all the palace turns. That I swoon even to dream that he might one evening call me to him, and that never could I refuse such a call.

The Restoration court was, famously, a place of beautiful women and of extra-marital couplings. The portraits it produced are very different from

the demure or patrician likenesses of the wealthy from the early Stuart period; they proclaim a message of pagan carelessness and luxury. Although the subjects may be nominally arrayed as a shepherdess or the virgin goddess Diana, or as the Virgin Mary herself or as St Catherine (a token salute to the Queen, whose own antiquated Portuguese style *was* demure and restrained), canvas after canvas actually shows one or another young, lovely, bold-eyed woman of the times.

Billowing, informal draperies suggest that the wearer has either just got up from a couch or is just about to fall backwards on to one. The formal arrangements of lace and jewellery set off by black velvet, which are to be seen, for example, in Hollar's earlier fashion plates, have been abandoned in favour of brilliant, gold-sheened silks and diaphanous Indian gauzes half slipping from the shoulders. Lawn under-shifts are barely retained in place by the careless opulence of large brooches. Single strings of pearls, clasped round the neck, repeat the nacreous tints of exposed, fine flesh. The hair, invariably curled, is no longer pulled back from the forehead or restrained into elaborate chignons, but cascades in a fine imitation of childlike naturalness. (This was also the time when luxuriant periwigs of long, curled hair came in for men; by the 1670s even the austere Evelyn had adopted one, and admitted that it made him look younger.) Cumulatively, the effect is a potent mixture of amoral innocence and over-ripeness. These loose garments did not demand a trim figure, and indeed many of the women must have been 'big-bellied' when they were painted. Barbara Villiers, Lady Castlemaine, Charles II's *maîtresse en titre* for most of the 1660s, bore him five children in as many years, and he had another seven or eight by other women — a flagrant sign to his unfortunate Queen that the barrenness of their marriage was wholly attributable to her.

Peter Lely painted Castlemaine, as he did her successors Louise Keroualle (a French Catholic), Frances Stewart, and several others including Nell Gwyn ('Nay, good people, I am the Protestant whore!'). Even devout Margaret Blagge, who kept well apart from the loose morals of the court, acceded to her mother's request that she should be painted by Lely in the overblown rose style. By the 1670s the young girl-children of the rakes and

courtesans of the previous decade were also appearing in paint, in the same *fausse-naïve* nymph guise.

> . . . [Hollar] haz a daughter, that was one of the greatest Beauties I have seen.

Women did not have to be of distinguished origin to join the 'Windsor Beauties', if their looks and manner warranted it. Lord Rochester's friend and bedmate, Jane Roberts, who was also briefly the King's bedmate and who, like Rochester himself, eventually died of a combination of syphilis and the mercury that was used to treat it, was of obscure birth. But perhaps she was not quite as obscure as Nell Gwyn, 'the darling strumpet of the crowd', with her long-remembered oranges.

If, indeed, Hollar's daughter moved in circles where 'being a Beauty' was a generally recognised role, as Aubrey's fleeting reference suggests, then she would not have been at all socially out of place, though it is true that her chances of marriage would have been another matter. For reasons to do with family, money or the lack of it, and employment through patronage, many seventeenth-century women remained unmarried. Aubrey, normally assiduous about adding such details – often noting, when he does not know them, that he must '*quaere* So-and-so' to learn a name – mentions no husband for her.

One may perhaps wonder that Hollar himself never used his daughter as a model, but by the time she was grown up the *Theatrum Mulierum* was long behind him. A new generation of etchers, following where he had been the first to tread, was turning out copious prints of ladies who were not personifications of style or season but named celebrities. Meanwhile Hollar was addressing his remarkable skills not to the depiction of furs and thin veiling but to the intricacies of Gothic tombs. Did no one else feel moved to record his daughter's loveliness, or was maybe paid to do so? There are a number of oil paintings of this period the identities of whose sitters have been lost. Somewhere, perhaps hanging in some out-of-the-way place, the young Mistress Hollar's face may yet look out opaquely on a world of altered people and places that no longer recognise her, or know how her life went.

<div align="center">*</div>

It is ironic that, in their portraits, the stars of Court and fashionable circles appear to be living in a perpetual hothouse, complete with grapes. Or else they are in some idyllically balmy land that might be Italy or might be still further off, judging from the black or brown child-servants who make occasional appearances at this time. Ironic, because the second half of the seventeenth century and the first half of the eighteenth actually saw some of the coldest winters on record. The famous Frost Fair on the Thames which lasted for weeks, with the roasting of chestnuts and oxen, and a fox hunt on the ice, was not till 1683–4, but in at least half a dozen winters between 1660 and 1680 the river froze above London Bridge. Even in years when this did not happen, frost and snow were a regular event. No wonder so many tons of coal were burnt in London, leading Evelyn to complain in a famous essay on pollution, the fore-runner of many others:

> It is this horrid Smoake which obscures our Churches and makes our Palaces look old, which fouls our Clothes and corrupts the Waters . . . the very Rain . . . and kills our *Bees* and *Flowers*.
>
> (*Fumifugium*)

Evelyn, a much-travelled man, pointed out that the 'venemous vapours' of coals were prohibited in several European cities to protect the delicate trades of dyers and weavers. He suggested that, as in Paris, wood should be burnt in London rather than coal, and that in this intention, as well as for ship-building, many more trees should be planted. He was a great planter of trees in his own gardens in Deptford, a place just far enough from the 'horrid Smoake'. One must suppose, therefore, that it was beside a fire of logs that Mrs Evelyn wrote to a man friend in December 1669:

> The flowers and greens . . . are candying in snow to be preserved for the Spring, and our delights confined to the little wooden room . . . a dull fire circled with a philosopher [her son's tutor], a woman and a child, heaps of books, our food and entertainment, silence our law so strictly observed that neither dog nor cat dares transgress it, the crackling of the ice and whistling winds are our music which if continued long in the same quarter may

possibly freeze our wits as well as our pens . . . So stupid hath the congealed air rendered us . . . I am inclined to believe myself a tortoise, a good secure invention.

Wenceslaus Hollar, born and raised in eastern Europe, is not likely to have been perturbed by severe winters. However, he missed the 1669 spell of cold. For he had gone to a genuinely warm place: he was in Tangier. It was the furthest he had ever been, and it was to be his last great journey.

Chapter XI

The Last Adventure

When Charles II married Catherine of Braganza in 1662 it was not for love or mutual attraction. This was a dynastic alliance between two world sea-powers and she brought as part of her dowry two Portuguese trading stations: Tangier on the North African side of the Straits of Gibraltar, and the island of Bombay on the western coast of India. Of the two, Tangier was regarded as a strategically important bastion against the naval power of the Dutch, and the English were much more impressed by it than they were by remote Bombay. The merchant adventurers of the East India Company had had their eyes on Bombay for some time, but Pepys, wearing his Admiralty hat, called it 'a poor little island', offering little but coconut groves and rice paddies. In any case, ships took so long to make the passage there round the Cape that when the company despatched by Charles II did finally arrive, to claim it for the British Crown, they were vigorously repulsed by the local Portuguese agents, who said they had no knowledge of any arranged handover. The island was not ceded to the British till 1665. In the meantime it was Tangier and its possibilities that had been exciting interest at home.

It was said that if the Dutch had got their hands on it, they would have at once have built a 'mole', an enclosed, fortified harbour on the Dutch model, by which to dominate trade in and out of the Mediterranean. A mole, therefore, was what the English should build, and in 1663 a team was

sent out to survey the terrain and to make plans. Christopher Wren, that fast-rising star, was approached but turned down the invitation. The most gifted man in the eventual team was Jonas Moore, the mathematician and Royal Society fellow, yet another of these energetic scholars of the time who were applying abstract knowledge to practical ends.

Moore had worked on the East Anglian fen-drainage project in which William Dugdale had taken a great interest. Hollar must have met Moore in Dugdale's company, for some of the Fen maps were engraved by him. Now, on his return from Tangier in 1664, Moore got Hollar again to engrave the maps he had drawn. Although it was Faithorne who was now the accredited royal engraver and did many plates for the Royal Society, there is evidence that he was taking on too much work. A letter written towards the end of 1664 from Hooke to Boyle concerning a publication contains a reference to:

> ... the engraver, who is not an Englishman but one, that I find a very good workman, and very punctual to his word; which was the reason I did not employ Mr Faithorne, as you directed, he having so very often and often disappointed my expectation.

Is this another of those fleeting references to Hollar, who was still here, there and everywhere, but often not entirely visible? Three years later, it was Hollar who was chosen by the Society to design the frontispiece to their own *History*.

His engraving of Moore's map was used as something like an early investment brochure, for the general idea at that time was that there was money to be made in Tangier. Moore himself did well out of the project, and possibly Pepys did too: at any rate, Pepys liked the map enough to frame it and have it hung up.

Hollar too, preoccupied as ever with the need to improve his finances, may have hoped belatedly to emulate these men and their acumen, but I think there was another reason why he became enthused with the idea of going to Tangier himself.

At this point, the Arundel family re-enters the picture. The Collector

Earl's eldest surviving son had died during the Commonwealth, not many years after his father, but he left five sons behind him. At the Restoration the dukedom of Norfolk, lost under Henry VIII and so desired by the Collector Earl, was bestowed once again on the family, a reward for their unflinching royalism and a covertly sympathetic royal gesture towards their Catholicism also. The current Duke was Thomas, he who had been painted as a little boy in a red jerkin and was now, sick in mind, living in seclusion in Padua. But the next son, Henry Howard, who eventually inherited the dukedom, was in England and flourishing. He and his first wife, the daughter of the Marquess of Worcester, had spent much of the Commonwealth quietly at Albury. Here, Henry Howard, now in control of the family finances, managed to sort them out and pay off the immense £200,000 debt his grandfather had left behind him. He also did further work to embellish Albury, with the help of John Evelyn, who had been the Collector Earl's young advisor some twenty years before. Together they canalised the little River Tillingbourne that Hollar's prints depict and turned it into a formal water-garden, rebuilt the grotto as a 'Roman' bathhouse (apparently the family obsession) and made a secret passage to it through the hillside from the next village.

With the Restoration, Henry Howard also resuscitated his grandfather's dream of rebuilding run-down old Arundel House in the Strand as a modern Palladian palace facing the river. This new plan (by Robert Hooke, of the Royal Society) was designed to use some of the surrounding gardens for terraces of modern houses to be lucratively let. There was a further suggestion of building a permanent 'college' for the Society within the remaining grounds of the main house. Here again Evelyn was very much part of the scheme. In his Diary for 9th January 1667 he recorded:

> To the *Royal Society* which since the sad Conflagration, were now invited to sit at *Arundel* house in the strand, by Mr Howard, who upon my instigation likewise bestowed on the *Society* that noble *Library*, which his Grandfather especially & all his *Ancestors* had collected: this Gent, having so little inclination to bookes, that 'twas the preserving of them from imbezilment.

He had already noted Howard's over-generous tendency to give away books, pictures and other valuables from the Collection to 'priests, painters and panders'. Later the same year, when Evelyn examined the Arundel marbles – 'these precious Monuments . . . miserably neglected, & scattred up & downe about the Gardens & other places of Arundell-house' – he easily convinced Howard to donate the lot to the University of Oxford. Evelyn's intentions were no doubt good and without self-interest. But in practice neither the Royal Society nor the University looked after these bequests as they should have, and in this way what had survived of the great Collection was finally dispersed and much of it lost.

Henry Howard was, however, an able and intelligent man in practical matters, as his presence in Royal Society circles would suggest. He had already been on a diplomatic mission to Vienna and Constantinople. In 1669 he was chosen to lead the second expedition to Tangier to report to the Crown on the state of the new colony there and to try to negotiate a trading treaty with the 'Emperor' of Morocco. It was hardly a mission as grand as Lord Arundel's journey through Europe to meet the Holy Roman Emperor during the Thirty Years War, but it was still a royal embassy in the same spirit. Hollar, no doubt informed of it and encouraged by Evelyn,

decided to join it. Who said that the past could not be brought back, and his old, happy situation in the bosom of a great family regained? He had always loved ships; they are among his favourite subjects, but he had never till then been on a sea voyage longer than the Channel crossing. It was an opportunity to be seized.

MEMORIALL of W. Hollar, March 1668/69.

If it may please to his Majestie to send me with the Lord Ambassador Henry Howard (with whose Grand-father I was in such like Employment) and allow me one Hundred pound, towards the fitting of my selue and leaving my House and Family in good condition, in my absence, Then I will adventure my owne Person and time, and give account to his Majestie (God willing) of all what is worthy to be observed in those parts, especially the City of Tangier, for although there is a large Map thereof, & done by my owne Hand, but the same being performed onely upon the Authors tradition by word of Mouth, and my owne bringing into Method (Except the dimensions of its Circumference which I question not) I conceive, that if one should compare the Print, with the thing it selue as I intend to doe if I come thither he should find but little likeness, and perhaps a quite another thing whereof partly I know some Considerable faults already. Therefore I would Examen all, and take designs thereof on all sides, and give to his Majestie much better satisfaction, although the other had (by report) more for his paines than I doe require here, which proffer I account to be feasible and worthy of acceptance, and pitty if neglected by such Opportunity.

Wenceslaus Hollar

his Majesties Scenographer

or Designer of Prospects.

Whether or not Charles II appreciated being told in Hollar's customary, rambling, not-quite-good-English style that it would be a pity if he lost this chance for a bargain, apparently Hollar received the requested £100. This should secure the comfort of Honora and the children during a prolonged absence: in the event, he was away just about a year.[1]

Howard and other notables, Captain Kempthorne and a handsome fleet of ships set sail from Plymouth in late July 1669. They evidently made good time, via the Scilly Isles, the Bay of Biscay and Cape St Vincent, for the date of the first 'Prospect' Hollar drew of the fortifications of Tangier shows that they had landed and settled in by September. The colony then consisted of a garrison of some 1,200–1,400 officers and men, plus a civilian population of a few hundred: these included English merchants and various others – Portuguese, Spanish, Dutch, French, Italians and Jews, also some Portuguese monks whom the English regarded as trouble-makers. With its warm sea-coast climate, Tangier seems to have been a pleasant enough place for a few months' stay, but it was very isolated and confined, since going beyond the walled limits of the settlement was not safe.

This time there is no William Crowne on hand to give us the daily details of their life, but what is documented in official communications is the frustrating nature of Lord Howard's attempts to do business with the Emperor. The Moors, as the Moroccans were known, were accustomed to making raids on Tangier and burning crops planted outside the walls. They were unaware of the conventions of European diplomacy, and in any case had a policy of not being friends with more than one or two European countries at a time; it suited them better that these predatory northerners should be divided among themselves. By and by the Emperor, ignoring messages about the gifts that the King of England had sent for him, dealt with further overtures by simply going off into the interior and not responding to appeals. Infuriating as this was, some of Howard's party felt a certain relief, since the Emperor had the reputation of having a vile temper and no one was quite sure that he might not summarily murder his honoured guests if they ever did catch up with him. Other dangers were dissident Berber tribesmen, and also plague, always a bogey on these expeditions into foreign parts. Another peril surfaced when a part of Howard's retinue were on their way to Salé, down the Atlantic coast, on a further abortive mission to contact the Emperor: they were pursued by some of the pirates who famously frequented the shores of Barbary.

It is assumed that Hollar was a member of this party, for he sketched and

later engraved a picture of the encounter with the pirates, which took place on 29th December 1669. His finished print was used the following year in a book John Ogilby published on Africa, one of a projected four-part series covering the known world. Hollar's print shows two English warships under the command of Captain Kempthorne (in the *Mary Rose*) protecting three other ships from six pirate vessels, with a French ship making off to one side. This narrow escape is the last-known distinctive event of Hollar's long and eventful life. He was then sixty-two years old, an advanced age in that or any other era to be on the high seas in a sailing ship in danger of enemy attack.

George Vertue, in his later short account of Hollar's life, mentions this attack, variously describing the pirates as 'Turkish' and 'Algerine', and says that eleven people were killed and seventeen wounded before the English ships made it safely to refuge in Cadiz. He adds:

> Yet, after all these Difficulties, at his Return to England, after long Attendance and Loss of Time, he could get no more than One Hundred Pound for all his Labour and Service.

As usual, Vertue has got this slightly wrong. The hundred pounds was

the advance Hollar asked for and received from the King, and he must subsequently have got quite a lot more from the sale of prints. Howard's whole embassy returned from the Mediterranean in July 1670, and it was presumably not till he was home again that Hollar began turning his material into plates. In 1673 Overton published *Divers Prospects in and about Tangier. Exactly delineated by W:Hollar, his Majesty's designer, An. 1669 and by him afterwards to satisfie the curious etshed in Copper.*

Some years after Hollar's death, Honora sold most of his large and beautiful watercolours of Tangier to the young Hans Sloane, the physician and connoisseur whose name is remembered in Knightsbridge streets and the Chelsea Physic Garden, and whose collection formed the original basis for the British Museum. They and others are in the Museum's collection to this day, with the faint stains, fold-marks and otiose inscriptions that they had picked up at earlier stages in their existence, now lovingly protected from all further mishandling. They form a detailed and poignant memorial to both the artist and his subject. The town and fortress of Tangier was clearly, by the late 1660s, quite extensive, with outposts called by names such as 'Peterborough tower', 'Whitehall fort' and 'Monmouth fort' extending over several square miles. In a nearby bay, christened Whitby, 'the Stone for the Mould is fetshed and the Workmen doe quarter'. Red-coated soldiers garrison the Vauban fortifications, tiny figures disport themselves on a distant bowling green, and the various persons who stand about on hills in Hollar's most complete and decorative view all appear resolutely English gentlemen of the Restoration period. Even the hills themselves seem to have more in common with the rolling green downs of the South Coast, complete with chalky tracks and dew ponds, than they do with the north African littoral. However, Hollar, as he promised, made a wonderfully complete record from all points of the compass, which would have been useful for many years to come and invaluable today – except that, in 1683, Charles II decided to abandon the whole useless, expensive place to the Moroccans. He had all the fortifications blown up first; the newly constructed and never completed mole took months to demolish entirely. Except for a few segments of wall buried in the Casbah, not a trace of what

Hollar saw and recorded remains today, either on the ground or as a significant part of history.

One may therefore feel it was rather a pity that it was not to the other part of Queen Catherine's dowry that fate directed Hollar. For it was Bombay, that 'poor little island', that was subsequently to develop into a key centre of British colonial trade and eventually into a world-class city. Of the Portuguese trading post at which the English arrived in the mid-1660s to stake their claim, we have only a fleeting, retrospective 1670s' description by John Fryer, surgeon to the East India Company, and no pictures. How good it would have been to have had several of Hollar's passionately detailed and accurate representations of the fortified *quinta* on the foreshore, complete with 'a delicate garden voiced to be the pleasantest in India'. The shell of this house remains today, buried deep within the Indian naval establishment in the heart of downtown Bombay. Hollar would have shown us the four brass cannons, the guards in Portuguese pantaloons, the small men in turbans tending the garden, the background of sea-creeks and rocky hills . . . Or would he, somehow, have made even India look rather like his adopted homeland?

When Wensel knew that he was to accompany young Mr Howard — or Lord Howard, as I should say now: a very pleasant gentleman, it seems, and not half so much the Great Lord as his grandfather — he, Wensel, was much pleased. He had great expectations of this voyage, for diverse reasons. And also because, he said, old Mr John Tradescant the father, whom he met but the once at Arundel House but much admired, had made such a voyage, passing by Gibraltar and the Spanish Isles, and had brought back with him the Argier apricocke, which groweth now in England and is much prized.

It always seemed to me, when Wensel used to talk together with our friend John Tradescant the younger, dead now too some ten years, that Wensel envied the great voyages the men of this family had made and would fain emulate them. But I was afeared for him, for all manner of reasons, tho' I know not exactly what. Would Mr Howard's company, I wondered, make the needful allowances for Wensel not being a young man like themselves? I did not wish to tell my anxiety to Wensel, for he thinks himself as strong as ever, while yet complaining far more than was once his way. So I made out that I was afeared on account

of Pirates, being as how I knew that old Mr Tradescant on the Argier had gone with the Fleet that was launched against Pirates.

Wensel said that that was in former days and that my worries were foolish. He would go, and that was that. And yet, lo and behold, they did meet a narrow 'scape with pirates, and Wensel came home full of the tale and with images taken of the encounter to show. O, what would the children and I have done had he been slain there in foreign lands or, still worse, made a slave by the heathen Moors?

(I should add Meg's name too. But, in truth I know little of her life these days. For all she dwells near at hand, and calls to see us, the visits be but brief. I find that I have little notion of how she spends her days and who, apart from Lady L———, may be her chief companions. She is always most finely clad.)

When Wensel was at first come back to England, he was very happy with the expedition and with the company he had kept and the designs he had brought home. But since then the time has run on and he begins to feel that not so much good has come of his going away, and that the work he lost by his long absence has not been equalled by the requests he has had on his return. I surmise that the embassy was a failure for Lord Howard who, for all his labour, did not get to meet the Moorish prince, and he has mayhap lost interest in Tangier. We hear he is reconstructing his palace in Norwich, against the day when he shall become Duke.

In King Street here by Whitehall Wensel lately chanced upon Mr Pepys, who stopped to talk with him and told him that the Tangier Commission are much perturbed with troubles from that quarter, and that in the end the place may cost too dear in men and arms to keep. Wensel seemed much cast down by this intelligence, and I do not believe that this was solely on account of his own labour being thereby partly lost. It seemed to me that he regarded the faltering of the Tangier enterprise as a bad omen.

He is working harder than ever, which should not make me uneasy, yet it does. He complains he is not paid his deserts, something that he never would say in former days, and that this is why he must labour so. All the prints for Mr Ashmole's famous Garter book will soon, please God, be accomplished, and Wensel is starting on work for Mr Sandford: an History of the Kings of England, I think. Mr Ashmole is a very great person these days, much in the King's favour (so he tells us). He is married now to Mr Dugdale's daughter; he has lately been made a Doctor of Physick at Oxford (which puzzles me somewhat, for I never heard he was a physician), and has his own closet of rarities here in Whitehall, which foreign nobles visit.

I fear me that some of these rarities may come from Hester Tradescant's collection, for trouble in that quarter continueth. While Wensel was gone to Tangier she came to visit me here in Westminster. I had not seen her for a great while, and methinks she was looking more pinched and sharp than ever — but then, we are none of us young folk any more. She drank a cup of sweet wine with me, and then fell to complaining much of Mr Ashmole. She says that, since he married again, he has been removing things out of her house to his own. I do not fully understand how this can be: as she tells it, 'tis as if she were to come to our house and go thither again with my blue-and-white chinaware! I tell her, 'So do not invite him any more. Instruct your servant not to bring him in.' But she seems to think this is not possible. Indeed, I do not fully compass the friendship between her and Mr Ashmole (if friendship it be). In the time of the great Fire, when she had already lost her Case in Chancery against him, she allowed him to store much of his library with her, and yet now she speaks of him thus.

Poor woman, she is alone in the world, save for such friends as she may have. I bethink me now that she, like I, lost a dear stepson whom she had raised as her own; but my case is much different as I have, God be thanked, my husband and my daughters.

She wanted me to ask Wensel to use his influence with Mr Ashmole and thus get him to desist. I could have told her (but did not) that Wensel would never do any such thing, even if Mr Ashmole would listen to him, which I do not suppose he would. 'Twas fortunate that I could say with a clean heart that Wensel was gone out of England and 'twould be many months before I should see him.

After Wensel's return I told him about Hester Tradescant's words, but he said not much. I have never asked him if he regrets being in Mr Ashmole's company in the time of the signing of the famous Deed — nor yet if Mr Ashmole bears him any resentment that Wensel allowed himself to be called as one of Hester's witnesses, along with her cousins and some neighbours, in the case before Lord Clarendon.

I have never asked him, for it would be no use. For Wensel, although he is made sad or angry at a reverse as readily as he is made joyful by a happy event, does not, I believe, know the notion of regret. He does not repine over what is past and done. Nor does he seem to feel guilt, that fear of God's all-seeing eye in which most of us mortals go. He honours God; I see him at his prayers, tho' these be but brief; he comes some times with me to St Margaret's church. But he would just as happily attend a Roman church or perhaps any other one, if the occasion and the season warranted it. It distresses and irritates him even to hear of other men's disputes

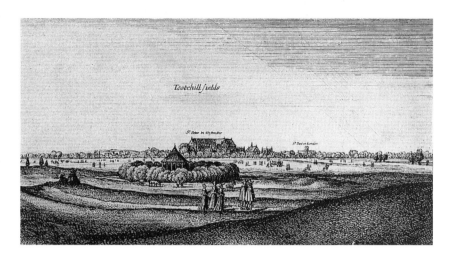

over such matters. But no more nor less, I have come to think, than it distresses him to hear Sarah and Paulina dispute over a puppet or a necklace of beads.

Thus, though he makes a commotion over small things, he ever makes light of deeper matters. When something sorely grieves him, he prefers not to speak of it, as one who should make out that it never was. And then, twenty years later, the grief surges forth, and bitter for the keeping of it.

He never spake of Margaret after she was gone. He never even speaks the name of his son. Poor boy, I would fain know where he may lie. I have an idea that he may be in Tothill Fields, beyond The Abbey,[2] for there was a great Plague pit there, they say, now covered over with grass almost as if it had never been. Wensel has made a pretty plate of these fields, with people taking their ease near the maze there, quite in the old style he did use when he made his pictures of London town, before he worked so much on great churches and castles.

'Tis my belief that when Wensel learnt of Jamie's death he did make enquiry of the men on the dead carts in those streets to know whither they went. It may even be that he followed a cart at a distance, at night, and so saw the pit where the bodies were cast. But when once I tried to ask him this, he would not even answer me, but turned away, and was absent for the remainder of the day and far into the night. And then the following morn he was himself again, said he'd been at the 'Change coffee house, and it was as if my question had never been.

I do believe, at least, that young Mr Place is a comfort to him. An only son can never be replaced, no more than can a friend from youth: we heard of Mr van der Borcht's death of a sickness in Frankfurt only belatedly, and I know that that too grieved Wensel much. But in Frank Place he has found a companion after his own heart, for which I am abundantly glad . . .

. . . a Person who was intimate with Hollar, and who had learnt of him his Method of working and has given good Proofs of his Skill and Affection to the Art in several Plates, marked *F.P Francis Place*.

(George Vertue)

Mr F. Place was a clarck in some office here in Town. & got acquainted with Hollar of whom he learnt his manner of Etching. he having already a knack of drawing & a genious that way.

(Vertue, in his Notebooks)

Hollar was a person I was intimately acquainted withal. but never his disciple nor anybodys else. which was my misfortune.

(Letter from Francis Place to Vertue)

Francis Place was born of a land-owning family in Yorkshire in 1647: when Hollar met him in London in the late 1660s he must have been much the age that James Hollar, born 1643, was when he died.

Place was apparently working then, and on and off later as well, at fairly mundane commercial occupations; for a while he seems to have been running a pottery works. But as one of a small pool of educated men in rural northern society, he had a ready entry to the group of gifted amateur artists and connoisseurs that gathered round Henry Gyles, a glass painter, who lived in York and had London contacts. A few letters between Gyles and other members of the circle have survived, which show the same passionate concern with books, new science and new methods of work that the Royal Society displayed at a rather more celebrated level.

Letter from Thomas Kirke, in London, to Henry Gyles, at the Michaelgate in York, June 1674:

I have been twice at ye *mathematicall Clubb* which [. . .] every friday night, on friday sennite I mett Mr *Moxon* there who writt A peece of *perspective* (which you have of mine) & we went to Mr *Faithorne ye graver* & drunk a glasse of wine with him and A friend of his A young painter I suppose; Mr *Moxon* and Mr *Faithorne* were att high words whether ye true knowledge of perspective was absolutely necessary for A painter or noe. Mr Moxon affirmed it was & Mr Faithorne denied it . . .[3]

In London in the late 1660s 'Franck Place', as he was known to his friends, was engraving Leonardo da Vinci heads very much after Hollar's manner. It would seem that it *was* Hollar who taught him the art, for by the early 1670s Place was etching some of the plates for Ogilby's book on China (a companion-piece to his one on Africa). Place's rather rueful disclaimer, late in his life, that he had ever been Hollar's pupil, probably relates to the fact that he was by then a gentleman of leisure. He wished to make, politely, the point that he had never been in the *trade* of engraving – the social nuance that dogged Hollar throughout his career.

Some of Place's surviving prints and drawings, now in the British Museum collection, do seem to owe much to Hollar's style, especially one of Flamsteed's new observatory in Greenwich Park on the site of Duke Humfrey's Tower. He also emulated Hollar's italic hand, and, like him, drew butterflies and beetles. But he spent much of his life in his native Yorkshire, and his watercolours and etchings of York, Hull, Scarborough, Knaresborough castle and of local bird life have a delicacy and suppleness of their own: one senses that he was more of a countryman than Hollar, and less concerned with architectural detail. He married late, towards the end of the century, and it was probably by this match that he achieved financial security. He was nearly seventy in 1716 when he responded by letter to George Vertue's request for his memories of Hollar, and over eighty when he died. George Vertue wrote of him then:

This year [1728] dyd at York, Francis Place an Ingenious Gent whose works in painting drawing & graving also Metzotint are deservedly esteemed by the Curious and lovers of Art. In the latter part of his life having means

enough to live on he passed his time at ease being a sociable and pleasant companion much beloved by the gentry of those parts having in his younger days been a noted sportsman particularly for fishing, but Time and a great age brought him to his Grave.

It seems one of those ironies of fate that, well after Hollar's own death, this son-figure should have grown into just the kind of happy English country gentleman that Hollar himself liked to imagine himself being, but never was.

Mr Hollar ... was the most indefatigable man that has been in any Age ... he has often told me, he was always uneasie if not at work.

In the absence of any other factual information from the last period of Hollar's life, one can only look at the works he went on producing. In the early 1670s the third volume of Dugdale's *Monasticon* came out; and also Ashmole's sumptuous *Garter* volume, with its hugely detailed Hollar prints of formal processions and a dinner in Windsor Great Hall with all the individual Garter knights there. (They are not, in the picture, throwing bread rolls at each other, as Evelyn had disapprovingly seen them do.) Even as this book appeared, Hollar was embarking on prints for another similarly grand volume, Francis Sandford's *A genealogical history of the kings of England*. It was Sandford whose name had been linked in royal patronage with Hollar's own over the abortive London map scheme; he was now Lancaster herald at the College of Arms. (He was to lose reputation and fortune by supporting James II against William III, and ended up in prison for debt, but that was after Hollar's day.) Some of the etchings of fretted Gothic tombs that Hollar did for Sandford are among the finest and most subtle work he ever accomplished; they are also some of his last works. For a man now well on in his sixties, whose eyesight, however unusual, surely cannot have remained quite as it had been in his prime, they are truly extraordinary.

At this same late period of his life Hollar was also busy with the illustrations for another tome in the Dugdale tradition, *The Antiquities of*

Nottinghamshire, conceived by an antiquarian-minded gentleman of that county. It was a substantial commission, involving over fifty etchings: indeed Hollar may have been still working to finish the job when fate overtook him, for the last two plates are definitely by someone else and some others may be. In any case, the original drawings are not by him: it seems as if Hollar had now finally abandoned his habit of travelling the length and breadth of the land to make drawings on the spot. He was beyond the age at which he would reasonably have been expected to undertake such journeys on horseback, and although by this period coaches were better sprung and more widely used for country travel than they had been a generation earlier, a long-distance journey in one was still an ordeal. The highly organised public stage-coaches, speeding from London to Bristol, York or Edinburgh over improved gravel roads lay hidden in the next century.

There are, however, a few more personal plates from these last years of

Hollar's life which suggest that he did still make the occasional journey, possibly by ship round England's coastline, which was a generally more comfortable option. In 1673 he both drew and engraved a map of the Newcastle harbour, complete with a picture of a ship being deliberately blown up and sunk in the Tyne estuary, possibly to block that waterway to large ships. The event dates from the third Dutch War: the print is his last example of the kind of current-event picture which had been such an important element earlier in his life.

There are also some small views of Plymouth Sound dated as late as 1676, but I do not believe Hollar travelled there that year. It seems more likely that, with his lifetime practice of making plates from drawings squirrelled away some years before, he was using up the last of the sketches he had made when he had sailed with Lord Howard to and from Plymouth half a dozen years earlier. By the same token, though no doubt for deeper reasons, one of his very last prints (some like to think, his last of all) was a river scene near Prague based on drawings he must have hoarded all his life in England.

As if all this was not enough occupation, in the 1670s he continued to work for John Ogilby as he had done for years. He did plates for the polymath Ogilby's own translations of *Aesope's Fables*, for his *Africa*, *China* and *America* books, and for his far-sighted plan to map all the roads of Britain. It must also have been at this time that Hollar supplied some of his characteristic ships on the river, and the segment containing the Tower of London, for the forty-sheet map that Ogilby published with Morgan. That Hollar, who had once planned his own wonderful map, was prepared to take on this sort of hack-work for others accords with the snapshot view of him which has come down to us from Francis Place:

> . . . a method of working not common. he did all by the hour in which he was very exact for if any body came in that kep him from his business he always laid ye hour glass on one side, till they were gone. he always recond 12d an hour.

One cannot help thinking that an artist who assumes the role of an

honest journeyman at a shilling an hour is underselling himself, if not in his specific rate, then in general terms of his standing and reputation. If Hollar had been less visibly determined to earn each day his daily bread, would he in the longer run have served his own interests better? His ceaseless work, which may have been partly driven by something deeper and less rational than actual debt, inevitably created for others the impression of a hand-to-mouth existence.

The contrast between Hollar's compulsive approach and Ogilby's own more inspired one is sadly illuminating. Ogilby knew a number of serious reverses in his long life, including the disastrous loss of all his property and stock in the Fire, but he always managed to retrieve his fortunes again with a clever modern idea – original translations into English for a newly literate readership, atlases and histories of the opening world, a fund-raising book lottery . . .

> He had such an inventive and prudentiall Witt, and Master of so good addresse, that when he was undon, he could not only shift handsomely, (which is great ingenie) but he would make such rationall proposalls, that would be embraced by rich and great men, that in a short time he could gaine a good Estate again: and never failed in anything he ever undertooke, but allwayes went through with profits and honour.
>
> (Aubrey)

Hollar, with all his wonderful gift, his industry and his evident courage, did not have Ogilby's foresight and skill at turning matters to his advantage. He does not seem to have borne Ogilby any ill-will on this account, otherwise he would hardly have helped out with the London survey map; rather, he probably regarded him as a friend and a most useful source of steady employment. But in the same year (1676) that Ogilby and Morgan were preparing to publish their map, Ogilby died, with his books on Asia and his great *Britannia* project unfinished.

He was older than Hollar, the same age as the century. He was buried beneath the floor of St Bride's Church, the Wren church then just being

completed to replace the one that had been burnt ten years before. In the long run, virtuosity, like so much else, is forgotten: Ogilby's 'prudential wit' has not lasted as Hollar's shadows have done. Yet, for Hollar, the passing of his old colleague must have seemed like the end of an era.

Chapter XII

Various Deaths, and Survivals

When my old friend Mr Hollar sent word from London that he was to sail that summer on a merchantman from Rochester to the mouth of the Tyne, I sent word back that I would ride over from our home in Dinsdale to meet him. Kept in Yorkshire by my tedious pot-trade, I had not seen him for over two year, though I had had word of him in that time by my good friends Harry Gyles and Tom Kirke.

It was a half day's ride north, no more than that on a good horse, and I remember even after all these years how bonny was the Tees as I set out, and how great our pleasure was in seeing one another again. I had brought proofs of my new gravings with me to show to him. I found him before an inn by the water, drawing the rigging of the ships with his accustomed attention to the minuteness of things. He was there at the behest of a gentleman, who was making a map (I think) for the Duke of Newcastle. Mr Hollar was ever at some one's beck and call, which I thought a shame, but I saw that he was happy to have this work, as was his way.

He seemed to me then in his accustomed health and vigour. But I recall that, after two or three years more, when I made a visit to London in winter for my affairs and called on him then, he had gone down somewhat. His mind was dwelling on the past, for he fell to complaining to me of old Peter Stent, dead then many a year, who, he said, took advantage of his need in a difficult time, and that his best prints of those days should now be worth far more than Stent gave for them. This had long been my own opinion, but I never, I think, had heard him say so before and so it has stayed in my memory. He waxed quite passionate as was his wont, but then, I suppose, we spake of other things and he grew calmer, and in the end spake with his old good cheer of future plans.

After we had dined, a good hearty dinner as ever in his house, served to us in the parlour by his two young daughters who were much grown since I had seen them last, he fell asleep before the fire. His Dame (as we say in the north country) told me that he tired greatly, which was no wonder to me with the age he had reached and his work that he stinted not.

I recall her saying further that anxieties, of which in former days he made light, now oppressed him. In particular, she said, he was distressed by the idea that he might lose the keen sight of his eyes on which all his work depended. She took me up to the chamber he did use for his work. She showed me a fine plate he had graven some years back on the which, after his name, he had writ 'sculpt. aetate 64'. He was proud of his sight then, still needing no spectacles for graving at the age of sixty-four. Perhaps he had lately noticed some change, for age as I now understand comes to all of us.

When he awoke I took my leave, begging him to let me know by and by how he fared, for even in those days letters could be sent with ease to the care of the Post House in Northallerton, and thence on to Dinsdale with the packman.

It was the last time I was to see him.

His house then was in Gardiners Lane by King Street, where it goes towards Westminster, though today, with the destruction of much of the Palace in the two fires at the century's end, it is much altered thereabouts, I am told. The house was spacious enough and the furnishings as I recall were comfortable enough, in the London style, without more. When I heard later that he and his family had been at the last in real want it much grieved me, and grieves me still to think on it.

The wide street space labelled on contemporary plans as Whitehall extended then from Charing Cross only as far as the Banqueting Hall. Beyond that was a Tudor gate, with a second one further on, both spanning the narrower road known as King Street. This was often just called The Street, for it was the main highway of the Whitehall–Westminster agglomeration, which has been described as less like a palace in aspect than a sprawling village. There were gabled inns in King Street, and the district was patchworked with alleys, yards and gardens leading one from another. Kings' mistresses then had their linen hung out to dry like anyone else. On the side furthest from the river, lodgings granted to courtiers, prestigious but often cramped, stood alongside ordinary dwelling houses. Citizens such

as the Hollars, making their way home after nightfall through the mainly unlit streets, could look in at upper windows and see candlelit balls taking place, a parallel world so near, yet out of reach.

Gardiners Lane itself ran into King Street on the western side just before the point where, today, the main road opens out into Parliament Square. Two smaller alleys, Cherry Tree Court and Bowmans Court, ran off it. The name 'Gardiners Lane' was there by 1612, and presumably it was then a place of cottages for those who worked in the numerous court gardens to the west and south. New houses were built there in the 1630s, as accommodation in the area became more sought-after. The house that Hollar rented by the later 1670s (he did not apparently own it) had three storeys with a habitable attic above. We know this from an inventory of the place made after his death.

In the same month of September 1676 that Ogilby died, the battle of wills between Hester Tradescant and Elias Ashmole, which had rumbled on for years, reached its decisive combat. Since Ashmole's third marriage, to William Dugdale's daughter in 1669, there had been accusations from Hester that Ashmole was visiting her and removing objects from the Collection. The Chancery case of 1662 had declared the Collection to be Ashmole's, but it had not been handed over and Hester had been selling off objects from it, so it would not be surprising if Ashmole had indeed been doing what Hester said he had.

In 1674 he seems to have decided on a new tactic. He bought a house in

Lambeth adjoining Hester's house and garden. He may have thought that this might ease a gradual and amiable transfer of the rarities from her care to his, but if so he was mistaken. Since Hester was still convinced at heart that the Collection was rightfully hers, her forebodings about Ashmole's intentions now took on a paranoid quality. He was having building works done on his house: she made accusations to neighbours that he had had a door knocked through between his garden and her orchard 'by which he might come into the house as soon as the breath was out of my body, and take away my goods'. She also claimed that he had taken a strip of land that was rightfully hers. Ashmole counter-claimed that she had built a pile of earth and manure by his garden wall, which had enabled thieves to climb in and steal his poultry, and that she had gone on leaving the pile there for six weeks after he had been robbed.

This unneighbourly argument escalated, with further accusations from Hester that are, whatever one may think of Ashmole, implausible. She was now claiming that he had 'forced her to deliver up to him her Closet of Rarities and that had she not done so he would have cut her throat'. This was too much, and Ashmole accused her of slander. Either in fear of a further legal suit, or in a genuine access of greater lucidity and qualms about her own behaviour, on 1st September 1676 Hester signed a witnessed Confession, admitting the falsehood of what she had said. The document has survived:

> . . . in truth, I prest him to receive the same Rarities; and when he entreated me to keepe them, and not only used many arguments to persuade me to it, but set on other of my friends and neighbours to persuade me likewise, I would not hearken to their advice, but forced him to take them away, threatening that if he did not I would throw them in the streete, and he having at last consented to receive them, I voluntarily helped to remove some of them myself.

Even if one feels that Ashmole had waged a long and devious campaign to gain what he desired, Hester, with her hysterical aggression and self-pity, was evidently playing games too. Her games were less consistent than

Ashmole's; she was her own worst enemy, and her morbid belief that he would be the death of her proved in the end self-fulfilling.

A year and a half after her Confession, Ashmole noted in his dairy:

4 April 1678. 11 H: 30 AM. my wife told me Mrs:Tredescant was found drowned in her Pond.

　　She was drowned the day before about noone as appeared by some circumstances.

There is no further comment, but later the same month the diary records, 'Removed the pictures from Mrs Tredescant's house to mine.'

This sad end to an old friend was not one Hollar lived to see.

The winter of 1677 was another cold one. In February Sir Edward Walker, the Garter King, died in Shakespeare's house in Stratford, which he had bought for his old age. He was succeeded as Garter by Dugdale, himself over seventy. Whatever some of his contemporaries thought of Edward Walker, he had been a loyal supporter of Hollar's work since their days together as Lord Arundel's gentlemen on the Rhine. A month later, Hollar followed him.

It was on 25th March, then as now a Quarter Day, but also the New Year's Day of the Old Calendar. So Hollar died as he had lived, on the cusp between the old world and the new.

Neither Pepys nor Evelyn noted Hollar's death, and the event is not mentioned in any contemporary letter that has come to light. Because of this, it has been said that the illustrator for the rich and celebrated of his time passed from life unnoted and unmourned. This is not entirely true. In the diary Ashmole kept at the time, he wrote against 25th March, 'Mr Weneslaus Hollar died', though this was one of many short entries that did not figure in the Diary he edited for publication many years afterwards.

　　Later that summer he gave a grand dinner at his house in Lambeth, newly extended to hold the rarities, to which he invited all those who had subscribed to his *Garter* book. It would be nice to think that, in that self-congratulatory company of the successful, one of the toasts drunk was to

the memory of the artist who made the book what it was, for the illustrations were fully appreciated. In a letter to Ashmole about them three years later, Sir Thomas Herbert, courtier, traveller, writer and associate of Dugdale, wrote, 'Mr Hollar's death is much lamented.'

The truest account of Hollar's passing probably comes, as ever, from Aubrey. He does not seem to have been present at the death-bed himself, but evidently spoke to someone who was. As Secretary now to the Royal Society, he was often back in London and may have attended the funeral:

> Winceslaus dyed a Catholique, of which religion, I suppose, he might be ever since he came to Arundel-house . . . shiftlesse as to the world [he] dyed not rich . . . He dyed on our Ladie-day (25 March) 1677, and is buried in St Margaret churchyard at Westminster neer the north west corner of the Tower. Had he lived till the 13th of July following he had been just seventy yeares old.[1]

In his first draft, Aubrey put 'died poore', but later altered this to the more moderate term. He gives no indication of a particular crisis of funds coinciding with the day of death. Yet a persistent story about such a crisis took shape decades later, originating with Francis Place and taken up by George Vertue. Place was in Yorkshire at the time and Vertue was not yet born. However, the story has now acquired a mythological power of its own, like that inspired by Shakespeare's legacy to his wife of his second-best bed.

> He was near 70 when he died about 36 or 40 years ago in a house he had in Gardeners Lane King Street Westminster of a Parralitick fitt. & before his departure the Bayliff came and seizd all he had, which gave him a great disturbance & he was heard to say they might have stayed till he was dead.
> (Place)

> . . . he d'yd, but so indigent, that there was an Execution in his House; of which, when he was dying he was sensible enough to desire only to die in his Bed, and not to be remov'd till he was buried, which was to the New

Chapel Church-yard *Westminster* where he was interr'd.

(Vertue)

Bailiffs did not, however, seize and carry away 'all he had', for the inventory that was made of the house's contents two months later shows that no such clearance had taken place. The house appears to have been adequately furnished by the standards of the time, though without anything particularly new or fashionable in it. One does not know, of course, if the Hollars had resorted to selling off items in recent years — pieces of blue-and-white 'Delftware'? Ornate candlesticks? — but the kitchen had the usual cooking implements and brass and pewter pots. The 'parlour' next door, in practice probably the dining room and the place for receiving visitors, had a table and chairs and 'hangings of old striped stuff'. In what must have been a fairly large room on the floor above were three tables, a writing desk, stools and a storage chest: I think this was Hollar's workroom. Above that were two bedchambers, each with a bed and bedding; one (the daughters'?) with two chests, a table and a screen; the other (Mr and Mrs Hollar's, I think) with 'grene Baze Curtains & vallance 4 Chairs one Tble & Carpet one lookeing glasse & Andyrons'. Andirons support the logs in a fireplace: it sounds a cosy private sitting room. Above that again was an attic with a bed, table and stools, perhaps the sleeping quarters of a servant. Someone to do the heavy cleaning, draw and carry water, chop wood, mind the fire and generally run errands was almost invariably found in middle-class households, even impoverished ones, since he or she cost little more than their keep.

The house sounds quite spacious; indeed, in the parish accounts for the year before Hollar's death, the annual church rate for 'Wantoslaus Hollard' and his household was assessed at ten shillings, while most of his immediate neighbours were assessed at four or six shillings. The rate is noted at the year's end as having been paid in full.

The reason an inventory was taken was that Hollar died intestate, and Honora therefore needed this in order to have administration of his estate granted to her. This is further evidence that the Hollars, however chaotic

their finances, were people of a certain standing. The great mass of working people lived, died and passed on their scant possessions without such formalities. A solitary item appears in the inventory for 'prints belonging to the decds trade'. Among these must have been the 'large volume pasted with copper cuts' that Honora is known to have sold to Hans Sloane a few years later. But no mention is made in the inventory of all the rest of the material, including the Tangier watercolours and others, that she is known to have sold, nor of any of the tools of Hollar's trade, nor of any books. And even without these valuable extras, the estimated worth of 'all these goods' at the bottom of the inventory seems too low: £22.

It could be that what we have here is a piece of bureaucratic fudging. There may be a core of truth in the story about the bailiffs, for Lady Day was a day when quarterly rents fell due. If the landlord's rent was in arrears, he may well have sent men with a cart to the house, ostensibly to collect goods to the value of the debt, in reality as a general threat to hurry up payment, in the way that a distress warrant is used today. Twenty years before, the same threat had been used against the man who stood surety for Hollar in the Ambassador's chapel affair; then, the bailiffs were paid to go away. In the corrupt London justice system of the time, this was a usual practice and may well have been what happened on this occasion also. Hollar's reported demand to be allowed to die before the bedstead was removed sounds entirely in character for Place's 'very passionate man easily moved', but it seems unlikely that matters had gone quite that far: the evidence suggests, rather, that he died with his home substantially intact around him, in a decently equipped bedroom with a fire in it. The low estimate put on the furnishings two months later, with nothing described but the hangings, which are qualified as 'old', and the lack of precision on his valuable stock of work, may have been a well-understood connivance to reduce the widow's apparent inheritance and thus forestall further attempts at seizure.

That Hollar died without having made a Will seems all of a piece with the general improvidence which Aubrey noted. It is also, however, a sign that death came swiftly. A 'paralytic fit' would indicate a stroke, not a

lingering malady. Contrary to modern practice, in the seventeenth century people did not commonly make their Wills while still in good health. They waited until what they suspected to be their last illness was upon them, and then introduced the Will with some phrase such as 'being very weak in body but sound in mind'. But Hollar, it seems, was struck down too quickly for this, one day preoccupied with an urgent errand in town and a plate to finish for Sandford, the next a spent force. For a man whose life had been consumed in work demanding an exact coordination of eye and hand, this was surely a merciful end.

Evidently, from what Aubrey says, there was time for a Catholic priest to be called to give him the last rites. It is a measure of how close beneath the surface of things the Catholic faith remained in those years, in spite of all the official prejudice against it, that King Charles II himself is also said to have 'died a Catholic'. The meaning of the two crosses that ornament Hollar's burial entry in St Margaret's register, marking it out from the general run of entries, may, I suggest, be a coded sign of Hollar's known religious leanings. Another theory is that it may be the mark of a bishop having officiated at the ceremony. If so, was this a measure of the respect Hollar's name still commanded? The matter, like so much surrounding Hollar's life, remains an open question. But what is not in doubt is that the words 'the famous', added after his name in another hand, were put there only in the following century, almost certainly by George Vertue, who was the first person to seek out the recorded resting place of the man London had by then forgotten.

Of Honora, except for her sale of her husband's works to Hans Sloane, we know nothing more. She cannot have been desperate for money when Hollar died, for the sale did not take place for some years, and it was a wise move; Sloane was to prove an excellent custodian. The year after Hollar's death no 'Hollard' or any variant on it is to be found in the parish rate list under Gardiners Lane. Honora may have moved elsewhere in the district; many pages in the books for that period are missing, or have been rendered illegible through time and damp. So there is no evidence that, in widowhood, she ever became a charge on the parish of St Margaret's. In any case,

she may have moved away entirely. We know nothing of the fate of her daughters either, or yet of the destiny of Hollar's elder daughter, who would have been in her late thirties by the time he died. It may be that some of Hollar's chronic inability to save money, or even to keep out of debt, was due to his trying to assure the future of these girls and his wife in ways that have never come to light. Perhaps, sometime, from a packet of soot-rimmed, long-folded legal documents in an archive nominally concerned with quite other matters, there will emerge a faded paper bearing Hollar's signature promising a marriage settlement, or some other deed of gift. It is unlikely, after more than three centuries, but as an eternal possibility it remains.

As Hollar lay dying, John Evelyn was much preoccupied with Margaret Blagge, now Mrs Godolphin but still the chief star in his mental firmament: the frequent occasions on which he dined with her in her Whitehall lodgings are designated by a star in his Diary. Otherwise, he was taken up that spring with getting money out of the negligent King to fund the foreign service, and with stocking his new fish ponds at Sayes Court.

In the September of the following year Margaret Godolphin gave birth to a son. She died of puerperal fever in pain and delirium a few days later, her cries echoing down Whitehall. Evelyn was present when she died and took over from the distracted husband the arrangements for her funeral. He recorded:

> I cannot but say, my very Soule was united to hers, & that this stroake did pierce me to the utmost depth . . . She was certainly the best *Wife*, the best *Mother*, the best *Mistris*, the best *friend* that ever *Husband, Child, Servant, friend* [or] that ever any creature had, nor am I able to enumerate her vertues . . . The King himselfe & all the Court express'd their sorrow.

That same year, Henry Howard, now at last Duke of Norfolk and long a widower, announced his marriage to Jane Bickerton, a court Beauty, who was not generally considered his social equal. Evelyn refers to her as 'that infamous woman his Concubine'. She had a house of her own in

Weybridge, which the Duke now did up as his country retreat instead of Albury. After all his work over the years on the Albury gardens, and the happy memories connected with them, Evelyn may well have felt slighted that a different house was preferred, and he thought the Weybridge one vulgar – 'never in my daies had I seene such expense to so small purpose'. But in any case, at the end of that year, the couple went abroad. The mood of the times, which had been tolerant towards Catholics earlier in the decade, had once more turned against them, and the Duke was now disbarred from sitting in the Lords. Like his grandfather before him, he and his wife retreated to the Low Countries for several years. He did not return till well after his elderly uncle, Viscount Stafford, had been executed in the hysteria of the 'Popish plot' – the last religious beheading in England, the last spasm of the Reformation.

The Duke, who had been so energetic as a young man restoring the family fortunes, was now discouraged and prone to melancholy. Albury was sold to a Mr Finch. The grand refurbishment of the Norwich palace was never completed. Arundel Castle, badly damaged in the Civil War, was left ruinous, not to be patched up for habitation till the following century. As for the plans for Arundel House in the Strand – the Italianate rebuilding according to designs by Robert Hooke, the siting of new premises for the Royal Society in the gardens – these were abandoned. The year after Hollar's death the Tudor house and grounds, which had formed his first experience of England and the setting for the happiest years of his life, were in the hands of builders. What remained of the Collector Earl's garden statuary and stonework was broken into rubble.

At the same time, the eleventh-century St Clements Danes church, which had escaped the Fire of London but was now found to be in an unsafe condition, was rebuilt to designs by Wren, then at the height of his career. All around, timbered, dormered houses were being replaced by a more distinctively urban architecture, mainly in brick. A new London, whose style and street patterns have formed our idea of what London is, and still do so today, was fast taking shape.

＊

In January 1679, not quite two years after Hollar's passing, Elias Ashmole suffered a personal loss which was eventually to be one of the best-remembered facts about him. As a lawyer he had lodgings in the Temple, and a fire in the next room to his (said, as is usual with such fires, to have been started by a careless servant) spread to his domain. The books he had collected over thirty-five years, many of which he had managed to save from the Fire of 1666 by taking them up the river to Mrs Tradescant, were consumed by the flames. He also lost his huge collection of ancient and modern coins of brass, copper and silver; some of these were retrieved from the rubble later, but they were defaced and deformed by heat and the silver ones had melted. By a single stroke of good fortune, his golden coins and medals had been removed to his Lambeth house a short while before. He lost, too, a mass of seals, also prehistoric flints and all his manuscript notes on these and on history and heraldry. For an inveterate collector and list-maker, the blow was devastating. Vanished in the fire also were a large number of prints, both portraits and views of towns 'taken from copper cuts'. We must suppose that many of these were by Hollar's hand. Although a fair proportion of them must have been from plates which have survived in other copies or states, some, no doubt, were unique. Had Ashmole's collection not been destroyed, we might now have even more separate Hollar prints than the 2,700-odd already considered to constitute his impressive surviving work.

— '*Thy Shadows will outlast the Stone.*'

Most of Hollar's work is now safe — or as safe as paper ever can be — in national collections and libraries, or else in the hands of private collectors. In the last few weeks of the twentieth century, in Christie's auction rooms in London, in the St James's quarter which was new-built when Hollar was old, an original print of his 'Long View of London from Bankside' was sold. The reserve price placed on it was £25,000: it fetched £41,000. Meanwhile, this and many other of his best prints have been reproduced by modern technology with greater and greater refinement. Even if every one of his originals should fall victim to some nemesis of age and time, we would still

have a worthwhile record of his achievements.

The stones, as Vertue's epitaph predicted, have been less durable. In Whitehall, the Banqueting Hall is a lone survivor of the palace Hollar drew, marooned now among the dull edifices of Government. Westminster Abbey, with St Margaret's in its skirts, still proclaims its presence, but Westminster Hall, where Hollar spent days sketching individuals at the trial of Strafford, is hidden within the Victorian Gothic Houses of Parliament.

Gardiners Lane survived into the middle of the eighteenth century, when it was pulled down as part of the rebuilding programme to create a westward approach to the newly built Westminster Bridge. Its site is lost today among the monumental Foreign Office buildings of King Charles Street. However, the neighbourhood has retained another historical resonance. On a parcel of land immediately to the north of Gardiners Lane, about three years after Hollar's death, a rather unpopular Member of Parliament called George Downing built a cul-de-sac of plain brick terraced houses in the approved modern style. It is one of these that later, reconstructed behind its original frontage, became the perpetual home of Britain's Prime Ministers.

Elsewhere, though the change of scenery has been complete, pockets of the London Hollar knew would still be perfectly recognisable to him. The old timbered Holborn full of back gardens has vanished utterly, and the network of lanes behind St Clement Danes was finally swept away with the creation of Kingsway and the Aldwych, but the town-planning that produced Lincoln's Inn Fields and Covent Garden has proved wonderfully resistant to destruction.

As for Arundel House, the Surrey, Norfolk, Howard and Arundel Streets that now cover the site preserve, at least, the family names. On the eastern border of the Arundel estate, running down in the direction of the river which has now retreated behind the Embankment, the centuries-old Milford Lane still retains the name evocative of an older landscape. It is said that when the foundations were being laid for another 'Arundel House', a modern block of flats, down beneath the cellars of the late seventeenth-century houses that had occupied the site, the mechanical diggers unearthed

fragments of broken *putti* and a 'Roman head'.

In Greenwich Park you can still see essentially the same view that Hollar drew, though the Queen's House is backed by Wren's Royal Naval Hospital, which was not constructed till after Hollar's time: it has also acquired nineteenth-century colonnades. Sayes Court, the Evelyns' Elizabethan house and gardens nearby in Deptford, have fared much worse, though a faint trace is still to be found. In the early eighteenth century, after John Evelyn's death at an advanced age, wharves crept along the river from Rotherhithe and the district started the slide down the social scale which has hardly been reversed since. About 1730, the Evelyn house was demolished and was replaced by a workhouse; the rump of his famous gardens became a kitchen garden in which the inmates laboured. Another hundred and forty years passed; streets of dockers' houses now surrounded the site; the outgrown workhouse in turn was demolished. The Evelyn family, who were still the ground landlords, had the remaining fragment of open land laid out as a small public park complete with privet, railings and a museum-library in the best tradition of Victorian philanthropy. The park survives to this day, between the wall of the ex-Royal Naval Dockyard on the river side and a 1960s' council estate of cement blocks on the town side. It is home to the occasional drunk – and to an ancient mulberry tree, propped up and railed around, which is almost certainly a last survivor of Evelyn's extensive plantations.

The name of the ugly estate is Sayes Court. The nearby main road is called Evelyn Street. Not far off is another small park, named after Pepys.

The parish church of St Nicholas, Deptford, has kept the medieval tower the Evelyns knew when they worshipped there, although the central part of the church, which they saw rebuilt, has now been reconstructed again after a Second World War bomb. The plaque that commemorates the burial of three of their children near the tower has survived. Evelyn himself does not lie there. He is at Wotton church in Surrey, which stands alone on a country hillside west of Dorking that can have changed little since he was put there. Yet, by one of those ironies of time and chance, those of his contemporaries who found an uncertain rest in London churchyards have

remained undisturbed, and John Evelyn has not. He was an ardent Anglican; he did not subscribe to the Roman Catholic belief in the resurrection of each human body; he spoke out against the insanitary practice of burying dead bodies within churches. And yet, in accordance with the upper-class practice of the time, he was embalmed and laid in a heavy marble sarcophagus above ground, as if in preparation to meet his Maker. The slab on top of it was not, however, heavy enough. Almost three hundred years after his death, vandals levered it off, dragged out Evelyn's body, on which time and the healing earth had been prevented from having any benign effect, and severed from the body the head of one of the most distinguished minds of his generation.

A better, if fortuitous monument to him is the nearby estate at Albury. The water in the garden he planned has largely returned to the common stream, and the general layout still looks remarkably as it does in Hollar's plates of the 1640s. The park is a haunting, pre-Enclosure landscape complete with oak trees, gnarled stumps of earlier ones, and sheep. The family who owned the place in the 1800s removed the village that had grown around the little church, in order to leave the rebuilt Albury House in sylvan isolation. Today, the house contains flats for the well-to-do elderly. Though the vineyards have gone, the grotto – or Roman bath – ornaments the terraced hillside opposite, just as in Hollar's fashion print of the Autumn lady.

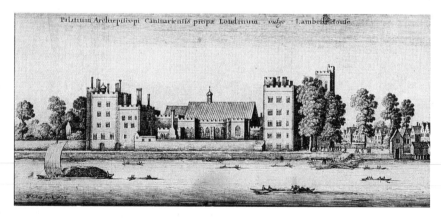

The Tradescants, after their fevered end, have found peace in a seventeenth-century oasis. Their estate by the Thames disappeared under nineteenth-century streets and a railway line as if it had never been. But St Mary's parish church, next door to Lambeth Palace and now redundant, has become a garden museum to their memory. In its graveyard is conserved a rebuilt version of the ornamental tomb, complete with carved palm tree, that Hester had designed:

> Know, stranger, ere thou pass, beneath this stone
> Lye John Tradescant, grandsire, father, son . . .
>
> . . . These famous Antiquarians that had been
> Both Gardiners to the Rose and Lily Queen,
> Transplanted now themselves, sleep here & when
> Angels shall with their trumpets waken men,
> And fire shall purge the world, these hence shall rise
> And change their Garden for a Paradise.

The epitaph is anonymous, but the author may not be far to seek. Ashmole, like many other seventeenth-century gentlemen, fancied himself as a poet. Is it not likely that he would have offered his services, in this as in so much, to his dear and bereaved friend Mrs Tradescant? He, incidentally, lies not far from her in the same churchyard.

An angel with a trumpet does appear, a little downriver, in the skies above London Bridge in Hollar's own most complete evocation of the city he made his own. Perhaps, as life ebbed from him in the tall, narrow house in Westminster, his imagination left the confines of his well-worn body to revisit the places he knew so well. It was a general seventeenth-century belief that the soul could go on such journeys. So, he would have travelled in spirit above the rooftops and the smoking chimneys, over the river with its boats and barges, to pause and tread weightlessly in the air above Southwark on that non-existent vantage point that his masterly skill had already supplied.

If he still returns there today – perhaps orienting himself by the squat

mass of the Tower of London, in a riverscape otherwise entirely transformed – he will see that Southwark church beneath him once again has builders at work. Victorian wharves and warehouses have been cleared away, and for the first time in hundreds of years the church is to have a waterfront on the Thames.

As with many of the sketchy events of his life, a small haze of uncertainty hangs around the place where all that was mortal of Wenceslaus Hollar actually lies. John Aubrey says authoritatively that he was buried in the churchyard of St Margaret's, Westminster, 'near the north west corner of the Tower'. In 1972, on the initiative of a Canadian scholar and admirer, a memorial plaque to him was set inside the church near this point. However, George Vertue claimed that Hollar was in 'the New Chapel churchyard', which is not quite the same thing. The New Chapel, which appears on Faithorne's 1658 map, was a chapel of ease for St Margaret's. It was situated further west, at a point now halfway along Victoria Street on the northern side, opposite Artillery Mansions and Strutton Ground. But while some of St Margaret's parishioners were interred in the earth around it, it is unlikely that Hollar was, given Aubrey's more specific indication.

A fragment of this more westerly burying ground survives, incongruously surrounded by large modern blocks, as one of those small public gardens that bring a breath of greenery and of the past to present-day London streets. A City of Westminster signboard bears information which, while it conflates this ground with the St Margaret's one, is correct about the identities of those who found a last resting place in the parish. Along with Colonel Blood, who plotted to steal the Crown Jewels and was pardoned by Charles II for his audacity, and a freed black slave of the following century who found in London a home and some celebrity as a writer, is mentioned that other permanent exile Wenceslaus Hollar.

Elusive as facts about him remain, in death as in life, it is pleasant to think that his name goes on being incidentally made known to office workers with their lunchtime sandwiches and to foreign tourists with maps in hand, as well as to the more determined seekers of the past whom each

age produces. From Lord Arundel, through such as Dugdale and Aubrey and on to George Vertue and his solitary, persistent quest for memories, then to nineteenth- and twentieth-century enthusiasts, the theme of search persists – the desire to strip away mentally the accretions of time and reveal again what was once there and in some sense still is.

The London Hollar knew is compacted beneath our feet, and it is his eyes that have bequeathed to us images of a world that would, otherwise, have vanished. But, more crucially, his precise, insistent, vision has become an integral part of the London of the mind that we carry within us. It is this idea of London that endures, freighted with its history, the ever-changing but permanent townscape, still lying as Hollar first saw it, in the bend of the river.

Notes

II THE ARTIST FROM BOHEMIA

1. F. Belsky.

III THE ARUNDEL CONNECTION

1. This William Pettye, or Petty, is not to be confused with the man of the same name who was an outstanding political economist in the following generation and was eventually knighted, though there may have been a family connection between them.

2. Comparatively recently it has been realised that the various references to van der Borcht, Vanderborg, -Burch and -Berg, which crop up in English reminiscences of the period, may all refer to the same person. Some commentators dispute this, but it is clear that the young artist referred to by John Evelyn as Vanderborcht, Vanderborgh and also Vanderburg, who painted Evelyn in oils at Arundel House in London in 1641, was Hollar's friend Hendrik.

V A NEW COUNTRY, A NEW LIFE

1. Franz Sprinzels, later known as Francis C. Springell.

2. Johannes Urzidil thought, during the Second World War, that it was in the

British Museum collections, but he seems to have been mistaken.

3. William Crowne did marry a wealthy widow, Agnes Macworth, in 1638. However, I do not know what her origins were. They had three children together, but their union does not seem to have been a close one. Twenty years later Crowne did not take his wife to America with him. There was also a persistent later story that his son John, the Restoration playwright, was really the product of a liaison between Agnes Crowne and the father of the poet John Dryden.

4. It has been suggested that this house cannot be in the environs of Whitehall because the picture shows no other houses nearby and the lie of the land and the river is not quite right. However, in this series of full-length figures, the backgrounds, all outside scenes, were put in afterwards. Each observes the convention that the lady was standing on some sort of raised platform or levee, though in reality none such would be found near Tart Hall, any more than it would on the other side of St James's Park, at Albury or in Cornhill. As to the house's apparently isolated situation, though London was spreading further westwards, creating the quarters round Westminster, Tart Hall, on the far side of the park, did stand away from most other houses then and for some time. A 1657 bird's-eye map by William Faithorne, who was weak on architectural detail but no doubt correct on basic street layouts, shows Tart Hall clearly in place and labelled, with a side lane and a parterre garden, still in a largely country setting. The house is said to have been pulled down at some point in the early eighteenth century, though there seems to be some confusion about this as it still appears on Foster's map of 1738.

VI FURTHER ESCAPES ABROAD

1. Francis Place, at the end of the 1660s, gained the different impression that Hollar's experience of bearing arms had been on the Continent during the Thirty Years War.

2. One of Hollar's Antwerp cat pictures is labelled thus, a description that commentators seem to have taken entirely at face-value.

3. In Lord Arundel's handwritten directions to Evelyn in 1646, there is a reference

to 'the one-eyed sculptor': it has been suggested that this might be a reference to Hollar and further evidence of his malfunctioning eyes. But I think it is more likely to refer to Evelyn's own genuinely one-eyed servant, Richard Hoare, who transcribed for Evelyn and apparently did some engraving for him.

4. First published in various pamphlets on etching that were produced after the Restoration. It is surely a mark of Hollar's continuing renown that his name on an Introduction was regarded as good publicity.

5. Matthias van der Borcht (1617–87). Meg may be mistaken in thinking that Matthias was related to Henry. Also active at that time was Gerard Ter Borch, who was no relation. But the picture may be seen in the Rubens House to this day.

VII London Streets

1. Copper itself was not cheap, which is no doubt why almost none of his actual plates have survived: many would have been used and reused by him and by others after him. Some, which are known to have been still in existence in the early nineteenth century, were later sold as scrap. Two have been discovered in the Bodleian collections, and there are unconfirmed rumours of a few others in private hands.

2. Hollar's print was used some eleven years later as the frontispiece to Inigo Jones's only and posthumous book, his treatise on Stonehenge, a choice explicable by the fact that Jones believed Stonehenge to be of Roman – that is, classical – Italianate origin. Hollar himself made a watercolour of Stonehenge which is now, sadly, lost.

3. The misperception of Hollar's domestic situation in the late 1650s has been increased by a statement of Aubrey's, repeated by subsequent commentators, that Hollar did not remarry till 1665, which the evidence of the parish record shows to be false. I think that either Aubrey miscopied his own note, inverting the digits and thus making 56 into 65; or else Hollar really did keep his private life so much apart from his public one for some years that Aubrey was unaware of his exact circumstances.

4. According to this survey, the house that had been Thomas Green's in 1609 had,

shortly after, become an inn, the Falcon. By 1650 it is described as having two storeys, with another three-storey house built in its garden. Next to that, going east to west, was another three-storey house, then a second inn, the King's Head – a tactless name, one might think, but pub names die hard. This inn was quite a substantial property, with a side addition and, in its back yard, a smith's workshop, stables and other outbuildings; evidently it was equipped to serve travellers setting out on or returning from the long haul to Oxford and other places west. Two three-storeyed 'tenements' had also been built on some of the land in front of it. Next door to it again came a decent-sized house (twenty-six feet wide), with a garden, a coach house and a stable, clearly a gentleman's abode. Then came yet another tavern, the Gate, presumably quite a good-class house, since it is noted as having 'a very faire and spacious dyneing room' thirty-eight feet long, and, behind it, gardens and a bowling alley. Then came two houses of three storeys, each house sixteen feet wide, about the dimensions of the modest terrace house of later centuries. Each had a garden with another, smaller building at the end of it, one of them described as 'decayed'. One of these houses, I believe, is most likely to have been the Roberts' property, with the surgeon living in the other. Next to these again at the end of the run, forming the corner with the newly constructed Little Queen Street, was a two-storey building with a shop on its ground floor.

5. The two extant letters from Hollar to Aubrey are both written on small pieces of paper in an elegant hand more cursive than the one he employed when making prints. They are now housed with the rest of Aubrey's extensive correspondence in the Tudor splendour of Duke Humfrey's Library in Oxford. The apparently hurried letter containing the Clements Inn directions is undated; the other (see Chapter VIII) is clearly dated 1st August 1665. By what was presumably a slip of the pen, Richard Pennington, Hollar's modern cataloguer, cites this latter in his general Preface as 1st August 1661. He compounds the error by ascribing this same mistaken date to the undated letter, though it is clear from their contents, their differing ink colour and the different textures of their paper that the two letters were not written on the same day.

VIII Gardens, and Other Rarities

1. Since Meg's destiny, except as a Beauty, remains unknown to us, I have provided her with a plausible one.

2. Roberts, including one who migrated to America, appear in the parish registers of Ashwell church, on the borders of Herts and Beds. This church has some ghostly connection with Hollar, since a detailed picture of what appears to be old St Paul's was scratched at some undetermined date into the stone wall by the tower, and is still preserved.

3. There was a Gabriel Roberts at the time, son of a vintner, merchant in the Levant Company, to whom John Verney, born 1640, son of minor aristocracy, was apprenticed. Gabriel and his brothers were typical of the entrepreneurial class that was rising fast in the seventeenth century, often becoming much richer than the landed upper classes, who, in turn, were not slow to make common cause with them. The Roberts also traded with Africa, and Verney spent some years on their behalf in Aleppo. The Roberts did own a large property in Hackney, then an exclusive suburb. I do not know, however, if they were really connected with the Roberts of Holborn.

4. No direct evidence has survived of a meeting between Hollar and Pepys, but they must have met since Pepys not only knew of Hollar's work but possessed, as Evelyn did, a number of his preliminary drawings — tokens given in friendship rather than sold. By his later life, Pepys had become a serious collector, and his acquisitions now repose in the library built by his bequest at Magdalene College, Cambridge.

IX Restoration Hopes — and a Hope Destroyed

1. As to an exact date for the London depicted on the map-sheet, common sense would suggest that if this first (sample?) sheet was completed in time for Hollar to make his confident Proposition to the King the same summer as the Restoration, then the London it shows must essentially be just pre-Restoration. The state of the building around Lincoln's Inn Fields, and the presence of what appear to be tiny soldiers drilling there, do suggest the Commonwealth. But various reasonably up-to-date elements make it clear that

Hollar was not relying on materials from many years before. The water-tower housing a pump to draw water from the river by Arundel stairs appears, and this was not erected till 1655. Similarly, a tree appears in the centre of the Covent Garden piazza which was not there in Hollar's 1640 picture of the place; this was gone again later in the 1660s, when it was replaced by a classical column. The post-Restoration era is suggested by the fact that the maypole is apparently back in the Strand. However, the place where it stood may have retained the name 'maypole' as a location throughout the Commonwealth, since the spot had become a stand for hackney coaches. This would explain why Hollar's ear had acquired the name without him apparently grasping its literal meaning.

2. John Fisher (1980).

3. Katherine S. van Earde (1970).

4. Richard Pennington (1982). His view is not shared by Arthur M. Hind (1922), Graham Parry (1980), Anthony Griffiths and Gabriela Kesnerova (1983) or Richard T. Godfrey (1994).

5. The Chamberlen dynasty of obstreticians, of French Protestant descent, were successively physicians to the court through the seventeenth century. They owed much of their success to their invention of the first obstetric forceps, which they kept a trade secret by hiding them beneath a cloth or (at home) under a floor-board.

6. William Boghurst, who published his *An Account of the Great Plague of London in the year 1665*, seems to have been an able apothecary as well as a courageous one. He thought it was stupid to incarcerate whole households when one member was sick, and did not hesitate to attend at the bedside of plague victims himself. He lived on for many years.

X Casualties of the Times

1. A record in a Treasury book for October 1668 of £50 paid to Hollar as 'royal bounty' may relate to this project, but that is all.

XI The Last Adventure

1. Confusion seems to have surrounded the dates of Howard's journey, which are however verifiable from the official records of the time. One commentator, followed by others, has surmised that the party was gone for eighteen months; this idea seems to have been based on a misinterpretation of the year on Hollar's 'Memorial' to the King, with its old-and-new-style dating for the month of March. Other references have suggested that his stay was under six months, but this assumes that a well-known encounter with pirates took place on the return journey. It did not, and this too is clear in the records.

2. The site of the plague pit is Vincent Square, where the boys of Westminster School now have their playing field. One must suppose that it was a lingering folk memory of the pit that kept this unusually large space unbuilt-upon a century later.

3. This reference to 'the true knowledge of perspective' would seem to offer further evidence against the notion that all seventeenth-century artists were reproducing accurate perspectives mechanically by the use of special equipment based on the referred-image principle of the camera obscura. Such devices are rarely, if ever, mentioned: one to be found in the Tradescant Collection was regarded as an exotic oddity. John Evelyn, who was keenly interested in new inventions, and in garden and peepshow 'perspectives', saw a device of this nature demonstrated at the Royal Society in 1670 and had evidently never encountered one before.

XII Various Deaths, and Survivals

1. Aubrey is working by the Julian calendar, still in use in England then on account of the Church of England's resistance to the adjusted calendar that Pope Gregory had introduced in 1582. The Gregorian calendar would then have made the 13th July the 23rd. England finally succumbed to the logic of that calendar in 1752.

Select Bibliography

Printed works consulted, not including books of general reference

Allen, Mea, *The Tradescants, their plants, gardens and museums, 1570–1662*, London 1694.

Anon., *A Collection of Very Valuable & Scarce pieces relating to the last Plague in the Yr 1665*, London 1721.

Ashmole, Elias, *The Life of Elias Ashmole Esq; in the Way of a Diary – Written by himself*, ed. by R.T. Gunther, Oxford 1926.

Aubrey, John, *Brief Lives*, ed. by John Buchanan-Brown, London 2000.

Barker, Felix, and Jackson, Peter, *London, 200 Years of a City and its People*, London 1974.

Bell, Walter George, *The Great Plague in London in 1665*, London 1951.

Boghurst, William, *An Account of the Great Plague in London in the year 1665*, printed for The Epidemiological Society of London, 1894.

Brett-James, N.G., *The Growth of Stuart London*, London 1935.

Burke, Peter, 'Popular Culture in Seventeenth-century London', *The London Journal*, III, 1977.

Cust, Lionel, 'Notes on the Collection formed by Thomas Howard, Earl of Arundel and Surrey, KG', *Burlington Magazine* XIX, 1911.

Darlington, Ida, and Howgego, James, *Printed Maps of London, circa 1553–1850*, London 1964.

Denkstein, Vladimir, *Hollar Drawings*, trans. by D. Orpington, London 1977.

Duffy, Eamon, *The Stripping of the Altars: Traditional Religion in England c. 1400–c.1580*, Yale 1992.

Evelyn, John, *Diary*, ed. by E.S. de Beer, Oxford 1959.

—— *Fumifugium*, London 1661.

Fox, Celina, *Londoners*, London 1987.

Fraser, Antonia, *The Weaker Vessel, Woman's Lot in Seventeenth-century England*, London 1984.

Globe, Alexander, *Peter Stent, London Printseller, c. 1642–1665*, Vancouver 1985.

Godfrey, Richard T., *Wenceslaus Hollar, a Bohemian Artist in England*, Yale 1994.

Greene, Graham, *Lord Rochester's Monkey*, London 1974.

Griffiths, Anthony, and Kesnerova, Gabriela, *Wenceslaus Hollar Prints and Drawings, from the Collections of the National Gallery, Prague, and the British Museum, London*, British Museum Publication 1983.

Hake, Henry M., *Documents relating to Francis Place*, Walpole Society publication, vol. X, Oxford 1922.

Hake, with Esdaile K.A. and the Earl of Ilchester (eds), *The Vertue Notebooks*, Walpole Society publication, vol. XVIII, Oxford 1930.

Harris, Frances, *The Holy Friendship, John Evelyn and Margaret Godolphin*, from proceedings of conference 'John Evelyn and his Milieu', British Library 2001.

Hartley, Craig, 'The Young Hollar in Prague: a Group of New Attributions', *Print Quarterly* VIII, 1999.

Harvey, Mary S.F., *The Life, Correspondence & Collections of Thomas Howard, Earl of Arundel*, Cambridge 1921.

Hibbert, Christopher, *London, the Biography of a City*, London 1969.

Hind, Arthur M., *Wenceslaus Hollar and his Views of London and Windsor in the Seventeenth Century*, London 1922.

—— *History of Engraving and Etching*, London 1923.

Hiscock, W.G., *John Evelyn and His Family Circle*, London 1955.

Howarth, David, *Lord Arundel and his Circle*, Yale 1985.

Hyde, Ralph, *The A to Z of Restoration London*, London 1992.

Jardine, Lisa, *Ingenious Pursuits: Building the Scientific Revolution*, London 1999.

Josten, C.H. (ed.), *Elias Ashmole (1617–1692) His Autobiographical and Historical Notes, his Correspondence, and Other Contemporary Sources, Relating to his Life and Work*, Oxford 1966.

—— *Elias Ashmole FRS (1617–1692)* Oxford 2000.

Laver, James *Costume*, London 1963.

Leith-Ross, Prudence, *The John Tradescants, Gardeners to the Rose and Lily Queen*, London 1984.

Longueville, J., *Rochester, and Other Literary Rakes of the Court of Charles II*, London 1902.

Macgregor, Arthur (ed.), *Tradescant's Rarities, a Catalogue of Early Collections in the Ashmolean Museum*, Oxford 1983.

McCray Beir, Lucinda, *Sufferers and Healers: the Experience of Illness in Seventeenth-century England*, London 1987.

Morrill, J.M., *Stuart Britain, a Very Short Introduction*, Oxford 1984.

—— (ed.), *Revolution and Restoration in England in the 1650s*, London 1992.

Nevinson, J.L. and Saunders, Ann, *'The Four Seasons' by Wenceslaus Hollar*, Costume Society Publication 1979.

Orell, John, *The Quest for Shakespeare's Globe*, Cambridge 1983.

Parry, Graham, *Hollar's England, a Mid-Seventeenth Century View*, Salisbury 1980.

Pearl, Valerie, 'Change and Stability in Seventeenth-century London', *The London Journal*, vol. III, 1977.

Pennington, Richard, *A Descriptive Catalogue of the Etched Work of Wenceslaus Hollar, 1607–1677*, Cambridge 1972.

Pepys, Samuel, *Diary*, ed. by Robert Latham and William Matthews, London 1970.

Picard, Liza, *Restoration London*, London 1997.

Porter, Roy, *London, A Social History*, London 1994.

Porter, Stephen, *The Great Fire of London*, Stroud, Glos. 1996.

—— *The Great Plague*, Stroud, Glos. 1999.

Robinson, John Martin, *The Dukes of Norfolk, A Quincentennial History*, Oxford 1982.

Routh, E.M.G., *Tangier, England's Lost Atlantic Outpost, 1661–1684*, London 1912.

Saunders, Beatrice, *John Evelyn and his Times*, London 1970.

Seaver, Paul S., *Wallington's World: a Puritan Artisan in Seventeenth-century London*, London 1985.

Schama, Simon, *The Embarrassment of Riches, an Interpretation of Dutch Culture in the Golden Age*, London 1987.

Springell, Francis C., *Connoisseur and Diplomat: the Earl of Arundel's Embassy to Germany in 1636, with a Transcription of the Diaries of William Crowne*, London 1963.

Stater, Victor, *High Life, Low Morals, the Duel that Shook Stuart Society*, London 1999.

Stow, John, *The Survey of London*, London 1603.

Thurley, Simon, *The Whitehall Palace Plan of 1670*, London 1998.

Urzidil, Johannes, *Wenceslaus Hollar, Der Kupferstecher des Barock*, Wien-Leipzig 1936.

—— *Hollar: a Czech Emigré in England*, London 1942.

van Eerde, Katherine S., *Wenceslaus Hollar, Delineator of His Time*, Charlottesville 1970.

Vertue, George, *A description of the works of the Ingenious Delineator and Engraver, Wenceslaus Hollar*, London 1759.

—— *Notebooks* See under Hake, H.M.

Walford, Edward, *Greater London*, London 1882–4.

Warner, Malcolm, *The Image of London, Views by Travellers and Emigrés*, London 1987.

Weinreb, Ben and Hibbert, Christopher (eds), *The London Encyclopaedia*, London 1983.

Whyman, Susan E., *Sociability and Power in Late Stuart England: the Cultural World of the Verneys 1660–1720*, Oxford 1999.

Index

Page numbers in *italic* indicate illustrations

Index